Books are to be returned on or before
the last date below.

D1583656

Welcome

BROKEN SCREEN

26CONVERSATIONS
WITH DOUG AITKEN
EXPANDING THE IMAGE
BREAKING THE NARRATIVE
EDITED BY NOEL DANIEL

BROKEN SCREEN

BROKEN SCREEN

Preface

Doug Aitken and Noel Daniel

These twenty-six conversations are drawn from talks with artists, filmmakers, and architects that occurred in places ranging from Aitken's neighborhood in Venice, California, to New York, Paris, Iceland, and Japan. In the following interview Aitken talks with *Broken Screen* editor Noel Daniel about the ideas behind this project.

Noel:
In their rawness and candor, the conversations collected here are more like personal exchanges between colleagues than formal interviews. How did the idea for the book start?

Doug:
When I travel for projects, the spontaneous conversations that happen with friends and colleagues are often what keep me going. For me they're the most stimulating moments. But often as time passes, the memories of these encounters start to fade. What was talked about stays with you only as sound bites. This book is an attempt to recapture the candid qualities of these encounters and to try to put into words the essential motivations behind the creative process. I wanted to retain the unfiltered openness in the original conversations, and to share them with anyone who might be interested.

Noel:
The conversations focus on ideas about nonlinearity and fragmentation that lie behind a cross section of work from the last sixty years to the present. What is the value for you in tracing these tendencies through recent history?

Doug:
Once when I was traveling, I saw these words scrawled on a bathroom wall: "It's like a hurricane, a hurricane. I'll see you at the end of the bar, though I don't know who you are. There's so much confusion here. It's like a hurricane." One of the questions *Broken Screen* asks is, do we stand in the calm center of this hurricane of modern life or do we step into its turbulence? And do we have a choice? I think we're just on the cusp of exploring our options. Everyone in this project directly or indirectly attempts to reflect on this landscape of fragmentation in their work, either through multilayered story

lines, fractured perception, or disjointed images. I wanted this book to let us in on how they approach and experiment with these questions.

Noel:
Was your decision to make these issues the touchstones of the project a result of your personal experiences?

Doug:
I think the experience of nonlinearity and fragmentation is with us all the time. They are sometimes seen as dangerous and are often associated with chaos. But in many ways, they're truer to reality. I want this book to challenge the assumption that disorientation is dangerous and to propose that the randomness we encounter in life can be very productive.

Noel:
The people you spoke with work in a number of different fields, including film and video, photography, painting, sound art, and architecture. One thing everyone has in common is that they've all reflected on the use of new technologies and mass media in their work. By bringing these people together, you've created a platform for looking at how these ideas resonate in a range of creative industries. As someone who works with diverse media, was this cross-referencing an essential part of the project for you?

Doug:
I think there's an assumption that each medium exists in a vacuum. But it's an illusion, and you can see this in the conversations. Ed Ruscha studied advertising; Richard Prince worked at Time-Life; Bruce Conner was an assemblage artist before making film; Rem Koolhaas wrote film scripts before getting into architecture; John Baldessari talks about the time *Chinatown* (1974) was being filmed outside his studio. It's interesting when you see these cross-pollinations. *Broken Screen* is more about raising questions than offering definitive answers. Although film and the moving image are very prevalent in the book, and while I consider them some of the most influential phenomena of the twentieth century, this isn't intended to be a film book. This is meant to be a book of ideas from everyone who participated—a tool for stimulation.

Noel:
In their straight-shooting tone, the conversations bring to the surface commonalities and tensions between the participants. Were you endeavoring to reach a consensus within this multiplicity of voices?

Doug:
There are no absolutes here, only opinions, contradictions, repulsions, and revelations. For me, it's refreshing to have the words of people like Amos Vogel, the legendary New York Film Festival cofounder who argues against today's commercial media, sit alongside those of film title designer Pablo Ferro, who's an absolute innovator in the applied arts and who has thrived in the commercial world. Everyone here is living and making work. In talking to these people, it was incredibly invigorating to witness their passionate responses to the world around them.

Noel:
How did you decide whom to speak with?

Doug:
Broken Screen is a project that evolved organically and the list of participants grew organically too. It isn't meant to be exclusive or definitive. There are many people from the past and present who are part of this discourse. One of the things I wanted to do was to create a communal dialogue with living artists that is open to further interpretation. It's a manifesto made up of many voices from many fields. The pollen is in the air and it's moving into a lot of new areas.

Noel:
Why do you feel it's important to talk about these issues right now?

Doug:
After a century dominated by the moving image, this book takes stock of the conditions of communication in the early twenty-first century. The value of these discussions for me is that they're an attempt to open up a larger discussion about how we're going to continue creating as we move in and out of the hurricane of modern life.

oe
da

One of the reasons I made *A MOVIE* (1958) was because it's what I wanted to see happen in film. I'd been waiting for someone to come up with a movie like this. And nobody did.

Bruce Conner

PEOPLE HAVE CRITICIZED ME FOR NOT HAVING A CLEAR STYLE — AS IF THERE ARE THINGS IN LIFE THAT DON'T HAVE CONTRADICTIONS. I HAVE WANTED TO GIVE MYSELF AS MUCH GROUND AS POSSIBLE AND AS MANY DIFFERENT VIEWPOINTS AS POSSIBLE.

Ugo Rondinone

We need to take images off the screen, like Moholy-Nagy envisioned more than sixty years ago. We can do it. One day you will see it everywhere.

Alejandro Jodorowsky

Claire Denis

Robert Wilson

Perhaps the body is moving faster than we think.

Fragmentation in my work is the result of my relationship to the world. A film is never what you intend it to be. It can't stay unified inside you forever.

Architecture's structure is one of the key areas where nonlinearity is starting to exist now. I think we're really beginning to see new ways of structuring architecture.

Rem Koolhaas

Splitting screens, splitting spaces, running time as real time and then as distorted time are things that have always obsessed me about cinema. The interesting thing about cinema is its potential for nonlinear timing.

Mike Figgis

There must be some hidden meaning, you know? It can't be like what you see is what you get. There has to be something else going on.

John Baldessari

now

no75 147750

Confusion is obviously a nonlinear state. In a confused environment the unexpected can happen at anytime. It is a very productive and beautiful state of mind to me, yet it's something that we often have difficulty appreciating.

Carsten Höller

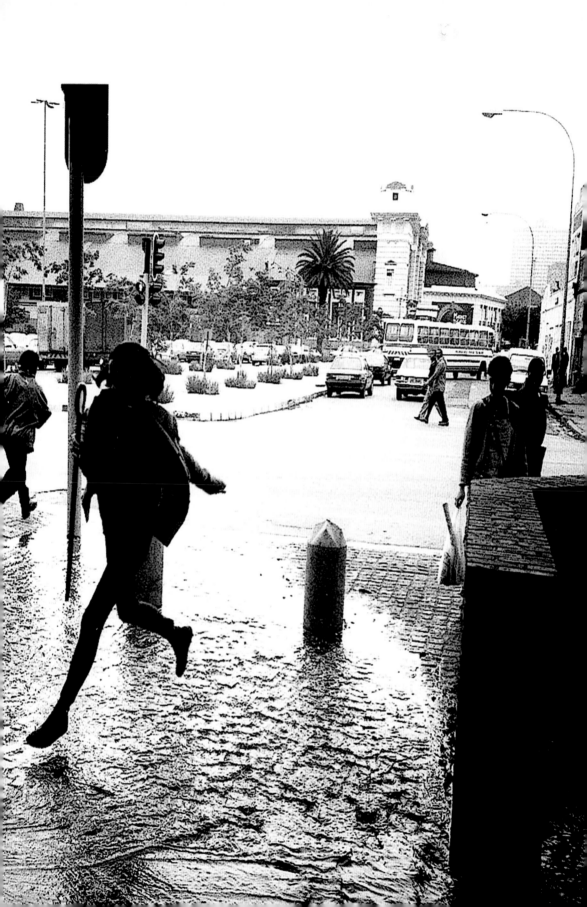

FRAGMENT

STRUCTURE

I THINK PEOPLE ARE BEGINNING TO REALIZE THAT THERE'S NOT A LOT OF RATIONALITY LEFT IN AN IMPOSED STRUCTURE.

JOHN BALDESSARI

HOW DO YOU MAKE THE AUDIENCE PART OF A WORK? MAKING THE VIEWER PART OF THE PIECE IS REALLY THE ISSUE FOR ME. IN PERFORMANCE THE AUDIENCE ISN'T SEPARATE FROM THE WORK BUT IS PART OF IT.

CHRIS BURDEN

Nonlinear
structures allow you
to explore time—
to open it up,
pull it back,
and reveal
the inner workings
of a single moment.

DOUG AITKEN

PIERRE HUYGHE

I want to remind the viewer that there are many different present moments possible. I'm interested in subjective viewpoints and in the multiplicity of viewpoints.

viewer

linear

We're at the very beginning of what films can really be. We haven't come close to the medium's full potential yet. Everything is still so linear.

ROBERT ALTMAN

DOUG AITKEN

WHEN YOU MAKE AN INSTALLATION, YOU'RE CONSIDERING THE VIEWERS' PHYSICAL CONNECTION TO THE WORK AND HOW IMMERSIVE YOU WANT THEIR EXPERIENCE TO BE. YOU HAVE TO ENGAGE THEIR SPACE CONSCIOUSLY.

I DON'T SEE POTENTIAL IN ONE NARRATIVE THAT DESCRIBES A PARTICULAR STORY. I SEE POTENTIAL IN THE IDEA OF THE SPECTATOR—IN THE RECEIVER, THE READER, THE PARTICIPATOR, THE VIEWER, THE USER. THE ACT OF PERCEIVING IS CRUCIAL TO MY WORK. THE NARRATIVE IS RIGHT THERE.

OLAFUR ELIASSON

PERFORM

CHRIS BURDEN

THE VIEWER HAS TO

I WONDER ABOUT THE WAY THAT MY WORK HAS BECOME MORE DENSELY LAYERED. DOES IT HAVE TO DO WITH THE FACT THAT THERE IS MORE INFORMATION AVAILABLE AND I CAN FIND IT FASTER? OR IS IT ABOUT HAVING A HIGHER TOLERANCE, LIKE AN ADDICT, WHERE IN ORDER TO GET A BUZZ YOU HAVE TO TAKE IN MORE?

FILM IS THE ESSENTIAL MECHANISM OF EVERY THING.

vision

:

:

I don't want to storyboard my mind.
CLAIRE DENIS

DOUG AITKEN

PIPILOTTI RIST
IT'S PART OF TRYING TO KEEP THE MOVING IMAGE FROM BEING REDUCED TO THE FLAT SQUARE OF THE SCREEN, WHETHER THE VIEWER READS THE SCREEN AS A TWO- OR THREE-DIMENSIONAL OBJECT IS ONLY A QUESTION OF HIS OR HER AWARENESS.

IT SEEMS YOU'VE ALWAYS RESISTED MAKING WORK WITHIN THE RESTRICTIONS OF A "BOX." YOU CAN SEE THIS IN HOW YOU SOMETIMES FIGHT OR PROVOKE THE FRAME. ARE YOU INTENTIONALLY TRYING TO BREAK OUT OF THE FRAME IN DEFIANCE OF FORMALISM?

CARSTEN HÖLLER

When I find myself in an influential environment like the cinema or an installation, the whole space makes me feel differently. It makes me unsure of what really is. It's about losing certainty. And then the real film starts, the inner film.

DOUG AITKEN

The question is, how do we go about formulating experience now?

WE NEED NEW OPTIONS BECAUSE THE OLD-FASHIONED, STRAIGHTFORWARD, LINEAR NARRATIVES WITH THEIR BEGINNING, MIDDLE, AND HAPPY ENDINGS HAVE NONE OF THE REAL MYSTERIES OF EXISTENCE THAT WE ALL KNOW TO BE TRUE IN OUR OWN LIVES.
AMOS VOGEL

HOW FAST CAN THINGS GO? WHAT ARE THE LIMITS OF OUR PERCEPTION? I THINK BEING A FILTER IS BECOMING MORE AND MORE IMPORTANT. WE HAVE TO BE VERY GOOD FILTERS NOW JUST TO SURVIVE.
CARSTEN NICOLAI

BOB WILSON
WE ARE ALWAYS ALTERNATING BETWEEN INTERIOR, EXTERIOR, AUDIO, AND VISUAL SCREENS. AS I'M TALKING TO YOU NOW, YOU BLINK YOUR EYES. WHAT DO YOU SEE? MAYBE FOR A SPLIT SECOND YOU WERE DREAMING OR SEEING A NEGATIVE IMAGE. THIS IS ALSO A PART OF SEEING.

IT'S INFORMATION AGE ART. MY GOAL IS TO CAPTURE THE IDEA OF THE THING RATHER THAN THE THING ITSELF.
ED RUSCHA

reak

Imagine you're sitting at
you haven't seen in a long

vooden table with a friend
ime and you begin talking...

Eija-Liisa Ahtila

The films and multiple-screen installations of artist Eija-Liisa Ahtila (b. 1959, Hämeenlinna, Finland) subvert linear storytelling in pursuit of multilayered narratives. Reworking the conventions of film and television, she creates fictionalized scenarios in realistic settings to convey the uncertainties of identity, sexuality, and relationships. Time sequences overlap and converge, and layers of meaning obscure the boundary between reality and fantasy. The split- and multiscreen formats reinforce the fragmentary structures of the narratives.

Doug:
I have this vision of you working in Helsinki, with its long Finnish nights and endless summer days, directing your films on the outer edges of the film community. Your film installations tell stories that are deeply introspective. They live beyond the confines of the film world in how personal they are. You distribute your films in both the art and film communities. What challenges do you face having one foot in each of these worlds?

Eija-Liisa:
Your description of me working here is quite correct, but I don't think it has to do with living in Helsinki. In my case I could say I'm both a filmmaker and an artist. When I make a work with moving images, I usually do both a film version and an installation version. The film version is distributed through festivals and on television, and the installation through galleries and museums. But if I think about my approach to the medium of the moving image itself, it's more as an artist. The important thing for me is to express myself through the medium. Only when I have to, do I think about the differences between the two fields, like when I try to get financing from the film world. It's then that I often realize how different my approach is. It's not always easy to find a common language. But fortunately there are people out there who are interested in the new developments going on in film narration.

Doug:
What led you to start using multiple screens in your installations?

Eija-Liisa:
In 1994 I got an invitation to take part in an exhibition at Index Gallery in Stockholm. I wanted to depict the lives of teenage girls, a subject that was not very common back then. I was living in Los Angeles at the time and there were these black-and-white Calvin Klein billboards made up of several images put together. Do you remember them? I liked the idea of that kind of broken space and thought I'd like to do a similar thing with the moving image to reflect the experiences that teenage girls go through as their bodies transform from those of girls to those of women.

Doug:
If only the advertisers knew that they had sold you the idea behind the billboard

THIS CONVERSATION TOOK PLACE BETWEEN HELSINKI, FINLAND, AND VENICE, CALIFORNIA.

I TRY TO BREAK THE OLD RULES OF EDITING

instead of selling you the clothes. Have there been other instances where advertisements have affected your work?

Eija-Liisa:
Not in terms of the subject matter of any advertisements, but yes in terms of their abbreviated and repetitive formats. I've done two works that were intended to be shown in advertising slots, *Me/We, Okay, Gray* in 1993 and *The Present* in 2001. It would be great to see more works by artists and filmmakers in among the advertisements on television. It's a format that has been completely abandoned and given over to advertisers. It would be great to be surprised once in a while.

Doug:
Your work tells stories that are laden with subtexts. You draw the viewer into dark, disjointed worlds where there are surreal encounters and sudden outbursts of violence. These worlds attest to the parallel realities inside your characters' minds and are often shown against the backdrop of domestic settings and other personal locations.

Eija-Liisa:
I want every subject matter to carry a particular rhythm. The size and running time of the images and the nature of the sound and lighting all need to serve this rhythm.

Doug:
Extreme editing techniques seem to be an important part of your work. Is there a specific idea about the moving image that you want to communicate through your editing?

Eija-Liisa:
I try to break the old rules of editing. During the editing process, there is so much going on that I need to have a certain distance from it in order to see how the story is taking shape in the material. This is why I never edit the works myself. I always work together with an editor during the whole process. There are a lot of traditional ways of editing that affect the nature of the narration, like cutting from one image size to another, editing around movement, breaking the line, and many other more subtle ones. But when you're working with three images that will ultimately unfold all at the same time on multiple screens in one installation, it is very different. Some of the rules apply, but they don't tell you how to deal with things like simultaneity or how to move a character from one screen to another.

Doug:
How do you go about doing this?

Eija-Liisa:
It's a lot of trial and error, and it's a lot of intuition. Every work has a rhythm of its own with demands of its own. There's so much you can experiment with, like showing action and reaction simultaneously, showing a detail shot along with a wide-angle shot, using images of different sizes at the same time, making time overlap by showing different parts of an action on separate screens. But for me, the choices always have to do with the subject matter and the atmosphere on-screen.

Doug:
How do you usually get started on a project?

Eija-Liisa:
Working is an ongoing thing for me, meaning that the long periods when I'm doing "nothing" are as essential as when I'm writing or editing. That's when I'm rearranging myself or changing my rhythm, so I can't really say exactly when a project starts. Each project is different depending on the idea or the subject matter, but at a certain point enough things have taken place around me that I start writing.

Doug:
So you script your films first?

Eija-Liisa:
Yes, and I work out what kind of form would best correspond to the subject matter, how many screens I want and in what kind of structure, and the overall shape of the space.

Doug:
Sometimes it feels like the process of filmmaking is inherently fragmentary. There are lots of pieces of equipment and locations involved in creating a work, and it requires working with many skilled specialists. I'd be interested to know what it's like for you to collaborate with a crew while making work that communicates such a personal vision.

Eija-Liisa:
I just spoke this morning with Arto Kaivanto, the cinematographer I work with who has shot almost all my films. I was telling him about a weird, new little work I've written and we discussed his schedule. The crew I work with is made up of all professionals and some of us have been working together for ten years. Before doing anything else, we talk about the script and the theme. We go through the trickier parts of it and plan the special effects using storyboards. Everyone has got his or her own part of the production to take care of. Mine is to keep things together and to make decisions that support the idea behind it all. My task as an artist is to intimately know the work, why we are doing what we do, and to make the right choices about setting, acting, lighting, dialogue, and so on.

Doug:
Where do you see the moving image going?

Eija-Liisa:
I think there won't be such a thing as film or video per se, only different kinds of visual worlds created by the moving image. In truth, I feel uneasy talking about the future of things that aren't alive. I feel that all moving images are interesting. If at some point I have a script that's good enough, I'd like to make a feature film, but that is not my goal. To me, it's just fascinating to experiment with stories and moving images.

Doug:
Besides your personal experiences, what other areas in the arts do you look to as reference points?

IN MY CASE I COULD SAY I'M BOTH A FILMMAKER AND AN ARTIST. BUT IF I THINK ABOUT MY APPROACH TO THE MEDIUM ITSELF, IT'S MORE AS AN ARTIST. THE IMPORTANT THING FOR ME IS TO EXPRESS MYSELF THROUGH THE MEDIUM

Eija-Liisa:

I've seen a lot of films that I admire, but I don't feel I have such a strong connection to any of them. For me, it's easier to have a conversation with text. Maybe this has to do with the form most films have. They are so closed. I just finished the second draft of a script I'm working on, and before I started writing it, I read some poetry. Maybe I could say that the work of the poets T. S. Eliot and Arthur Rimbaud have influenced me. But I'm not being fair. What could be anything like Eliot's *Four Quartets* (1936–42)?

Doug:

What then does the moving image do for you that poetry cannot?

Eija-Liisa:

You can make the inner experience you have with the written word more accessible to others. You can create a fictional world that can be accessed through the senses. For example, you can explore how to communicate what a winter night's light is like by thinking about what response a particular sound might provoke. Or by thinking about how many things can take place in one frame while still allowing the viewer to take in the dialogue. With the moving image, you can take it a step further.

Robert Altman

Filmmaker Robert Altman (b. 1925, Kansas City, Missouri) is known for his revolutionary use of sound, overlapping dialogue, and multiple narratives. He was a key participant in the resurgence of American filmmaking in the 1970s and remains one of the most independent and consistently innovative filmmakers in Hollywood. Also a writer and producer, he has made dozens of films, including *Nashville* (1975), *3 Women* (1977), and *Short Cuts* (1993), and has experimented with a diverse range of genres such as film noir, drama, and the biopic.

Doug:
Your films are known for their multiple, interweaving story lines. When did you start becoming interested in this kind of filmmaking?

Robert:
I had wanted to get rid of linearity in film since the 1960s, and I saw potential for it some years later in the script for *Nashville*. I remember thinking it was a dreadful script, but I felt I could do things with it I had wanted to do for a really long time. I had worked on some of these ideas in a film in the mid-1960s called *The Chicken and the Hawk* about World War I pilots, but it was too expensive so I never got anywhere with it.

Doug:
With over fifty years of experience in the film industry, you've had one of the longest careers of anyone in the business. You've seen filmmakers come and go, some suc-ceeding, others not. In your opinion how important is the idea of nonlinearity to the future of filmmaking?

Robert:
We're at the very beginning of what films can really be. We haven't come close to the medium's full potential yet. Everything is still so linear.

Doug:
It's always puzzled me because linear filmmaking doesn't really have very much to do with how we experience the world. In your films peoples' lives crisscross, converge, and diverge in ways that are often closer to how we really live.

Robert:
You know when you go to a dinner party and you don't know many of the other guests? You spend hours with them and then afterwards you and your partner rehash the eve-ning: "Who was that blond girl? Was she married to that guy?" "No, she was his sister..." You never get it straight. You spend hours and hours and hours with these people and you don't know who the fuck they are. I like capturing this confusion in film where you can't tell who's who. This is what real life is like. Some critics think a filmmaker has an obligation to make things clear to the audience. In 1977 when *3 Women* came out, they were like, "What the fuck is this about?" Nobody got it.

They couldn't accept it. But today's critics say it's great *because* you don't get it. To me, this just means that critics have been educated in film to the point where they can accept its confusion now.

Doug:
So what were your early influences?

Robert:
Growing up, I wasn't as interested in movies as I was in radio drama. Radio was the great art form to me. Right around the end of World War II, things were really beginning to happen in radio. I was particularly interested in great dramatists like Norman Corwin. It was around this time that people like him and the legendary horror writer Arch Obler started getting a lot of attention. Then television came along and fucked it all up.

Doug:
Every time a new medium is invented, it seems inevitable that there's a backlash, but television seems pretty unique in the extent of its influence. One of the most obvious ways television has changed our lives is in the sheer volume of aural and visual information it exposes us to. Do you think in all of this, a positive outcome might be that it increases the viewer's ability to read the image in a more sophisticated way?

Robert:
I think people have become more educated, but I also think they've become less sophisticated because of what they're watching. Most of the moving images that people are exposed to come from television, and the problem is that they give you all the answers. People don't have to work for them. They know they will be told the same story again and again and that everything will be explained to them. I want to make films where if you take your eyes off the screen for a split second, you'll miss what's going on.

Doug:
The kinds of narratives used in television programs and commercials haven't changed that much, but they're continually being upgraded and repackaged. It's like getting a magazine each month that you subscribe to and seeing that the content is the same, it's just the layout that's changed.

Robert:
That's all it is.

Doug:
So you grew up on radio drama. Has that influenced your use of sound?

Robert:
I approach sound the same way an artist tries to give images atmosphere. I try to express the way we experience sound in real time. When I was first coming along in film, I got fired again and again because people like Jack Warner, cofounder of Warner Brothers, would say, "Who has actors all talking at the same time?" Well, I haven't had any experiences in real life where people don't talk all at the same time. People don't wait around for each other to shut up before they speak.

Doug:
The way you use audio has always reminded me of Phil Spector's "wall of sound" studio productions, where he would put a lot of instruments into a tiny recording space to enhance each instrument's sound. To me, you build volumetric spaces with sound in a similar way. Where other directors might isolate the principal characters' dialogue to focus the viewer's attention on it, you create multiple vignettes on-screen where all the characters remain just audible enough so that the viewer can move from one vignette to the other. It really enhances the feeling of simultaneity. When I'm confronted with this kind of sound as a viewer, I feel encouraged to create my own version of what's going on.

Robert:
In art the constant across the board is the growth inherent within it—which is in fact the viewer's own potential for growth born of all the experiences they've had up to that point.

Doug:
Here I'm thinking specifically of Nashville, *where you miked the characters separately, or in* The Long Goodbye *(1973), where the film's sound track is composed of variations of the same melody, reinforcing the simultaneity between the scenes. It's interesting because this kind of fragmentation enhances the legibility of the film rather than confuses it.*

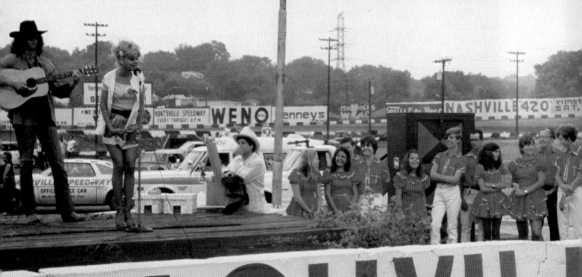

Doug:
It seems like you incessantly search for different ways to represent a fragmented reality in film.

Robert:
Film is not about a frozen frame. As a filmmaker, I am not working with one single moment like a painter or a photographer. Whether you're conscious of it or not, as a filmmaker you're dealing as best you can with all the elements of real life that surround your subject. Even though I knew nothing about country music, I did this even when making *Nashville.*

Doug:
Like how Kafka had never been to the States before writing Amerika (1927).

Robert:
And George Bush has never been...anywhere!

Doug:
No kidding! Do you think of your films as collages?

Robert:
They are collages of sorts, but they're also portraits of ideas. When people see a film, they draw on their own background. Everything I said or thought or did yesterday becomes part of my background—my personal history—and so today, everything I say is filtered through yesterday and the day before, and so on.

Doug:
A lot of contemporary culture, whether it's film or literature or pop music, seems to be driven by referencing what others have already done. What's your view on this?

Robert:
With every film that gets made, other directors say, "I could have done it better. In my next film, I'm going to light it better, have better costumes, better music, better dialogue. Everything will be better, better, better." Filmmakers work too hard at this. What they're really doing is making a film they've seen many times before. That doesn't interest me personally so much.

Doug:
Do you think it's possible to create something that isn't connected to the past?

Robert:
I think it's probably impossible to create something that doesn't have any references to anything else at all. I can go through each of my movies and in every one of them there are little things that nobody but me could possibly ever notice. There are references to things beyond what plays out on-screen.

Doug:
I think what you're talking about is evident in the many different layers of your films: in the sound, the editing, and the overlapping story lines. But in the end the films come across like tightly woven tapestries.

Robert:

If the plot isn't obvious, viewers are forced to draw on their own experiences to understand it. They have to dig into their subconscious. This is what I want. For me, the greatest accolade anyone could give me about one of my films is to say, "I don't know what that was about, but man, was it right on." It's making a film about an emotion. Consider how acute your sense of taste is: whether your hamburger tastes good, bad, salty, or sweet, it's irrelevant to your brain. Our brains perceive these different tastes in the same way, even if we experience them simultaneously. I think a film should do that too, and art. Film's greatest danger and biggest drawback is that it's too explicit.

Doug:

Perhaps these I-don't-know-why-but-it's-right moments in film or artwork strike a chord because that's when intuition is the source of meaning rather than language and conscious perception. In these moments memories of the past often come together with the present.

Robert:

That's right. Let me tell you this story. I was a pilot in World War II and after the war we made a film about how pilots were trained. One of the things we showed was how a pilot had to go through dozens of steps in a very linear way to start the plane. Each pilot had a checklist so they could remember them all. But then we showed how some pilots had been trained to remember how to start the plane by visualizing sixteen images simultaneously, and on up to as many as sixty-four. They actually learned faster and better that way than when the information was presented to them as a linear checklist. This made a big impression on me. I have come to think that this is true in everything from love to sports—in anything where you're doing lots of things simultaneously. It is like our sense of taste that I was talking about before. Fragments that give an overall impression are much more important to me in my work than the plot.

Doug:

The Player (1992), Short Cuts (1993), and Nashville are all like sculptures to me. There's a three-dimensionality to how the stories interweave, and the films seem to reveal new impressions with each viewing.

Robert:

That was my intention: to have more than one thing happen at a time. It's about mixing up emotions. It's like seeing your mother-in-law drive your new Jaguar off a cliff. It's mixed emotions. You lost your car, but you got rid of her. Do you feel more joy or more pain? Well, you experience both at the same time!

Doug:

That's a tough one! In your films there are visual and aural tunnels and trails of multiple narratives, but there's no obvious blueprint to help the viewer like in most films. Nevertheless, even without this, if you turn on Short Cuts at any given point and start watching it, you can still understand it.

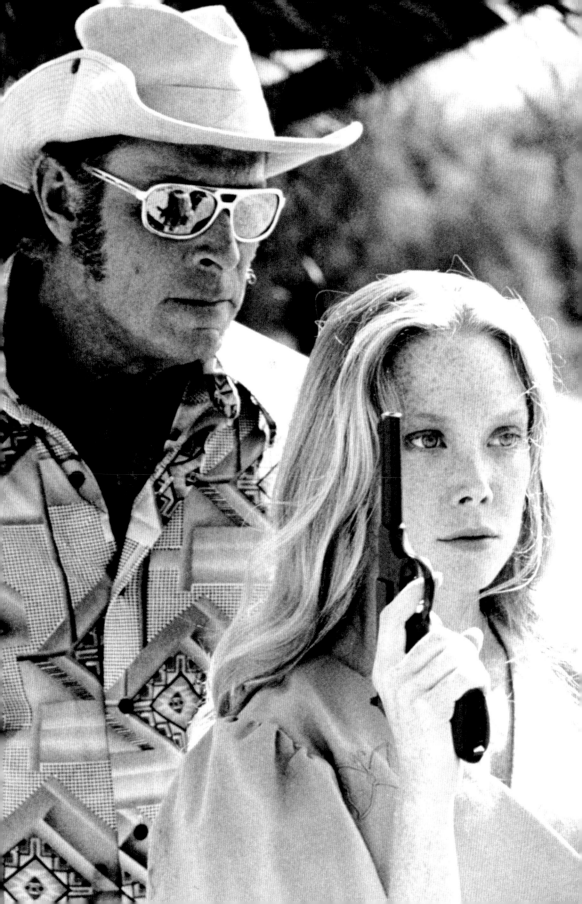

Robert:

Yes, you could, and it wouldn't make a bit of difference. I don't believe films have a beginning or an end. The only real end I know of is death. You can pretend something has a happy ending: the boy kisses the girl and they walk into their little cottage and that's the end of the story. Only, the next morning he wakes up and sees her kissing the milkman. He gets his shotgun and blows the milkman's head off, cuts up his wife into little pieces, and puts her in the milk bottles. That's not a happy ending at all! When something looks like it is a happy ending, it's really just a happy stopping point.

Doug:

That might just be the definition of mainstream cinema: having the appearance of a happy ending, but in reality having only a temporary conclusion. Personally, I don't like reaching conclusions. I like believing that there is always more to follow the next day and the day after it that's new. I wonder if these closed-circuit narratives in film limit how we can appreciate open-endedness in our own lives.

Robert:

But viewers demand an ending. It is what Warhol's experiments in film were all about —that it doesn't make much of a difference at which point in the film you start watching it, or if you fall asleep!

Doug:

You often use a lot of different characters in your films. In Nashville, *there are twenty-four characters, and forty-eight characters in* A Wedding *(1978). When you started using more characters in your films, were you seeing how many you could handle and still retain the plot?*

Robert:

I wanted to have all those characters so I could experiment with nonlinearity. When I make a film, I ask myself, where do I start and what do I start with? I want lots of things to happen at the same time so the audience is forced to react. This is really important to me.

Doug:

You have worked in the shadow of Hollywood your entire career, making films that communicate to a broad audience but that also feature your experiments in nonlinearity. How are you able to keep one foot in the experimental film world and one foot in mainstream cinema?

Robert:

Film is a very strange art because you can't do it alone. As a filmmaker, you can't just go up into your garret, stretch a bed sheet out, and put some pigment on it. It takes a lot of money and a lot of other artists to do it.

Doug:

It's a communal art that relies on many different professionals, but there are some directors who create a very strong hierarchy on set to get things done. Are you like this when you film?

Robert:

Well, there has to be a monarch. Someone has to be there to say when to turn the lights on and when to turn them off again. But the art of film comes from all different elements gathered together. It doesn't come from any one person.

Doug:
You have said that you are very interested in the visual arts, especially painting.

Robert:

I find inspiration everywhere, but I equate making films with painting more than I do with theater or literature. In literature there is one author and he or she has a one-to-one relationship with the reader, but the reader sets his or her own tempo. In film there is a multiplicity of authors and the film has a fixed tempo. A film that is two hours and four minutes is going to be two hours and four minutes for everybody who sees it.

Doug:
You seem to encourage your actors to develop their own dialogue.

Robert:

That's what making films is about. The actors I work with are all terrific. They're the ones who have the difficult task of communicating the message.

Doug:
Do you normally stick closely to the script when you shoot, or do you see it as something to be fleshed out in the process of filming?

Robert:

We shot *Nashville* in a more linear way, sticking pretty closely to the script. The first scene in *Nashville* was the first scene we shot, and the last scene in the film was the last one we shot. Everybody was there all the time from the beginning to the end. With *Short Cuts* I had to shoot groups of characters at the same time because of expediency and expense. I shot Lily Tomlin and Tom Waits for six days, then they were gone. Then I did the Tim Robbins stuff and then he was gone, and on down the line.

Doug:
How would you describe improvisation?

Robert:

Everything is improvisation. Dialogue in film is not Shakespearean poetry. When you read Shakespeare, you hear it; the words transmit all the meaning. But people don't watch films the way they read Shakespeare. Shakespeare is a brilliant poet, obviously, but the spoken word as poetry isn't what interests me in my work. Hopefully the words in my films don't transmit anything. They are replaceable. I wouldn't have scripts if I didn't have to; I'm more interested in creating atmosphere. The only reason people talk in my films is because if they didn't talk, people would think they were mad.

Doug:
So what would you say are the limits of film?

Robert:

Since film is two dimensional, everybody sees exactly the same thing. In theater you

turn your head to the left and to the right. You make choices about what to focus on. In film you don't do this. Everything is already there for you. That's why it's so dangerous.

Doug:
Dangerous?

Robert:
Artistically it's dangerous because it's very hard to involve the audience. Let's say there are two hundred seats in a movie theater and two hundred people come in and sit down. One person has come in because his mother died two days before; his life has been turned upside down and he wants to watch the movie to forget. A couple comes in and they are elated because something great has just happened to them. Nobody is in the same frame of mind. This is exacerbated because the film is not a live performance in real time.

Doug:
Do you think the film creates unity or disunity among the audience members?

Robert:
Film should bring everybody together at the same time. That's why we use strong dramatic input like blowing somebody's head up. I can make anybody jump by shooting a gun off behind them, but that is a problem if it still doesn't bring the audience together.

Doug:
Do you find it hard to get people's attention?

Robert:
Last night, I went out on our terrace and there was a beautiful sunset. Now, if that had been on a calendar hanging on the wall, you and I would never look at it. But when you experience it firsthand, you feel the air and the temperature and whatever has happened to you at that particular time, on that day, and in your life. It's about finding these ways to open up your sensors.

Kenneth Anger

Filmmaker Kenneth Anger (b. 1930, Santa Monica, California) fuses pop culture iconography with occult tableaux in a fierce revolt against the imagery of genre filmmaking. One of the first filmmakers to overtly reference homosexuality, he made nine short films between 1947 and 1981 that have profoundly influenced generations of artists, filmmakers, and musicians. Inspired by the writings of legendary occultist Aleister Crowley, his films unleash sexuality, dream sequences, and fetishes in an onslaught of symbolic detail and pioneering editing.

Doug:
We're walking through your neighborhood, Echo Park in Los Angeles. It's a raw place that stands in marked contrast to the façade of glamour that is Hollywood. It's unusual that as a filmmaker, you grew up around the industry. Most people in the business are drawn here from elsewhere in the States. How did it all start for you?

Kenneth:
I started making films with a home movie camera when I was seven.

Doug:
Your films have always made strong use of graphics, yet have no dialogue. Why?

Kenneth:
I have always loved silent movies. I used to watch a lot of them when I was younger because my grandmother was a costume designer for silent films. I made my first film using my family's 16mm Cine-Kodak, which you had to spring-wind by hand and that wasn't able to record any sound. This was before portable tape recorders. So I basically just began making silent movies with musical accompaniment. And I'm still doing that.

Doug:
It sounds like you broke free really early on from the idea that film has to have an overall story line. Instead you concentrated on atmospheric impressions. There can be something incredibly powerful about watching moving images without any dialogue.

Kenneth:
I'm glad that you think I'm trying to break away from narrative in my films. That's what I am aiming for.

Doug:
Do you see similarities between your films and the silent visual language of dreams?

Kenneth:
My dreams are like films played over and over without any dialogue and totally unrelated to anything else in my life. As I've gotten older, I've finally gotten rid of the nightmares, or at least have gotten tired of them. Maybe they just don't scare me anymore.

THIS CONVERSATION TOOK PLACE IN LOS ANGELES, CALIFORNIA.

Doug:
After watching your films, they seem to rearrange themselves in my memory. I can never remember the exact sequence of images, but I can vividly remember certain impressions. To me, your films are like pills—tight and compact—that expand outward into atmospheric mental images, agitating one's sense of rationality.

Kenneth:
That's okay by me! I think watching film can be very similar to dreaming. That's why it's a fascinating medium. Although, according to some psychologists, you can think a dream has lasted for hours, when it was really just a few minutes or even seconds. But I don't know, I think science is just a bunch of bullshit. To be an authority, they have to say something definite when they really do not know. That's why I like myths. With myths you're never imposed on from the outside. You can come up with your own stuff.

Doug:
Even though your films are short, their primal qualities really do suggest myths of your own making. Even Scorpio Rising *(1963), the film that has the most candy-coated pop culture feel to it of all your films—with its hot rods and black*

leather—seems more like an age-old myth than a contemporary story. The narrative is driven purely by dramatic symbols.

Kenneth:
Mythology is really important to me. I studied it as soon as I could read. I love it and feel part of it.

Doug:
Your early films like Tinsel Tree *(1941–42) seem to tap directly into the subconscious. Even though you made it when you were just a kid, it's obvious that it wasn't just an exercise in figuring out the craft of filmmaking. It's violent, beautiful, and incredibly raw emotionally. Where did your drive to make the film come from?*

Kenneth:
My family had a German ritual of burning our Christmas trees. That was the origin of *Tinsel Tree.* I felt the tree was being treated like a goddess, dressed up in fancy finery, and then violently burned. We had these fabulous nineteenth-century hand-blown glass peacocks from Germany we'd hang on the tree along with the strands of tinsel and electric lights. And then, when the tree had done its bit of show business for us

and the holiday was over, my family would haul it outside and set it on fire. Since it was dry, it took only a few seconds for it to go up in a beautiful pyramid of fire.

Doug:
To stand in front of a blazing tree in your own backyard is a really primal experience to have had as a kid. Many of your films seem to agitate the viewer in a similar way. It's like you're not only trying to seduce the viewer, but to attack the viewer visually—to send things up in fire and smoke in front of them.

Kenneth:
I hope so. Kick 'em in the nuts every now and then.

Doug:
I recently watched Scorpio Rising *again and it struck me how much the film creates a drama out of surface alone.*

Kenneth:
It is very much about surface, shiny surfaces and hard surfaces, and the reflective quality of things.

Doug:
That film in particular completely abandons storytelling and, instead, portrays American motorcycle culture through its details. It focuses on the sensuality of an inanimate object and the impenetrability of its aesthetic form. Even though there's no narrative entry point, you're still able to create a sense of progression without any character development.

Kenneth:
I introduce the character Scorpio, but he's just a device. I don't follow him from beginning to end.

Doug:
The details and textures—the chrome, shiny metallic paint, leather—foreshadows the hot rods and customized cars in Kustom Kar Kommandos *(1965). You abstract the surfaces to the same degree that Stan Brakhage does in his films, but your subject is the fetishized image, a perfect abstraction lit to the nth degree as if it were a television commercial. But unlike a commercial, you deliver a philosophical question instead of a product.*

Kenneth:
The simplicity comes from the limitations I face working alone. I don't have a crew. I do everything myself. I do my own lighting, my own camerawork, my own cutting. The whole thing is a one-man show.

Doug:
I'm sure you're aware of this, but your work has had a huge influence on music videos, especially the way you fragment time and distill the imagery down to its essence.

Kenneth:
People have copied me outrageously in MTV music videos. Should I sue or not? Fuck 'em. They are the ones making the money. I don't give a damn. No one has offered me

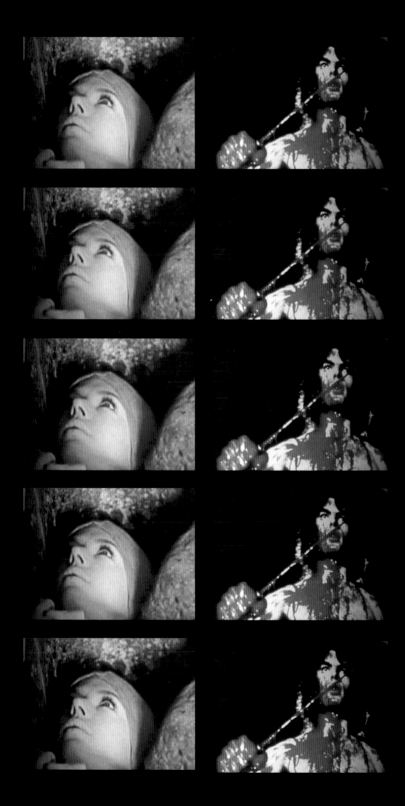

USING NONLINEAR SEQUENCES, INTERCUTS, AND JUMP CUTS IS LIKE THE ART OF THE MOSAIC, LIKE ANTONI GAUDI PIECING TOGETHER BITS OF COLORED BROKEN POTTERY.

films. I resent that, but I don't advertise myself. It's much easier to rent my films than to hire me. I see the logs for who has rented what and when, so I know when someone keeps a copy for a couple of weeks, which is unusual. But you know, I wouldn't make a music video if it were offered to me unless I was absolutely wild about the music. I wouldn't be a fucking whore and make some wallpaper concoction to go with a piece of music that I thought stank.

Doug:
Yeah, I can't imagine you making MTV wallpaper either! One of the ways that I think your work has most influenced the music video is in your approach to time: the non-linear sequences, the intercuts, the jump cuts.

Kenneth:
It's sort of like the art of the mosaic, like Antoni Gaudí piecing together bits of colored, broken pottery.

Doug:
I think there is a link between your work and Alejandro Jodorowsky's films, particu-larly El Topo *(1971) and* The Holy Mountain *(1973). They both work on a mythological level and the stories are often told through symbols alone.*

Kenneth:
I admire his films, but I don't approve of the killing of animals. I have a thing about cruelty to animals. I know him quite well and I've really taken him to task for it. But Jodorowsky comes from a Catholic background. Like Luis Buñuel, his work has that heavy martyred-saint bloodbath side to it, which is different from my aesthetic. Mine is German Protestant and I rebelled against it very early on.

Doug:
What do you think of the films being made today?

Kenneth:
Commercial films are still too fucking long. Some features go on for nearly three hours. I could cut them down to seventy minutes and they'd be snappier and better.

Doug:
Your films are all short films. Why is that?

Kenneth:
I appreciate short forms, like the sonnet or the haiku. You can express things better with a few lines of text or by using images over a short duration.

Doug:
Your legacy is incredibly far-reaching. Your films helped pave the way for the use of moving images in mass culture.

Kenneth:
If I had it to do all over again, I don't know if I would choose to be such a maverick and a loner. As I get older, life doesn't get any easier. It gets more difficult and I have

MY DREAMS ARE LIKE FILMS
PLAYED OVER
AND OVER
WITHOUT DIALOGUE
AND TOTALLY UNRELATED
TO ANYTHING ELSE.
AS I'VE GOTTEN OLDER,
I'VE FINALLY GOTTEN RID OF THE
NIGHTMARES,
OR MAYBE THEY JUST
DON'T SCARE ME
ANYMORE

John Baldessari

John Baldessari (b. 1931, National City, California) is one of the few conceptual artists to reflect critically on the visual language of film and photography. He reworks imagery from pop culture to precipitate new, often paradoxical meaning. His work, from montaged film stills to images overlaid with color or paired with text, questions the notion of fixed meaning. Inspired by Pop Art and Conceptual Art, he first used text and photographs in his paintings in 1966. He relinquished painting in 1970 and he has since worked with found photographs, printmaking, film, and video.

Doug:
In your work from the early 1960s to mid-70s, you seemed to be exploring many different aesthetics and mediums. It's as if every work is an experiment in evaluating how we decode information. Where did this come from?

John:
That period in my work you're talking about was when I was examining every bit of information I received about art to see how it applied to me. I wanted to figure out what was written in stone and what was malleable. In the end it became more about the selection process itself. Should I do this rather than that? Should I choose this image over that one? That's it at its heart—the artist's role is about selection.

Doug:
What turned you on at the time?

John:
I didn't know! But I knew what was boring—reading texts by academics telling me what I already knew. I had the feeling that a lot of other people felt the same way. We were all beginning to test things.

Doug:
By the early 1970s you were starting to use appropriated imagery. How did you first become interested in using images from film?

John:
Someone told me about a place in the San Fernando Valley where there were huge bins of ten-cent photographs for sale. Film stills and local news photographs were mixed in together. Neither had any commercial value. Whenever I had some free time, I'd go out there and go through these bins lined up like tombs. I was getting interested in film stills at the time, but it wasn't just that I was interested in movies. I was interested in film photography in general and in these found film photographs specifically. The more I got into it, the more I realized that in moving imagery there's a whole sort of embedded mythology to it, and in some Jungian way it endeavors to connect with us through this. After I'd bought all these films stills, I went about trying to innocently classify the images. Right away, I had a huge stack of violent ones. The next largest stack was of photographs of kissing scenes, and then scenes from Westerns,

THIS CONVERSATION TOOK PLACE IN SANTA MONICA, CALIFORNIA.

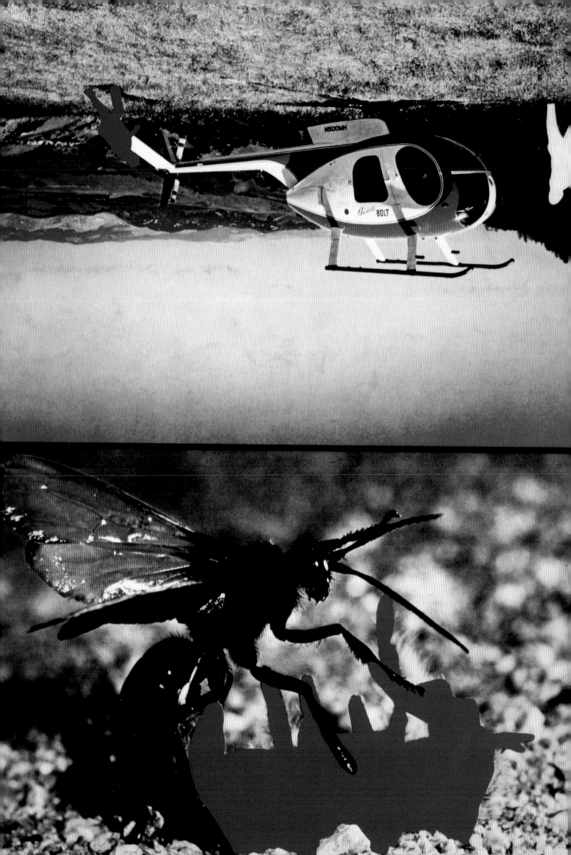

you know, someone riding a horse, someone being shot by an arrow while on the horse, then falling off the horse, on and on. It's fascinating all the classifications.

Doug:
It's as if you're dissecting films by isolating the dramatic actions—like creating a deck of cards of human experience.

John:
I was trying to figure out Shakespeare. What makes a movie? Well, iconic scenes make the movie. So what I began to do was take this raw material, the iconic scenes captured in these film stills, and use them like words in a dictionary to make up my own narratives.

Doug:
The idea of developing different narratives from repetitive actions makes me think of when Gerhard Richter worked in a commercial photo lab and created narratives from everyday snapshots he'd find there. The images you excavate are the opposite. They're dramatic cinematic images of violence and passion. Your source images look like they should be in motion, but they're caught frozen.

John:
I love clichés. They're truths that have endured but have lost their value and their meaning. Reinvesting clichés with energy is pretty good if you can do it. It's a great artist's task to take a cliché and reinvest it with meaning.

Doug:
Are you trying to unlearn the image in your work? Is it about trying to look at images without contaminating them with what you already know?

John:
Yeah, I think so. Trying to be innocent, it's pretty hard. Paul Klee said that you have to get to the point where you think like a child again. It's impossible of course—to see like it's the first time you've ever seen an image in your life. That's so wonderful.

Doug:
In editing the key is to always be aware of the images that come before and after the one you're working with. In your work I see you welding and editing images together in a similar way, but using still photographs rather than film frames. You purposefully create disjointed narratives, like putting an image of a flipped helicopter together with an insect in Helicopter and Insects (One Red) version I (1990). *You seem to resist driving the narrative forward along an expected trajectory.*

John:
I'm trying to make narratives that are less predictable. I mean, I love Westerns like the *Gun Smoke* movies because I like seeing how endless variations are made from the same formula. I spent a couple of months in India and stayed in this fancy house that had all these servants. At night they would watch Bollywood films together on TV. There's a real formula to these films. They all have a certain number of dance sequences, and the servants would get very upset whenever one of the films didn't

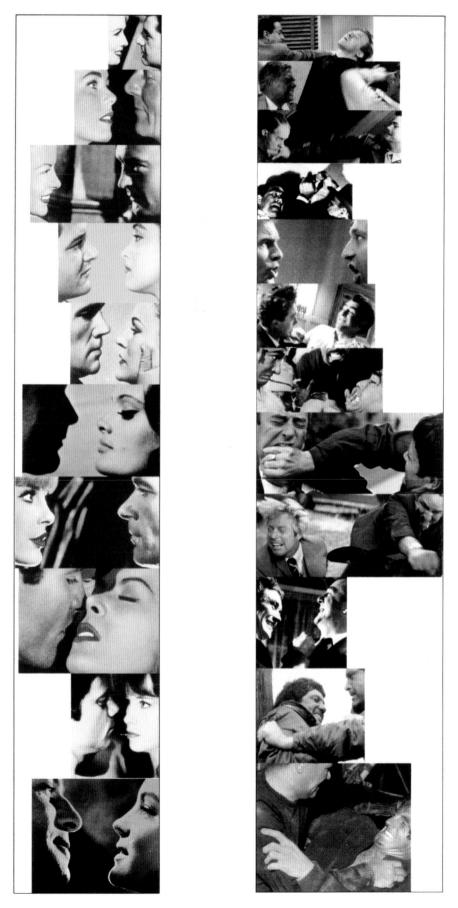

follow the formula. But within it, the filmmakers can do whatever they want. I find that fascinating. I don't know if you've heard this joke before, but it takes place in a prison. While everyone's eating, someone yells out a number, like 234, and everybody starts to laugh. Then someone yells out another number and, again, everybody laughs. And then another number gets called out and everyone laughs. And then another and this time, nobody laughs. One of the newcomers says, "What's all this about?" And someone tells him that all those numbers represent stories and jokes they've heard before and they use the numbers so they don't have to tell them again and again. And the newcomer asks, "So why didn't they laugh at that last one?" And the other guy goes, "Because it wasn't very funny." I guess the point I'm making is that it might come to this if we all keep using the same story lines.

Doug:
You know, in Los Angeles there's no escaping fictional story lines. We see film crews by the side of the road as often as we see road workers. There is nothing glamorous about cinema here. The film industry is a dream factory, but it is still very much a factory.

John:
What appeals to me is the blurring of real life and fantasy, like when I recognize my neighborhood in a film. It's as if fantasy is intruding on real life and real life is intruding on fantasy. It's not really clear what's going on, whether it's fiction or fantasy. I remember showing up one day at my studio and seeing all these movie trucks. Jack Nicholson and Roman Polanski were right outside my studio filming a scene from *Chinatown* (1974). I said, "Pardon me, I need to get into my studio." And then I was like, let me get this straight, what happens inside my doors is real life, and what happens outside is fantasy? Who's to say what is or is not fantasy? You could get really confused.

Doug:
Whenever I see images like Two Figures (Kissing) *and* Four Figures (With Knife and Chains) *(1990) of lovers and prisoners in silhouette, I am drawn to the fact that you have blotted out their identities. They become fictional fronts. The viewer can project his or her own version of the characters' identities onto the planes of color that cover their faces.*

John:
Well, I think the spectator is pretty smart. I listen to my son, you know. He's a pretty avid movie-watcher and he can be pretty devastating, so I think you can't insult the viewer. The best way is just to suggest something, to intrigue, to be a bit seductive. You just say, well, here's this and this. You figure it out.

Doug:
Do you see the picture frame as a kind of self-imposed structure?

John:
I'm trying to make the screen into a picture plane. I'm a painter and I always return to that arena. I can look at a film noir in purely classical terms and watch how shadows are cast misshapenly on the walls. I don't even have to listen to it. I just watch it.

Doug:
That makes me think of your photographic work Floating: Color (1972), *that shows rectangles of monochrome colors being thrown out of a second-story window. Can you tell me where this piece came from?*

John:
Actually, that piece arose from the word "defenestration"—the act of throwing something out of a window. I've always loved words that are really specific. You can't use them too often. I was also really interested in color at the time—non-relational color, as in, this green doesn't look great next to that red. I was interested in pure color that was free of an aesthetic formula. So I took a picture of someone throwing color out of the window in a random order.

Doug:
It's almost as if it's a portrait of color's anarchy. It looks like the colors are literally railing against the formalism of the photographic image.

John:
One of my students told me that the most influential thing I'd said to him was this: that the viewfinder was the worst thing that ever happened to photography. I remember doing a whole series where I would frame a shot, then I'd just arbitrarily move the camera and take the picture.

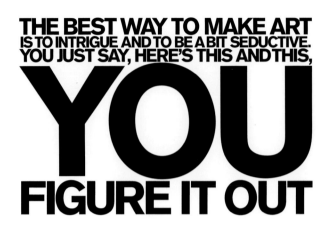

THE BEST WAY TO MAKE ART
IS TO INTRIGUE AND TO BE A BIT SEDUCTIVE.
YOU JUST SAY, HERE'S THIS AND THIS,
YOU
FIGURE IT OUT

Doug:
Do you think that viewers have become more educated in understanding nonlinear narratives in image-based work?

John:
Yes, I think so, because we're all educated enough now to look between the lines and to look for the lies. President Bush says something and we know that he doesn't really mean it. We're at the point where we can't take things literally anymore.

Doug:
How does this affect the way we read images?

John:
We see how it affects the president! He sets up photo shoots like he's in Hollywood. It's almost like you have to understand politics to mediate the images. I think people are beginning to realize that there's not a lot of rationality left in an imposed structure.

Doug:
The greater number of images out there means we have to be even better about making sense of them.

John:
Yes. I used to be able to keep the entire art world in my head. There's no way I can do that now given the amount of information we're bombarded with. Every day there's a new gallery and a new artist, so it's impossible. And if I extend that to all the other fields, I just can't do it. I subscribe to at least thirty different magazines and, even then, I don't think I have it all covered.

Doug:
One of the most interesting challenges to me is how we edit our lives—what we leave in and what we edit out.

John:
Nam June Paik and I used to teach together at Cal Arts and he told me once that what he liked about my art is what I left out. I always think that it's better to edit severely. It makes you have to really think about what you put in and what you edit out.

Doug:
It's like what you were saying earlier, that the artist's role is about selection. To me a lot of your work deals with editing—with getting rid of those moments that come in between the iconic scenes.

John:
I always liked the idea of the moment before an orchestra begins a concert—that moment of silence before something dramatic happens.

Doug:
The most interesting thing to me about art is the role fear plays—how we have to fight our own inhibitions to lay down a new track.

John:
I think what happens is that when you're young, you're pretty adventurous and will do anything to get attention, you know? When you get older, you're more cautious because you feel that you will lose your audience, so you become less adventurous.

Doug:
What do you think is next in terms of how we understand perception?

John:
It makes me think, what would happen if we all said, no, I'm going to resist the flow of information? Kind of like what happened in the 1960s when a giant NO went up from the counterculture. What harm could come of it? It could happen. You could reach a certain level of input and say, no, that's it, it's over with.

Doug:
But how does one secede from all this data?

John:
You just refuse. I don't know what that means, I'm just talking. But really, sometimes just saying no is the only answer you can give. There was this idea that out of all the wretched excess of the 1980s there would come a really pure conceptual art from people reacting against it. Lots of luck! I never saw it. One can hypothesize and conjecture all one wants, but artists are pretty perverse and are never going to do what's expected of them. I think that's where poets are ahead of us. They can go any way they fucking please and nobody really cares. Nobody's watching. It's a little harder for artists, a little harder for musicians, and terribly hard for people at home. Art—art is conversation. It's like a cocktail party, and there are boring people at cocktail parties and there are interesting people. The boring people are like the story you've already heard before—too long and too fucked up. In the end it's about how you tell a story to keep intelligent people interested. It's an art.

Doug:
It's like you're creating artwork to filter the images around us.

John:
It's a great game. You know, if I tell somebody, "Listen, I'll give you point A, I'll give you point B. Given these two bits of information, can you conceivably get to point C?" If they can't, in a way I find that satisfactory. The results end up all over the map. But if viewers can get within the ballpark of what I am thinking about, I think I've engaged the spectator and I think I've been successful. If they don't, then I say, well, okay, I'm being too obscure. I've misjudged my audience.

Doug:
So do you see each work as an experiment?

John:
Yeah, I'm fucking with the public.

Doug:
...while also giving them options. It's like trying to decipher all the white noise around us.

John:
Exactly. It's a fascinating game. I love it. There must be some hidden meaning, you know what I mean? It can't be like what you see is what you get. There has to be something else going on.

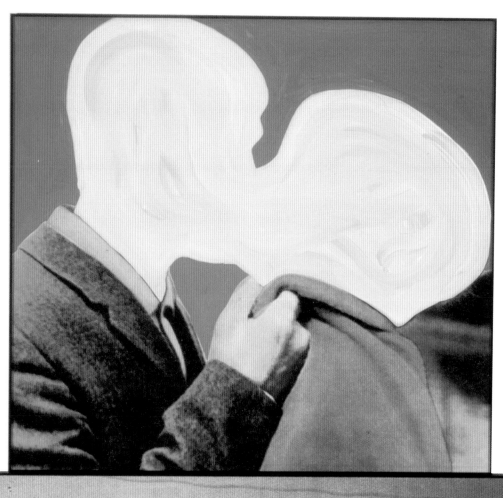
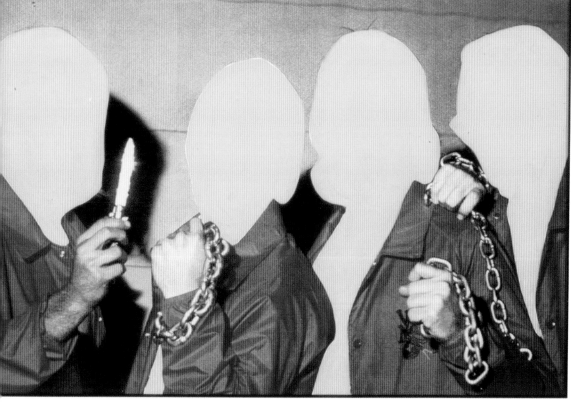

Matthew Barney

The work of Matthew Barney (b. 1967, San Francisco, California) combines sculptural installations, video, and performance. Raised in Idaho, he graduated from Yale University in 1991. Between 1994 and 2002 he released five films, numbered one to five but not produced in sequential order, that comprise the *CREMASTER* cycle. The films interweave layers of private symbols, biological processes, and historical references in an unprecedented visual epic. They feature the artist as several of the protagonists and explore history, cultural and physical regeneration, and sexuality.

Doug:
We're in Japan and our sleeping patterns are way off. We're getting a bite together, but it's hard to tell if this is breakfast or dinner. Does all the traveling, change of environments, and exposure to new information affect how you make creative work?

Matthew:
I kind of wonder about the way my work has become more densely layered. Does it have to do with the fact that there is more information available and I can find it faster? Or is it about having a higher tolerance, like an addict, where in order to get a buzz you have to take in more? I've always wondered—for myself anyway—whether I'm a product of my generation or whether it's just that I'm a very poor reader. I can't even finish a book. But I can start a lot of books. I think I tend to learn about something till I reach a point where I begin to understand it, and then I quit. So when I start researching my subject matter, it's bits and pieces from different things. I tend to think it has more to do with this being my natural process, my inability to do it any other way, but I'm not sure. Maybe it's a combination.

Doug:
Is it about reaching a point where making a work is no longer conscious and where the work begins to move on its own?

Matthew:
I think it's about wanting to live within the work. It's about treating it as a container rather than allowing the content to become dominant. On the other hand, I have a feeling it might have to do with my inability as a student.

Doug:
You seem very aware of this.

Matthew:
I think I have become more aware of this recently. I think I didn't used to be aware of it. Now I realize that I can't read.

Doug:
Yeah, me too! Maybe that's why this is a book of conversations—it's for people like us. When you say your work has become more densely layered, do you think this has become more so with each CREMASTER?

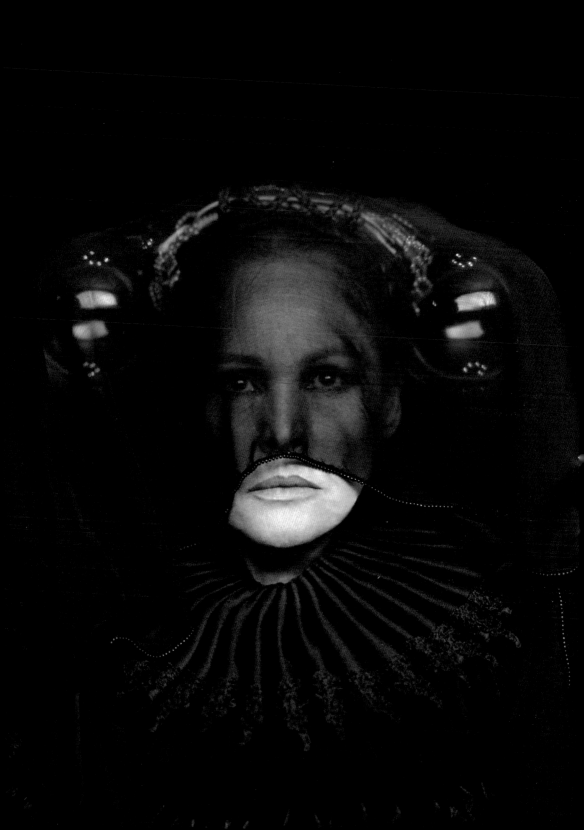

Matthew:
Each one doubled in complexity until it felt like I was reaching the ceiling of what I could do. It probably felt that way each time, but I think finally toward the end, it was more of a lubricated program. I had a group of people around me who really knew what they were doing and we were able to function. It wasn't just five of us trying to do something we didn't know how to do, like it was in the beginning. So I don't think it's some inevitable arc that I am going to have to continue on. The piece *DE LAMA LÂMINA* (*From Mud, a Blade*, 2004) I did in Brazil with Arto Lindsay was relatively simple in terms of its structure and range of characters, but it was incredibly complicated in terms of the context. It was incorrigible.

Doug:
DE LAMA LÂMINA seems like a radical departure from the CREMASTER *cycle.*
For one, in addition to being a film, it was a public work you did during the Carnival de Salvador in Bahia. By contrast the CREMASTER *films are self-contained. In* LÂMINA *it was as if you threw an idea out into chaos and let the variables unfold.*

Matthew:
It didn't feel very good while doing it.

Doug:
Maybe that's a good thing. I often see moments of personal transformation in your

work, as if you're mutating on-screen. Your work seems to filter and collage your interests to such an extreme that in the end, the work is completely you. What are the influences for these moments of transformation?

Matthew:
I think some of the influences come from moorings I've had in my life that have meant a lot to me. Others come from emotions that I've experienced. And then there are those things that come from a more self-conscious way of making work—of going to a place and looking around for things that feel familiar. These things don't necessarily have to look familiar, but they have to feel like they belong to my range of experiences and can lock in with them. I'm not sure if this is a strategy or my limitation.

Doug:
When you're thinking of a project, do you have a whole narrative structure conceived, or do you create it as you go?

Matthew:
It is pretty structured by the time I start filming, but right up until that point it can change. It can change within a single scene, or there have been cases where a scene has been added. The way that I storyboard, there will be scene-by-scene sets of drawings and clip art. It's probably a little bit like thinking about it as simultaneous channels. Before making the single-channel CREMASTER works, I was doing multi-channel pieces, and I think the CREMASTER scenes really just grew out of thinking about things as simultaneous channels—of thinking that things were taking place simultaneously even though each film is a linear edit. In my mind everything is still happening simultaneously. In that way it is really hard for me to shoot a scene where the action isn't executed in real time. I really have to force myself not to think about it in that way.

Doug:
Yeah, duration is a huge issue in the CREMASTER cycle.

Matthew:
For everybody!

Doug:
Including the audience! No, just kidding. But seriously, the CREMASTER cycle goes against the grain of linear film and traditional edit points. You really push the limits of pacing in the films.

Matthew:
Yeah, a lot of that had to do with seeing how these ideas would operate within a movie theater. And enjoying the challenge of it operating as a film while also operating as a couple of other things.

Doug:
Like what?

Matthew:
Like a program for making sculpture. And also something that functions within a larger system of sculpture that includes the moving image.

Doug:
I like the way you blur these boundaries in your work. Do you see aspects of performance or experimental theater as part of this too?

Matthew:
Yes, definitely performance. I think that's what video was for me in the first place.
It was a way to try to engage the space between two objects and to document
that engagement.

Doug:
*It sounds like you started using film and video as a tool to allow you to work from
a polymedia platform. It makes me think of the three-monitor installation* DRAWING
RESTRAINT 7 *(1993), which is about this idea of using film within a larger system
of performance and installation. Linear filmmaking can be totally provocative, but one
is always operating within a legacy where there are rules about duration, structure,
architecture, the viewer, and the audience. How can film in general be expanded?*

Matthew:
I feel like video might liberate it a little bit. If theaters were outfitted with video, you
could start imagining what you can't do with the clunky film projector. You could start
imaging things like, why not have a multichannel experience within that architecture?
Why not? At one point right in the middle of the production of *CREMASTER 3*, I woke
up one morning and said, fuck, this piece should really be vertical. The entire piece
should be vertical, 16 x 9 feet on its side. And I thought, but what am I going to do in
the cinema? Transfer it to 35mm and then what? You crop the image and it wouldn't

I KIND OF WONDER ABOUT THE WAY THAT MY WORK HAS BECOME MORE DENSELY LAYERED. IS IT BECAUSE THERE'S MORE INFORMATION AVAILABLE AND I CAN FIND IT FASTER? OR IS IT ABOUT HAVING A HIGHER TOLERANCE, LIKE AN ADDICT, WHERE TO GET A BUZZ YOU HAVE TO TAKE IN MORE?

work. Then you would have every theater that you're dealing with all pissed off about the matting and the fucking curtains and all that stuff. I think you can start to imagine things like that a little bit easier if you are dealing with video. But, for myself, I have a problem imagining showing a piece in a gallery that's projected with a video projector. You and I probably differ on this for sure. That was one of the things that first led me to transfer to monitors for the early installations. For me, I wanted to make a single-channel piece. The problems are different if you are creating a spatial experience with a multichannel projection.

Doug:
It seems, though, as if you use digital flat screens and monitors in a very spatial and architectural way. Thinking again about DRAWING RESTRAINT 7, *I remember seeing the installation at the Whitney Biennial in 1993. That was a really beautiful, eloquent, and interesting use of the moving image. It would not have been the same if you had used just one monitor. The three monitors made it possible for the viewer to circulate around the images. Your work has progressed in a radical way from there, and I don't just mean in the technological details. The* CREMASTER *cycle itself is based on a nonlinear presentation of the moving image, in so far as it was filmed out of order, so to speak. You started with* CREMASTER 4, *then made 1, 5, 2, and finally 3. And within each piece, the viewer has to navigate his or her way through the work, weaving in and out of the multiple narratives as if moving along swell lines in the ocean.*

Matthew:
Yeah, definitely, and sometimes the moving image helps to facilitate that, even just in terms of broadcasting or beaming images. I think maybe it's the same question we were talking about with cinema: how devoted are you to the architecture of the art institution?

Doug:
I prefer maximum flexibility in a space so things can grow and change, like...

Matthew:
...Kabuki!

Doug:
...karaoke!

Matthew:
I think I got something out of my system doing the *CREMASTER* cycle in the cinema. I don't feel anymore like putting something into a certain kind of architecture just for the sake of inhabiting it. If it fits it on the artwork's terms, then great, but if not...I think what I'm saying is, I'm happy right now thinking in terms of an exhibition. I'm thinking of it as a multichannel piece. I may end up doing a film edit out of it, but I'm not worried about that right now and that feels good. I think I flushed something out of my system by doing that thing in Carnival. That was like being flushed in a toilet for a week.

Doug:
Do you think you would do something like DE LAMA LÂMINA *again?*

Matthew:
Definitely. I would like to. I could imagine doing that every five or six years. It is very good for me, very good. It's an environment that I cannot control at all or even think about controlling.

Doug:
Do you feel very controlling in your work?

Matthew:
I think there is always the desire to create a situation that I cannot control, to construct scenes that I cannot control, like the demolition derby in CREMASTER 3. That was very exciting. Yet at the same time, I think the pieces themselves are done in a very controlling way.

Doug:
I wanted to ask you about the aesthetic polarity in the CREMASTER cycle. It seems like there are incredibly white, fetishized spaces with highly controlled lighting in the films, yet there are other scenes that feel very loose. How do you balance going between these two extremes? Is it difficult? It seems like you were trying to push yourself to let go in the Carnival piece.

Matthew:
Which again was not a pleasurable experience, although I think it was really good for me. I think that somewhere in the future there's a project like that which would take place in a slightly more controlled environment where I could really exercise something that I wanted to.

Doug:
Can you imagine doing a piece without any video components?

Matthew:
That is what I am thinking about—doing something that would function the way an opera does, like some sort of live theater. I still haven't figured that one out, but I always come back to it. Every time I finish something, doing a live work is the first thing I think of. Growing up competing in sports creates a relationship to performance. It might have something to do with trying to recover that place in my life. In a performance there's one moment, there's no second take. If I look at people who are great performers, I am in awe of them because I don't feel that way myself. I feel quite comfortable with the process of having two, three, and twenty takes—with being able to walk away from something, think about it, come back, and do it again.

Doug:
I almost feel like the process of filmmaking is a performance in itself. The act of filmmaking becomes an extension of the performance on-screen.

Matthew:
Especially on the level that we do it. You can imagine what it would be like to work on a larger scale where you wouldn't actually have that experience. At a certain point it's spread out among so many people that you no longer have the experience of performance or of capturing a creative, emotional gesture.

I THINK IT IS ABOUT WANTING TO LIVE WITHIN THE
WORK. ABOUT TREATING IT AS A CONTAINER
RATHER THAN ALLOWING THE CONTENT
TO DOMINATE.

Doug:
The weight of film production is a heavy one. We're coming into a new era of light-ness and nomadism, where a sixteen-year-old with a Mac can direct, shoot, and cut a film. I'm interested in seeing how this changes the Hollywood studio system.

Matthew:
Hollywood blockbuster films are so over the top, they have become something else entirely. Like you, I am interested in either end of the spectrum. It is everything in the middle—the straight-on storytelling stuff—that I am not really that interested in, like so-called independent film.

Doug:
How important is music to you in your work?

Matthew:
I've always been very involved in the music. I spend a lot of time with Jonathan Bepler as he's writing it. It helps me in the part that I'm doing. I think that there is something musical about making a visually driven piece without any dialogue. You remember lin-ear editing, right? As soon as we started working with visual bars in these nonlinear editing programs, it became much more like working with a piece of sheet music. It instantly made more sense. The guy I had done linear editing with was strict about not rewinding and looking at what we'd done until we were finished, otherwise we'd lose tape quality. So every hour and a half we'd roll back and look at what we'd done. Linear editing sounds like some kind of antique process now. It's so weird.

Doug:
Editing in general, I think, really instills in you the importance of time. But with non-linear editing you work your way through the edit in a much more fluid way. It's like a dance with images and sound. You can move a bit this way or that and create differ-ent temporal patterns. You can introduce a subconscious quality into it. The differ-ence between linear and nonlinear editing is almost like the difference between a typewriter and a computer. It comes back to the idea of how you tell a story.

Matthew:
I'm trying to remember the first piece I edited nonlinear. You know what I think it was—which is really ironic—the first *CREMASTER* I did was my first nonlinear edit.

Doug:
Matthew, it feels really good to talk about this stuff!

Matthew:
It's refreshing! I end up in these interviews where I always feel like I'm being forced to talk about things I don't know anything about. It's nice to just talk about the way that we make what we do. People who approach it from a journalistic standpoint don't have as much of a connection to that.

Chris Burden

The physically daring, pyrotechnical, and guerrilla-style work of artist Chris Burden (b. 1946, Boston, Massachusetts) in the 1970s was epitomized in his most dangerous performance, *Shoot* (1971), where he was shot intentionally with a handgun at close range. His early performances, videos, and photographs, which are this conversation's focus, emerged in tandem with the increasing prevalence of TV networks. Here Burden talks about the challenge posed to him as a young artist by TV's unremitting presence in everyday life, and about the need to intercede in its flow of images.

Doug:
Your early performances, videos, and photographs seem to be devised to shatter the distance between the viewer and the work. Their boldness lurches them out of the frame. I'm thinking of work like Through the Night Softly *(1973), the black-and-white 16mm film you made of yourself crawling through broken glass which became the art commercial* TV Ad *(1973). I'm also thinking of* TV Hijack *(1972), where you staged the hijacking of a television station. They all seem to work within the strictures of commercial television. Where did your interest in this come from?*

Chris:
The ideas for these pieces came to me because I wanted to broadcast something. Thirty years ago there was no satellite or cable television or any of that. There were just the major television networks. TV seemed like a one-way street. I remember talking about it with friends and we were like, "How can we get on TV? How can we send a message back?" It seemed impossible. TV just seemed like such an omnipotent force. I then realized that the solution was to buy advertising time. Then you are the client and the stations can't deny you access.

Doug:
Paying for advertising to broadcast art would be nearly impossible today. How did you go about convincing the stations to air your work?

Chris:
My first commercial broadcast was *TV Ad*. I didn't actually do the original performance with the intention of broadcasting it. I just decided to broadcast a film of the last performance I did, which was *Through the Night Softly*. I took the film and went to see a TV salesman at KHJ-Channel 9 in Los Angeles. I paid up front and they aired the piece for a while. It was just a ten-second loop that they played in a thirty-second spot. But one night the station manager was watching TV at home and he saw my ad come on, and it was so bizarre looking that he called the control desk and said, "What the hell is that? Pull that thing! Pull that thing!" And then he fired the salesman who had bought it. But I had paid in advance, so I called the station up and said I hadn't seen my ad run for a while, and when they told me they'd pulled it, I threatened them with breach of contract. They ended up putting the piece back on the air

THIS CONVERSATION TOOK PLACE IN TOPANGA CANYON, CALIFORNIA.

and playing it a couple extra times to pacify me. That was really fun—to have a major station quaking in its boots to try to appease me because I spent all of $900.

Doug:
It seems like quite a few of your performances refer to films or parody things that we've seen in the media. I'm thinking of Oh, Dracula *(1974), which evokes one of the most recognizable horror film characters of all time. And again it makes me think of* Through the Night Softly, *which looks like footage of a wounded soldier on his stomach crawling through the Vietnam jungle. The title seems like it could almost be...*

Chris:
...the title of a movie?

Doug:
Exactly. And of course there's the famous Shoot *performance, where you were shot in the arm by a friend. I've always wondered if* Shoot *was an attempt to question the distance between the Americans at home watching footage of the Vietnam War every evening on the nightly news and those fighting the war. Were you trying to agitate this habitual desensitization to violence?*

Chris:
Vietnam had a lot to do with *Shoot*. It was about the difference between how people reacted to soldiers being shot in Vietnam and how they reacted to fictional people being shot on commercial TV. There were guys my age getting shot up in Vietnam, you know? But then in nearly every single household, there were images of people being shot in TV dramas. The images are probably in the billions, right? It's just amazing. So what does it mean *not* to avoid being shot, that is, by staying home or avoiding the war, but to face it head on? I was trying to question what it means to face that dragon.

Doug:
It's as if you were interrupting the cliché of violence in the media with your own reality—the reality that you got shot, were in pain, and that you could have died.

Chris:
The physicality of *Shoot* was very real. The piece exists as a photographic image, but it exists as a mental image in people's imaginations too, even for those who didn't necessarily see the piece: "Did you hear about the artist who shot himself?"

Doug:
The mental image becomes part of us. It lives on in our imaginations. When you talk about your work, in a way it seems like you're more interested in creating an image, whether physical or mental, than in the action itself.

Chris:
The most important part of my performances is that they are disseminated as thought.

Doug:
It's like generating your own personal propaganda.

Chris:
Absolutely.

Doug:
To me, the ideas expressed in your work invoke the same straightforward visual land-scape that you see in commercials. The photographic images of the performances are like the visual equivalent of sound bites. As you said, you don't necessarily have to see them for them to be effective in getting across an idea. But the work also sets up fragments of stories without endings. It seems as if you want the viewer to complete the story. In this way, works like Oh, Dracula *and* Solaris *(1980), where you rowed so far out to sea that you were visible only by telescope, are like film stills set in motion —entirely physical, living film stills. Where did this come from? Did you watch a lot of film growing up?*

Chris:
I used to watch tons. In high school me and my buddies would go out and see films three or four nights a week. We saw all the old Jean-Luc Godard movies and all the art house stuff. Then I came out here to Los Angeles and one of my best friends was in the industry. He was kind of a hack writer and I started seeing the industry through his eyes. I haven't been to a movie in twenty years because of it. I absolutely shut that door. But it has made me illiterate in some ways.

Doug:
But you seem to know a lot about TV.

Chris:
I used to watch TV, it's true, and I still do. But with film, I'm actually in moral opposi-tion to it. I'm turned off by that industry, even though it's the strongest thing America has. It's more powerful than our foreign policy.

Doug:
TV Hijack *is a pretty aggressive attack on the broadcast image. Can you describe how this piece came about? You were asked to be on an art show to talk about your work, and then you turned the tables on them, right?*

Chris:
One of my fantasies was to do a TV hijack. It just so happened that I was asked to do a performance on a local cable TV show. Here I had this wonderful opportunity, right? During the interview I said I was going to demonstrate a TV hijack. And then I went a little further and said that I wanted the presenter, as my hostage, to perform obscene acts on TV. But then I sat down and there was a big sigh of relief because everyone thought it was over. But I had brought my own video crew and they were filming the whole thing. Then in the middle of it, I asked if I could take a look at the studio's tape and I grabbed the reel, switched it off, and rolled it out into the hallway. The TV director was just standing there speechless. He didn't know what the hell was going on. I told him he could have my tape of the show for broadcast instead, but he refused. I was trying to make his TV show mine and he was trying to use me, too, for his own purposes. I felt it was a contest between artists. For the TV director, the program was his art. Me being on that show, I was just one of the paint tubes in his palette, right? And I saw him in that way too. We had a major conflict of interest. It was like, who's in charge here and whose art is this? And it was also a battle about who had the final say in controlling the airwaves.

Doug:
You each had a certain image you wanted to disseminate. At the time not many others were thinking about broadcast media as a place to make art. What made you need to question the media's authorship?

Chris:
I was realizing at the time that the first thing you want to do in art is control the media. That's the key. Well, *TV Hijack* certainly made some waves!

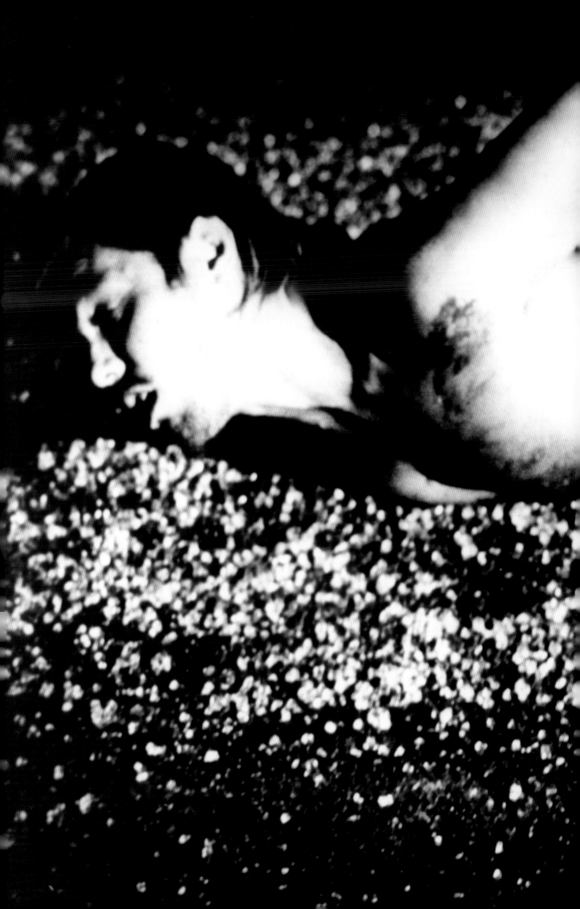

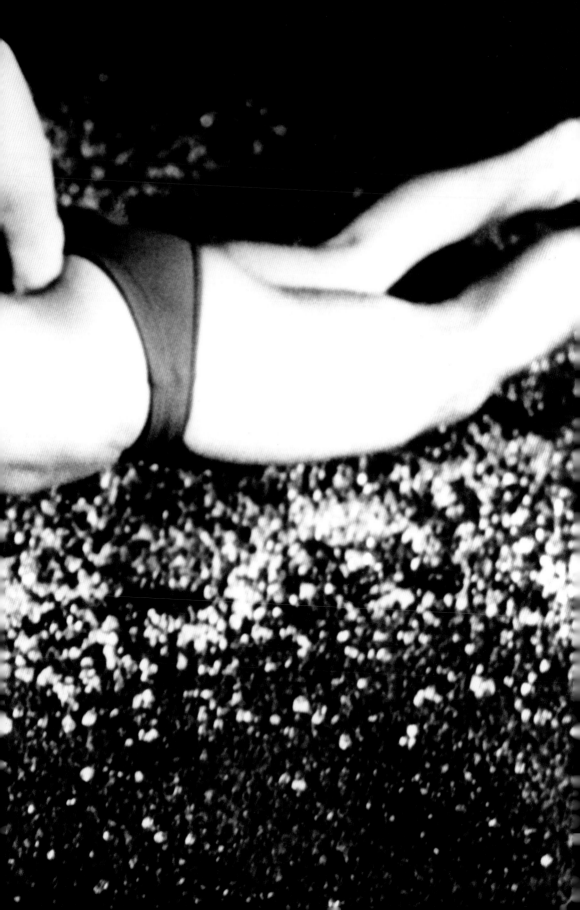

Doug:
You've also used photography as a way of influencing the media and subverting the idea of photographic truth. Could you describe what went into the photographic project 747 (1973)?

Chris:

In 747 I was trying to make an actual, physical image of me shooting at a 747. I had gone out with a loaded .22 to where the planes fly right over Venice Beach, and I shot at an airplane once. The photos turned out to be pretty shitty though. So I went out there another time, pointed the gun at a plane, and again got shitty photos. You couldn't really see the gun I was using. So I went and bought a big plastic water pistol that looked like a Luger so you could really see it in the final photograph, which in the end was staged. I didn't actually shoot at the plane in that one. The photograph was reproduced in *Penthouse* seven years later and an airline executive saw it and reported it to the FBI. They came and visited me, but for God's sake, they didn't have a case. You can't prosecute someone on a photograph.

Doug:
What I find so interesting in 747 is that it comes off not as a performance, but as a graphic image. And from what you're describing, it sounds like you were trying to create the most volatile image possible.

Chris:

When I was in graduate school at UC Irvine there were these really mean secretaries who were just shitty. I don't know why, but they were just nasty. I had a little Minox spy camera then, right, and a developing tank at home. I'd take pictures of them surreptitiously and then go home, develop the negatives, chop them up, put them in my breakfast cereal, and eat the negatives.

Doug:
No way!

Chris:

Yeah! Ha ha. And the next time I saw them and they were mean to me, it felt really good! I was empowered. It was a way to get back at them somehow. It wasn't serious, it was just a fun ritual, but it was really satisfying and they never knew. I'd processed them in a sort of cannibalistic way and somehow it took away their power.

Doug:
You destroyed their power by destroying their image, but also by making it part of you.

Chris:
Yeah, there you go. Primitive people are really spooked by having their picture taken by and large, right? They think you're stealing their soul. It's interesting, it was sort of the same thing for me.

Doug:
I'm interested in how you create work that pulls the viewer out of the passive position of looking at things from within the safety of the gaze.

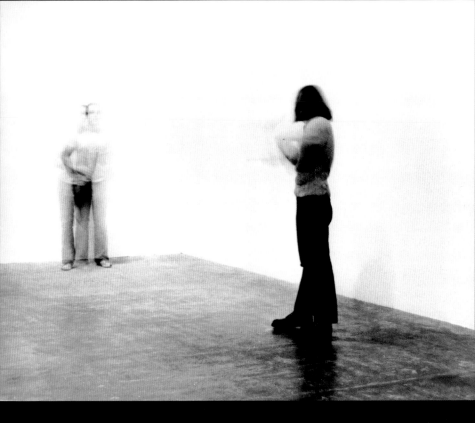

Chris:
The question is, how do you make the audience part of a work? It's kind of like cultural terrorism. I don't think of myself as a terrorist though, but I realize that whoever saw the piece *Dos Equis* (1972), where I set up two enormous burning crosses on a road, must've had the shit scared out of them and will never forget it. They probably turned around and drove away as fast as they could. That's what I would do if at 1:30 A.M. I came across flaming crosses ablaze in the night sky on a little canyon road. Whoever saw it, I'm sure to this day that they remember it. It's part of them and that was really the issue for me in doing the piece. A bunch of us at the time were thinking about doing art that was time based and action based, and we realized that in performance, the audience isn't separate from the work but is actually part if it.

Doug:
The audience becomes part of it by never forgetting it. The memory of the experience endures as a powerful fragment of the real thing.

Chris:
Yes, the viewer has to perform too.

Bruce Conner

In 1958 artist Bruce Conner (b. 1933, McPherson, Kansas) made the groundbreaking twelve-minute collage film *A MOVIE*. It was created entirely from black-and-white newsreels and found footage and revolutionized the use of appropriated imagery in film. A leading figure in assemblage art and the West Coast counterculture scene, Conner made twenty-one films from 1958 to 1981, a selection of which is shown here in stills. As one of the first artists to have used pop music with the moving image, his films are among the forerunners of music videos.

Doug:
5, 4, 3, 2, 1...calling Bruce Conner. In the rolling fog of San Francisco, I know you're there...hello Bruce. I'd like to hear your thoughts on A MOVIE, *the film that jumps, skips, and trips. Before you made the film in 1958, you were making collages, drawings, and still images. How did your work lift off the page and onto the reel in such an extreme way?*

Bruce:
One of the reasons I made *A MOVIE* was because it's what I wanted to see happen in film. Ever since I was fifteen years old, I'd been watching movies and thinking of ways to play with their story lines. For instance, I would imagine taking a backlit shot of Marlene Dietrich in *Blonde Venus* (1932) walking through a doorway and overlaying it with something like the final words from *King Kong:* "Beauty killed the beast." Then I'd imagine the next shot being something else entirely with different sound. Basically, for years I'd been playing with bits and pieces of different films in my head, and I kept assembling and reassembling this immense movie using pictures and sounds and music from all sorts of things. I'd been waiting for someone to come up with a movie like this. And nobody did.

Doug:
It's as if you instinctively wanted to construct one single movie out of every movie you'd ever seen.

Bruce:
I thought, surely there must be somebody out there making experimental films, or maybe experimental historical films, using other movies as sources. I was determined to find this film, and I just didn't. I had always been interested in trying to find films you couldn't see in standard movie theaters, and from very early on, I was involved in film groups and clubs. It was the only way you could see these films. You have to realize that in the 1950s it was really hard to see any interesting feature films. You couldn't even see Charlie Chaplin films. Period. No one played them. You couldn't see films like D. W. Griffith's *Intolerance* (1916) or Leni Riefenstahl's *Olympia* (1938) in any theaters at all. If you wanted to see these kinds of films, you had to start a non-profit film society and rent the films from the Museum of Modern Art. When I came

THIS CONVERSATION TOOK PLACE BETWEEN SAN FRANCISCO AND VENICE, CALIFORNIA.

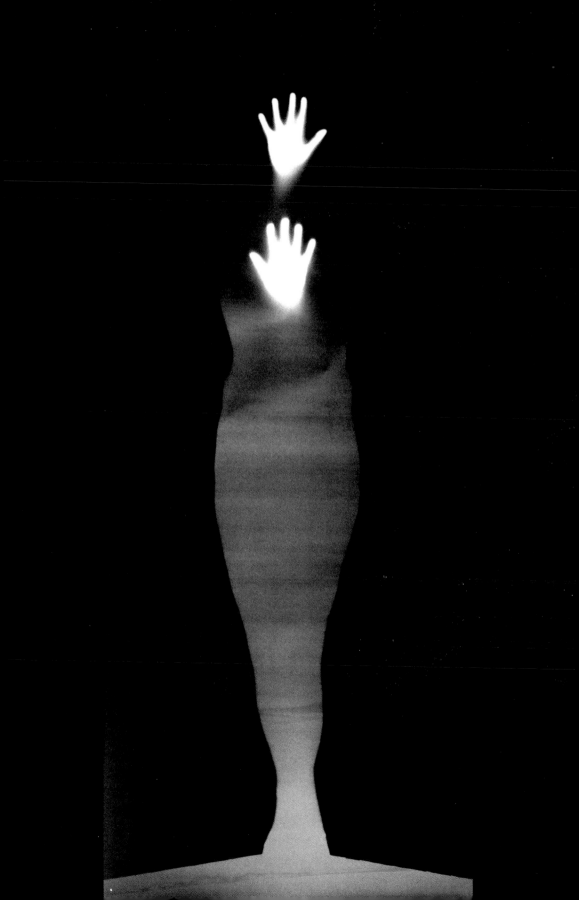

to San Francisco from Colorado, I started a film club with Larry Jordan called Camera Obscura. We were the only film society or film group in the entire Bay area at the time. There were no theaters showing at that time. We were it.

Doug:
How did you begin making A MOVIE?

Bruce:
Film from other movies was really hard to get your hands on. The only piece of film that I owned at that time was this filmstrip that I'd found at a friend's house. It was a scrap of film showing a woman almost completely naked on a stool in the process of taking off a stocking. My friend had discovered it in his brother's dresser. He gave it to me since he knew I was interested in film. This filmstrip got the whole project started. I was inspired by the projectionists who sometimes mistakenly ran the countdown leader on-screen before the film. I'd originally wanted to surprise everybody at Camera Obscura by sticking this filmstrip between the numbers in the countdown leaders of what we were showing. But Larry Jordan said if I did, he'd quit the film society. He was outraged by the idea. So I decided that the only way I could deal with this—and still watch what I wanted to see on-screen—was to make it. Larry showed me the basics of splicing and so for two weeks let me use his wet splicer, his movie projector, and his viewer. I went out and bought a bunch of shortened versions of films at local photo shops, like 100-foot versions of things like *Hop-Along Cassidy* (1935) and newsreels. These had all the action and visual elements of film that I needed, and eventually I even spliced the filmstrip that had been given to me in between the numbers in the countdown leader of *A MOVIE*.

Doug:
The way you edited the found footage in A MOVIE, *you took out all the extraneous elements and put the key dramatic scenes together into a narrative. Can you tell me about your ideas behind the sequencing of the footage?*

Bruce:
A MOVIE is a nonlinear film. Its fragmented structure makes the narrative appear to change and shift. People would say to me, "Oh, you reedited that film since the last time I saw it." Or, "You added something and took something out." And of course, I hadn't changed it at all. It just looked like it had changed from the way the footage was edited.

Doug:
There are so many different images in the film, people don't necessarily catch everything the first time they watch it.

Bruce:
Just by putting images together, relationships between things are suggested, whether they exist in real life or not. If you run three images together in sequence, people are going to draw a conclusion between them, and I wanted to play with this. A large part of the construction of almost any communication has to be its recreation by the person who experiences it. And this is not going to be the same all the time. It's going to

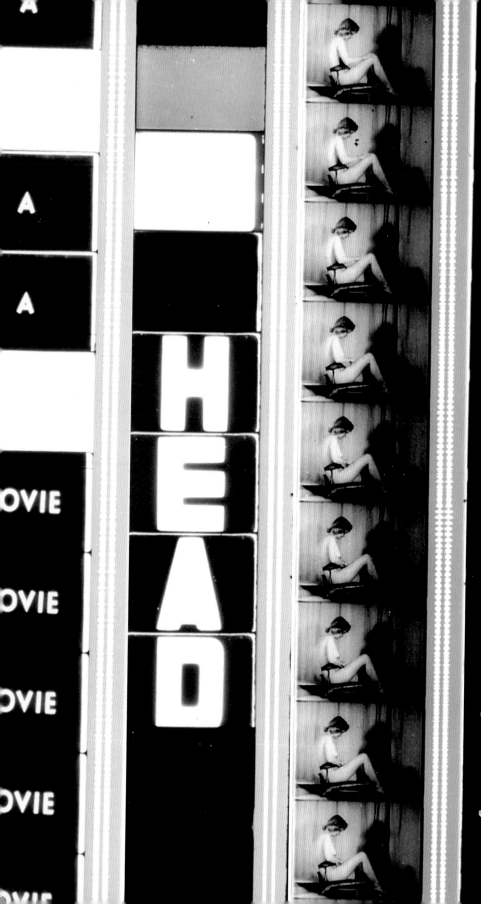

change with the viewer. Then there's the space between the images also, which is important. I extended this space by putting in black leader to isolate images or to make the screen suddenly go black, leaving the audience to wonder what was going to happen next. In *A MOVIE* I could play with the unplanned and the unexpected. I made them part of the entire concept of making the film. In fact, when I initially conceived of making *A MOVIE*, my ideas were even more extreme than the film ultimately became. What I wanted to do, I was not able to do back in 1958.

Doug:
What were the circumstances like that you were working under?

Bruce:
First of all, I didn't have the money to do what I wanted. Secondly, there was no support for me in museums or any other place. To realize the project I'd wanted to do, I would have had to produce it myself and push it into a place like an artist-run gallery. But back then there were only about two or three in all of San Francisco and virtually nothing else.

Doug:
What had you originally wanted to do with the film?

Bruce:
What I wanted to do was use a rear-projection loop projector so the film would be running continuously without end. I tried to capture this idea in what became the final version by splicing "THE END" into the film, but not at the actual end of the film.

Doug:
It seems like you were really making a statement by intercutting that along with "A MOVIE" and "BRUCE CONNER" in random places. It's a provocative way of making the viewer question the traditional structure of film. They're like traps.

Bruce:
Yes, and then after the words flash on-screen, the film just keeps on going.

Doug:
Even though technically speaking A MOVIE *has a beginning and an end, it still suggests a very fragmented narrative. You can start watching it in the middle or three minutes from the end and it doesn't really matter because there's no linear narrative. What other things had you originally wanted to do with the film that you couldn't ultimately?*

A MOVIE IS A

NONLINEAR FILM.

ITS FRAGMENTED STRUCTURE MAKES THE NARRATIVE APPEAR TO CHANGE. PEOPLE WOULD SAY TO ME, "OH, YOU REEDITED THAT FILM SINCE THE LAST TIME I SAW IT." AND I HADN'T CHANGED IT AT ALL.

Bruce:

I'd also wanted the film to be played in a small cube of about 10 x 10 x 10 feet that you could stand inside. And I'd wanted the lights to change and there to be tape recordings, radio programs, and television sound that would impinge aurally on the viewer at random moments. This way, the film could be viewed in a different context every time it ran. For example, one time it could have Ottorino Respighi's "Pines of Rome" with it, which is what I used in the final version of the film. And then for the next loop, it could have a silly pop song playing with it, or lions roaring at off moments. However, that said, I was working for ten cents above minimum wage as an usher in a movie theater at the time. It would have been impossible. I did not even own a movie camera.

Doug:

Having watched so many films, making A MOVIE *must've felt like a really intense opportunity to put into practice all these ideas about film you'd been having for so long.*

Bruce:

One of the values that I was dealing with in making *A MOVIE* was that I considered each shot of footage a movie in itself. For example, a shot of an airplane turning in the sky, that's a movie to me. So on one hand, *A MOVIE* is twelve minutes long with a start and a finish, and in this way is linear. But on the other hand, it has individual shots in it that are maybe two seconds long, and to me these are little movies that break up the film.

Doug:

It's interesting because the film reveals its own structure—the exact opposite of what traditional cinema does when it makes the technical craft invisible. In the editing you worked intensely with jumps in time and place, and with the scratches and skips in the original footage. The way you edited it was very much outside the tradition of narrative film. A MOVIE *seems like a manifesto for perceiving a world that's inherently fractured and fluctuating. Where did this come from?*

Bruce:

When I think of *A MOVIE*, I think about all of my life prior to that time and whatever I knew or experienced. My feeling is that nonlinear perception can't be beat from when you are one day old. So when I refer to the essentials of perception, I try to think back to how I reacted to things and how things impressed me when I was a small child. I remember when I went to see a movie for the first time, I didn't understand what was going on. There on the screen was a thirty-foot-tall image of a loud, obnoxious, unpleasant creature. I didn't realize that it was just a person. Instead, my experience was of a whole series of disjunctive images. I'm sure that's what people have to train themselves to ignore when they adapt themselves to reading moving images in television and cinema. It's like establishing a language of understanding. And when I think about nonlinear perception, I think about the way you collect various pieces of information and put them into some kind of functional use to make sense of the world. It is about consciousness itself.

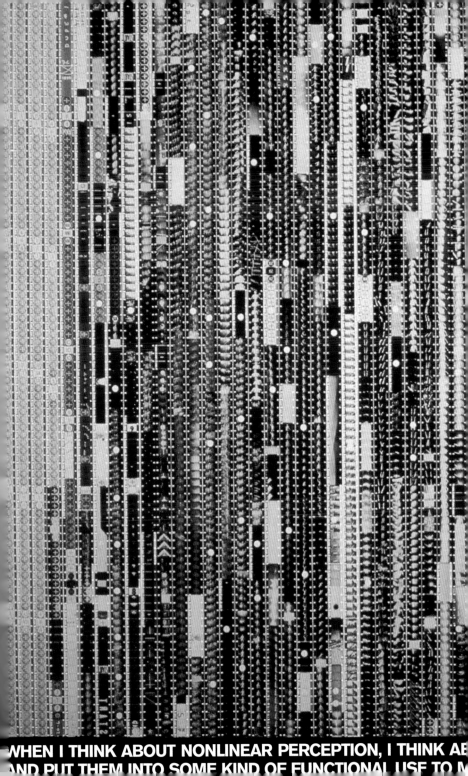

WHEN I THINK ABOUT NONLINEAR PERCEPTION, I THINK AB
AND PUT THEM INTO SOME KIND OF FUNCTIONAL USE TO M

WAY YOU COLLECT VARIOUS PIECES OF INFORMATI
SE OF THE WORLD. IT IS ABOUT CONSCIOUNESS ITSE

Claire Denis

The films of Claire Denis (b. 1948, Paris, France) explore in intense visual detail her characters' inner lives. Her work is minimal and spacious and portrays her characters' fractured yet ineluctable connections to others, to their cultures, and their countries. Raised in Africa until the age of fourteen, she assisted filmmakers such as Jim Jarmusch and Wim Wenders before making her solo debut with *Chocolat* (1988). Images from her acclaimed drama *Beau Travail* (1999) and her film about an encounter between strangers, *Vendredi Soir* (2002), accompany this conversation.

Doug:
To me your work is as much about reflection and repose as it is about action and storytelling. You seem to create ambient landscapes that are a little disjointed. Is this intentional?

Claire:
When working with a script that I've written, I feel I have to rupture it in the process of making the film. Everything I've written has to be a little bit destroyed and a little bit dislocated. I can't do it any other way. You have to do this to prove to yourself that it can't be realized in one way only. This inclination is probably just the result of living in the world. You know, the world changes so fast that by the time you start shooting, it's completely different from when you wrote the script. After you finish shooting, you know each frame by heart and it's in the process of editing that you can dislocate or fragment the footage. A film can't be logical.

Doug:
How important is this process of fragmentation to your stories?

Claire:
Fragmentation in my work is the result of my relationship to the world. But I never start a project with the idea of fragmenting it in mind. It would be too premeditated. It would be boring to me. Planning fragmentation is like planning disorder. It's like feigning dissatisfaction. It is completely fake to me. You have to first plan something that's unified, and little by little the disorder begins like a virus—like some location is impossible to get, or you run into financial trouble. A film is never what you intend it to be. It can't stay unified inside you forever.

Doug:
In filmmaking there are roughly two extremes: on one hand, adhering to the script and the storyboard, and on the other, basing the process on a more anarchistic method of improvisation. When you write your films, are you gathering pieces together into one overarching narrative, or are your films the result of a more spontaneous process?

Claire:
For me the process of creating a narrative always begins with one sentence, like "I am in love," or "I am desperate," or "I don't want to die." It has to be very simple yet

THIS CONVERSATION TOOK PLACE IN PARIS, FRANCE.

I DON'T WANT TO STORYBOARD MY MIND

very strong, and this one sentence has to survive all those boring moments you have to go through in making a film. If I lose my orientation, I just remember it's a film about this one idea. The rest are just details.

Doug:
It's as if the sentence is the seed and from there the ideas move out in all directions.

Claire:
If you stick to one sentence, then everything surrounding it—every smell, the weather even—can be used for this purpose. To me, that's what is important in filmmaking. You start with a journey. I don't want to work in a way where I absolutely have to have a certain street with a certain kind of café on it and a certain kind of weather report in order for the film to be made. When I choose a street and a café, I choose it as a whole entity, rain or shine.

Doug:
You don't want to fabricate reality, you want to use reality.

Claire:
People ask me if I storyboard a lot. I love to try to draw. I draw a lot, but it's not story-boarding. I don't want to storyboard my mind. It's part of a process. Sometimes I lose the drawings or I don't bother to bring them with me when I film. The actors and I try to explore something together during the shoot, but it's not actually improvisation either. It's all a process.

Doug:
You've shot films in a number of diverse locations. How important is traveling to you?

Claire:
Let's say I am supposed to fly to Korea tomorrow. It means almost nothing to me in terms of the practical things I'll be doing there, like eating Korean food or shooting film. But it means a lot to me in terms of the feelings I might have there. I might meet someone, fall in love, get drunk. If I have to tell someone what experiences or impressions I came away with from Korea, the most interesting things to me would probably be a lot of little experiences: smells, food, the sea, discomfort, comfort. Traveling is important. It's belonging to the world. No one considers traveling a big deal anymore though. A long time ago traveling meant being an explorer. Today traveling means being a tourist. My parents traveled a lot. My father was born in Bangkok. Traveling was their life. They built their life around moving across the surface of the globe.

Doug:
When you travel a lot, it sometimes feels more like you're standing still.

Claire:
Growing up, my father always said to me, "In life you have to choose between history or geography." As a child I was always attracted to geography more than history. I wanted to be like my father. I wanted to be able to read maps like he could. He would test me, "Where is north, where is south?" I still play this little game whenever I arrive in a new city that I have to find north as soon as I get there.

Doug:
How did you first get interested in filmmaking?

Claire:
It just kind of happened to me. My mother had seen a lot of films before she moved to Africa, where I grew up, so when I was a child she would tell me the stories and describe them to me as if I were in the audience. Then when we moved back to France, I wanted to watch all of the films my mother had told me about. That's how I became really interested in film.

Doug:
Your films are some of the stillest and most photographic I have seen. Do you photograph too?

Claire:
I recently bought a camera and I treat it as if it's the most precious thing in the world. It possesses something that leads me to make films. A photograph contains a moment, but it's not frozen. Even though it's a moment from the past, it's still communicative. I like painting and modern art, but more than anything, I like photography. For me, still photographs are like music. A photograph is both passive and active at the same time. You can see with your eyes the split second that has been captured. But photography is also nothing. It comes from a small box—the camera—and is the result of a chemical process. When you take a photograph, you try to capture an image, but you're never fully sure that you did. You only see what you've captured once you develop it. This kind of uncertainty has influenced me a great deal.

Doug:
That's interesting because your films seem to open up still spaces in a similar way. I find myself drawn into scenes in your films as I would be into a photograph. It's like the viewer is led inside the frame, but isn't directed to feel or think in a certain way. You let the silence speak for itself. There's a meditative quality that disrupts the narrative in an unexpected way.

Claire:
Whether your film is ten minutes long or two hours, you can choose to take two steps forward and then two steps to the side and three steps backwards and climb and dig around. I don't intentionally try to turn my back on traditional film. I wouldn't have the nerve to say that this is a new way of making films. It just happens. When I am in doubt about where the film is going, I try to create something that reassures everyone on set that we are headed in a good direction. But the direction I give creates expansion, not a straight line.

Doug:
Where do you see the moving image going?

Claire:
I have no idea, but I am ready for anything. I am very curious, you know. I'm not afraid of where it's going, but I'm a very fragile person. I'm more afraid of myself than I am of the future. I think a lot of people are like me, don't you?

I DON'T INTENTIONALLY TRY TO
TURN MY BACK ON TRADITIONAL
FILM. IT JUST HAPPENS.
THE DIRECTION I GIVE CREATES
EXPANSION, NOT A
STRAIGHT LINE

Stan Douglas

Filmmaker and photographer Stan Douglas (b. 1960, Vancouver, Canada) draws on film and television history to explore the way media images are constructed. Through film loops, recontextualized archival footage, split-screens, and the pairing of projections, he reveals the internal, invisible structure of the moving image. His work exposes a network of hidden meanings, political agendas, and displaced histories, and tests our habitual and often passive acceptance of media images.

Doug:
Before you started using video, had you been working with other art forms?

Stan:
When I first started out, I was making sculptures. I then began photographing them and realized that I enjoyed that process more than making the sculptures. I went from there to making slide projections and then eventually to film loops. I made film loops because I couldn't afford a video projector at the time, but ultimately I started working with video too.

Doug:
It's interesting that you started out as a sculptor since spatial relationships play an important role in your installations. What first inspired you to make installations?

Stan:
My first installations were quite self-consciously about working with an inventory of cinematic forms. I was interested in spatializing things like montage in the free jazz piece *Hors-champ* (1992); or synchronizing silent film and music in *Pursuit, Fear, Catastrophe: Ruskin, B.C.* (1993); channel changing in *Evening* (1994); compositing effects in *Der Sandmann* (1995); and interlacing images in *Nu•tka•* (1996). In these earlier works it was also important to me to have the viewers' bodies occupy the actual space of the projections so they could use them to negotiate the work.

Doug:
What I find interesting is how each piece investigates different approaches to the moving image. Journey into Fear *(2001) and* Suspiria *(2002–03) each have a Möbius striplike structure where the story line twists and overlaps without beginning or end. In* Win, Place or Show *(1998), you computer-programmed the images and sound into a loop of over 200,000 variations, and in the* Monodramas *series (1992) you designed shorts for broadcast in television commercial spots.*

Stan:
Early pieces like *Overture* (1986), *Television Spots* (1987–88), and *Monodramas* (1991) came out of a period when I was working with found footage and preexisting contexts. In later works like *Journey into Fear*, I wanted to explore how to say things

Doug:
How do you usually begin making a piece?

Stan:
I try to find a central metaphor for an idea and work with that. For instance, *Suspiria* is based on the idea that you trade money for commodities in order to make more money than you originally had, meaning that somewhere in the process, you get something for nothing. *Suspiria* does the same thing filmically: it generates an almost infinite number of stories from a fixed amount of visual material. I wanted it to generate the effect of transformation within what is actually a very fixed structure.

Doug:
Is the way you break up linear narratives and create infinite yet fragmented story lines a result of your experience of contemporary culture?

Stan:
The narrative in *Suspiria* appears to be changing but it's really in stasis, and that's the condition that I see in our culture right now. Culture isn't really transforming. There aren't the same utopian notions that were around before World War II when people had definite ideas about the kind of society and culture they wanted to work toward. It's as if believing in the future has become embarrassing.

Doug:
It's a unique time in art too right now because communication strategies from the commercial world and the art world have crossed over into each other's territory, yet it hasn't necessarily led to more innovative forms.

Stan:
That's our situation right now. Pop culture seems to be recycling itself very rapidly. This is especially the case in pop music, where we're already having grunge revivals, when grunge itself was a revival of punk rock. And DJ culture is all about using pre-existing recorded sound as a language. It feels like the cultural sphere is getting smaller and smaller.

Doug:
It seems it's not only that the culture of sampling is becoming more self-referential, but that the trends that make up the raw material are also living and dying more rapidly. They're recycled in a shorter amount of time and, as a result, there's an even wider range of material to draw from. I think that working in a nonlinear way is one method of handling this increasingly wide range of material.

Stan:
But you can always get a sense of its structure, which is the "bad infinity" of nonlinear pieces. *Win, Place or Show* was modeled on an old-school branching narrative and, like a lot of computer games, proposes the notion of limitless possibilities when, in fact, all the possibilities are predetermined, even if they are modulated by a random element. The game player is by no means free; he or she is more like a rat in a maze. I rarely play video games, but when I do, I try to figure out how it's structured. Once I do, I lose interest.

SO WHAT MAKES A SHOT TOO LONG? WHY IS IT BETTER TO HAVE THOSE FIVE FRAMES TAKEN OFF?

Doug:
Can you tell me more about the way you create loops in your work? It seems like you're not only interested in creating the idea of an endless story line, but also in fragmenting that same story line. I'm thinking of Der Sandmann, *where the two projections make a loop, yet also simultaneously interject and dissect one another.*

Stan:
Yes, that piece is like a Möbius strip running across two screens. On the left screen the first half of the image is blocked out then revealed and vice versa on the right screen. It just keeps going back and forth.

Doug:
Do you see your works as timepieces, each having a different tempo? For me I find that in the process of making work, each piece often has a certain beat that surfaces.

Stan:
For sure. In editing there are definitely very clear structures that have to be organized by rhythm and tempo. *Journey into Fear* is broken up at four precise but random points during each seven-minute segment. In developing the script, we had to work that fact into the narrative. There's a fixed cycle and after that's over, it starts again with the sound running in a different permutation.

Doug:
How has working with this range of cinematic forms influenced your ideas?

Stan:
I love cinema. I see lots of movies. Even though these days I watch more and more of them at home on video rather than in movie theaters, I actually think videos of films are a problem. Video and film have different effects on the viewer—the flicker of the light in the cinema, for instance, or the way film is better at representing space, and video is better at representing motion. But lately it's hard to keep straight the difference between seeing films in the cinema and watching videos at home.

Doug:
One of the most interesting things about making films and videos for me is that they make you constantly aware of how we experience time. Making moving image pieces is often a very slow process. How much of a role does this play in your work?

Stan:
I think the idea of duration is very important. When you watch a movie in the cinema, you expect it to be between ninety minutes and two hours. But in a gallery, to a certain degree you're free of these expectations and can do whatever you want. So as an artist, it becomes really important to be aware of both spatial and temporal parameters. Too often you see things in galleries that go on way too long or are projected much too big and would look much better on a video monitor.

Doug:
Editing is about sculpting time. For instance, if you're working with a single shot and

you want to trim two or three frames off of it, you're shaping the time in which the viewer will ultimately experience that sequence. At some point there's a conceptual breakdown and one's response becomes intuitive.

Stan:

Yeah, you start asking yourself, what makes a shot too long? Why is it better to have those five frames taken off?

Doug:

It's something that in many ways defies conceptualizing. That said, different projects have different structures and layers of information within them. Filmmaking is never entirely independent of all that has gone on before you. The history of the moving image casts a long shadow, and it can be a challenge to work independently of it rather than simply in opposition to it.

Stan:

I think it's always been that way. To a certain degree, works have always been built on the backs of other works before them. Any language is the combination or compilation of other usages of that language. And with film it's an extension of this same process.

Doug:

So the question is, where does work that uses the moving image go from here?

Stan:

There are conventions which are being expanded upon all the time and which we should continue to expand, like making films that aren't always ninety minutes long, not using predictable characters or traditional scripts, and not using the three-act structure that we see in Hollywood films. I think film is often used as an extension of the strategies of appropriation from the 1980s. Only now, we take the ambiguity of authorship as a given—every utterance and gesture is a version or elaboration of one that has come before it. We don't have to bother making a point of our inauthenticity. It is understood that culture is our raw material, so we can just get down to the task of making new meaning.

Doug:

In your opinion, could there ever be such as thing as post-cinematic film?

Stan:

I don't know, but it wouldn't involve the internet or computer games as we know them today because these are really post-television forms. It's hard to say, but I think post-cinematic film will incorporate the cinematic in the same way that postmodernism incorporates the modern. For years people have been saying that cinema died with the French New Wave and that the classical Hollywood system is over. Cinema has supposedly been dead for at least fifty years now, but I think storytelling with moving pictures will be around for a long time.

ER SANDMANN

Olafur Eliasson

In his photographs, sculptures, and site-specific installations, artist Olafur Eliasson (b. 1967, Copenhagen, Denmark) creates scenarios that explore the nature of perception. Using natural elements such as light, steam, and water, he engages the viewers' physical space, and invites them to speculate on their subjective sensory experiences. His work explores the notion that we can never know reality objectively, we can only contemplate our experience of it. The viewer thus becomes a participant, and as much a subject of his work as his physical creations.

Doug:
I feel like your work empowers the viewer to navigate through it on his or her own terms, as if it were a chess game. The viewer makes a move and then there is a countermove.

Olafur:
I used to talk about my works as if they were these machines capable of creating a phenomenon. Now I tend to see my work more as a tool you can use to create a phenomenon. Talking about it as a tool implies that you have the choice to pick it up and use it. What I'm after is this self-reflexive potential in art: our ability to evaluate ourselves in our surroundings.

Doug:
So if a work of art is a tool, what is it a tool for?

Olafur:
It's a tool for experiencing yourself from an external point of view.

Doug:
To look back at yourself?

Olafur:
Under normal circumstances, we look out at the world and take the world in. But these kinds of tools allow you to step aside and think about what you are doing while you do it, as if from an external point of view. It's not like a mirror where you're just looking at yourself. It's a way of considering the actual act of seeing at the same time. I think this kind of seeing, this introspective engagement, is very valuable.

Doug:
Is there the danger that you can lose sight of your body in this?

Olafur:
To me, there's a bodily element in this experience. What I'm talking about can be very physical. It's like when you're floating in water: you feel weightlessness but you also feel gravity's pull at the same time. It's not just a theoretical or mental exercise. It can be very intimate, almost sensual, tangible, and tactile. This is where my main concern is, and this ability to see ourselves is very worthwhile in the rest of the world. It is

THIS CONVERSATION TOOK PLACE BOTH IN LONDON, ENGLAND, AND VENICE, CALIFORNIA.

where I see art's potential within a larger context, especially because this type
of engagement is something that a lot of the rest of the world would like to avoid.

Doug:
So how can this be shared with others?

Olafur:
Art itself makes complete sense to me, but the way it's communicated, distributed,
and integrated into society through an institution is often very doubtful. It suggests
a hierarchy of how to behave and see.

Doug:
I sometimes feel it creates a trajectory of how we're supposed to experience art.

Olafur:
Yes, the experience is predetermined, and this conflicts with the artistic process to
the core. It's as if you have to see it in a certain way, otherwise you don't get it. I think
there is a conflict of interest within the arts about how it's presented, and I think that
this happens with my work too. Of course, I am extremely dependent on the larger
context of how things work and I have a sense of responsibility to any carrier of my
art, which is why I'm interested in these questions. But there's a tendency for muse-
ums to create a kind of palace of experience that's event driven and detached from
society. Sometimes going through a museum, art looks more like "infotainment."

Doug:
It's a problem sometimes because it imposes a narrative structure on pieces that are
nonnarrative. It's best when the viewing experience can be as flexible as possible.

Olafur:
Yes, absolutely. I agree. But a more complex format for art is often less commercially successful because it's a slower process and it's harder to endure. This is why I was interested in borrowing a private house in Pasadena and having the show *Meant to be lived in* (2005) there. It was an experiment with these formats.

Doug:
In Meant to be lived in, *you sealed off the entire interior so it became a darkened space lit only by the light sculptures. The refracted light that the sculptures projected onto the interior spaces made me think of László Moholy-Nagy's* Light Space Modulator *(1922–30). You created a space in which the viewer can directly engage with the projections. It's like a metaphorical screen for the viewer to project their perceptual experience onto.*

Olafur:
Yes, you could call it a screen to project onto. Yet, even though I'm obviously interested in demystifying the work and exposing this kind of infrastructure, I still believe in a worthwhile meaning in art beyond its structure. While *Meant to be lived in* was fundamentally a group of works inserted into spaces within the house, the space itself was about mediation. You entered the living room and the public areas first. Then as you went deeper into the house, it became more and more private. It was a temporal sequence for how long it took your body to work its way through the house.

Doug:
How the viewer moves through space is seldom addressed in exhibitions. It has traditionally been the domain of architects. I feel like you dealt with these questions

in your show The mediated motion *(2001)* at Kunsthaus Bregenz by creating differ-
ent ecosystems that the viewer had to negotiate. And likewise in The weather project
(2003–04) at Tate Modern where you used smoke, mirrors, and light to envelop the
viewer in the experience of a setting sun. You often set up experiential systems that
encourage the viewer to move through the sensory environment in a subjective way.

Olafur:
That was the nice thing about seeing people respond to *The weather project.* They
were doing things you wouldn't normally do in a museum, so somehow the museum
became part of the city. This is why I have strong faith in people's experiential capa-
cities. The experience of space has the capacity to put the space back into a context.

Doug:
Do you think it's possible for us to get better at dealing with a fragmented reality,
especially with the increase in information today?

Olafur:
When we talk about the increase in information today, we have to take into consider-
ation that when we look at anything, what we see is our personal history mediated.
A certain kind of information is successful if it makes sense to us and stays with us.
We're able to use it to orient ourselves in social and urban spaces—within any kind
of frame. This process of orientation is already a narrative, but not one that describes
a particular story. I don't see potential in that. I see potential in the spectator—in the
receiver, the reader, the participator, the viewer, the user. The act of perceiving is
crucial to my work. The narrative is right there. But there's a new kind of puritanism
now that insists on an absolute experience of truthfulness and the sublime. This is a
problem because it suggests a hierarchy where the person at the top of this hierarchy
is the one who possesses the most pure understanding.

Doug:
So, the insistence on pure understanding is a means of explaining away contradiction
and ambivalence.

Olafur:
I don't think we should underestimate our ability to orient ourselves within this frag-
mented world. I have faith in our ability to evaluate and to be critical. I think that our
ability to orient ourselves increases in proportion to the increase in fragmentation.
The world is not quite as apocalyptic as academics suggest. Sometimes I think
academics are so busy classifying our surroundings that the surroundings move
on and leave them behind. But this doesn't mean that we shouldn't exercise a bit
more skepticism and criticality.

Doug:
Is this process of orientation about retaining some of the bits and pieces of the infor-
mation we receive while discarding others, like a collage?

Olafur:
Yes, it's a collage, but not an assemblage. It's a collage where all the bits and pieces
are on top of each other in a pile, and each picture has an impact on the one after it.

While I understand that everything today is becoming more and more fragmented, I'm a little bit nervous about qualifying it as such because that would suggest that an opposite exists. It would suggest a so-called nonfragmented world, which in modern terms we'd called the "good life," and the "happy person" is someone who lives it. I don't think this is an option. It supports a polarized idea of the good and the bad.

Doug:
It negates the autonomy of the viewer.

Olafur:
Exactly. I think there is a tendency to have two different understandings of time— one physical, one mental. The healthier way of seeing things is if your physical clock and your psychological clock are the same. But there is more financial profit in the opposite because it splits the body and the mind by accelerating people's minds and slowing down the body. For example, it's like going into a fancy clothing store that's staged with young, beautiful people and ambient music. Your bodily awareness and your psychological awareness go off in two completely different directions. Of course, your body doesn't go anywhere really, but your mind drifts off into Marlboro Country. Then you walk out of the shop and you realize your mind has experienced a completely different temporal mode than your body and that your body has just been mediated. I think it's a worthwhile exercise to put the body and mind back together. I prefer it when we can play the game at least knowing when we are being mediated.

Doug:
Because your work often deals with the anatomy of the eye and the physiology of sight, as well as with light and time, it shares some common ground with film. The intimate experience of your work often reminds me of the quiet dark spaces in which we watch film, except that the viewer occupies that filmic space rather than watches it.

Olafur:
I certainly like the idea of the viewer being the exhibited subject, and this of course comes from film. But normally when we sit in a cinema, we watch the screen with passive bodies. Our bodies become unengaged. The screen is looking at you, telling you a story. You are the object of the film's gaze and the film becomes the subject. I think the idea that our bodies and brains have different lives is obsolete now. Sensitivity toward a certain touch is as much an activity of the brain as it is an activity of the body. So, dancing can be intellectual. For us, it's interesting to raise these questions since in our work we're engaged with the idea of an evolving relationship between people and the world.

Doug:
And of looking at the nature of these systems.

Olafur:
Yes, showing that the systems are not really natural, but cultural. Our engagement with space is never an end in and of itself. It's the evaluation of the experience overall that is even more important. It's about putting the brain in the body and the body in the brain.

THE BRAIN IS IN THE BODY AND THE BODY IS IN THE BRAIN.

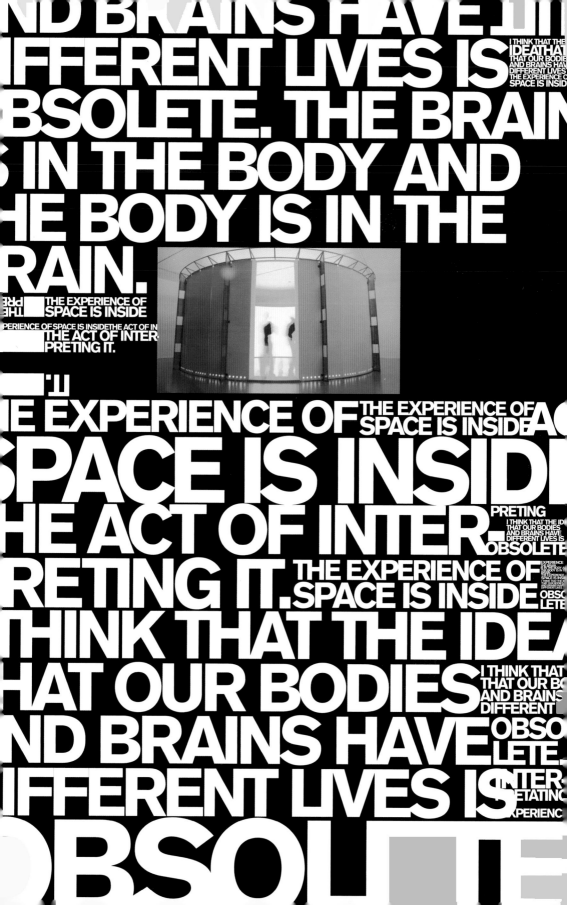

...ND BRAINS HAVE...
...IFFERENT LIVES IS...
...BSOLETE. THE BRAIN...
...S IN THE BODY AND...
...HE BODY IS IN THE...
...RAIN.

THE EXPERIENCE OF
SPACE IS INSIDE
PERIENCE OF SPACE IS INSIDE THE ACT OF IN
THE ACT OF INTER
PRETING IT.

...E EXPERIENCE OF
SPACE IS INSIDE
...HE ACT OF INTER.
...RETING IT. THE EXPERIENCE OF
SPACE IS INSIDE
...THINK THAT THE IDEA
...HAT OUR BODIES
...ND BRAINS HAVE
...IFFERENT LIVES IS
...BSOLETE

THE EXPERIENCE OF
SPACE IS INSIDE

PRETING
I THINK THAT THE ID
THAT OUR BODIES
AND BRAINS HAVE
DIFFERENT LIVES IS
OBSOLETE

I THINK THAT
THAT OUR B
AND BRAINS
DIFFERENT
OBSO
LETE.
NTER
ETATING
XPERIENC

Pablo Ferro

Pablo Ferro (b. 1935, Antilla, Oriente Province, Cuba) is the creator of some of most famous movie titles and editorial innovations in film history. Collaborating with directors such as Stanley Kubrick, Norman Jewison, Hal Ashby, and Gus Van Sant, he pioneered the quick-cut edit—used extensively today in advertising and film—and introduced the use of multiple screens to mainstream cinema. In a rare interview Ferro discusses the origins of his radical techniques and what it took to survive four decades as an art director and designer in Hollywood.

Doug:
Pablo, we're sitting here in your house looking at hundreds of storyboards on your walls. I can pretty much look at any of these sequences of images and get a feeling for each film. It seems like the unifying idea behind your work is to compress narratives down to their essences. You can really see this in the title sequences you did for Dr. Strangelove or: How I Learned to Stop Worrying and Love the Bomb *(1964),* The Thomas Crown Affair *(1968),* Bullitt *(1968), and* To Die For *(1995). In* Dr. Strangelove, *for instance, how did you and Stanley Kubrick come up with the idea for the famous "mating" scene, where the B–52s are being refueled?*

Pablo:
Stanley asked me what I thought about being on set in general, and I told him, the one thing I find interesting is that every mechanical model that's being made for the movie is turning out to be sexual.

Doug:
Sexual?

Pablo:
Yeah. There's always something going in and out. You know, in *Dr. Strangelove* it's everywhere. And we looked at each other and said, "We're doing a movie with B–52s refueling in midair!" You know?

Doug:
How much more sexual can you get?

Pablo:
Yeah! And I still feel that way. I saw it and Stanley saw it. Stanley got so excited about the idea. So when I finished cutting the montage for the title sequence, he came up with the idea to use the instrumental music track "Try A Little Tenderness" along with it. We put it together and it worked. The track was meant for it. It fit just like a glove. One or two adjustments had to be made, but everything else—Boom! —was right on. We couldn't believe it.

Doug:
You made hundreds of edits for this montage, which makes me really surprised to hear that you did the editing without having any music as a guide. Do you normally edit without sound?

DR STRANGELOVE

OR: HOW I LEARNED TO STOP WORRYING AND LOVE THE BOMB

COPYRIGHT (C) MCMLXIII HAWK FILMS LTD. ALL RIGHTS RESERVED

COLUMBIA PICTURES CORPORATION PRESENTS

A

STANLEY KUBRICK PRODUCTION

Pablo:
I do. It gives you a chance to take things out that are unimportant. I always have my own version in my head. That's why I'm able to edit without sound. Some editors hear that and they go crazy. They say, "What do you mean? You don't know what you're doing?" No, I know what I'm doing. After I'm done I say, "OK, let's put a piece of music in there," and the thing works. The train of thought that you need to follow is there. The music can't get you there. You can't depend on that, otherwise you become crippled. It has to stand on its own like it belongs together.

Doug:
When you made those titles for Dr. Strangelove, *movie title sequences had only been around since 1954, the year Saul Bass did the titles for Otto Preminger's* Carmen Jones. *The titling for* Dr. Strangelove *is handwritten, something no one had done before. How did this come about?*

Pablo:
We were trying to put titles over a certain shot of the planes and it wasn't working. You didn't know whether to watch the titles or the film. So I thought, why don't I do my handwriting thing. We put it in and it was great. The whole thing worked. I had always fooled around with it, but nobody accepted it. Stanley was the only person who ever accepted it.

Doug:
I love the layering of the text over the images. The line quality of your handwriting makes me think of Saul Steinberg's work or some of Warhol's early illustrations.

Pablo:
Yeah, well, you have to thank Stanley for that. He forced me to do it that way. I wanted to clean it up. I did it on tracing paper so I'd be accurate with the people's names. And, of course, when you do it on thin tracing paper with ink, it will wrinkle. But I showed it to him anyway and he loved it. He said, "Oh, yeah, that's what I want," and I said, "You got it."

Doug:
It sounds like a lot of what you did happened through trial and error.

Pablo:
Right. Those are things you need to solve a problem. You have to come up with something very unorthodox. There's no such thing as bad footage, just a bad idea.

Doug:
So how do you usually approach your projects?

Pablo:
I don't think about the problem, I just think of an idea and I let it tell me what to do. Necessity is always the best solution. It's amazing—you can do lots with an idea after it's formed. Very important, storytelling and all that, but I've spent a lot of time in the cutting room. When I first had my own production company in the 1960s, I did everything, so I see things differently than other people.

Doug:
Were the quick cuts that you pioneered in TV commercials in the 1950s and the film titles and trailers you did in the 1960s a way of condensing information, or were you trying to create a different experience of the moving image?

Pablo:
I started using quick cuts as a way to make people remember something. I told the commercial agencies, "No, you guys are doing it all wrong. By making it seem longer, you think that people will remember more." You could hardly remember what you saw when it was all together, especially if you were seeing it only once. So I told them they had to do the opposite. It's about turning something really big into something really simple.

Doug:
The irony is that this often takes longer because you're making more edits overall. When it's so short, you can't even consider packing in more scenes. Rather, you have to come up with triggers for memories or emotions by way of the edit. It has to be something that's simple so it will cut deep into the subconscious. But it is amazing too because one of your works might be only thirty seconds long.

Pablo:
Or ten seconds!

Doug:
It seems that you were really able to run with your natural instinct for compression in the trailers you made, like the one for Kubrick's A Clockwork Orange *(1971), where you edited a two-hour feature down to sixty seconds. You were basically turning the whole story into a high-speed strobe light of images.*

Pablo:
I remember Stanley saying, "Pablo, this looks better than the movie," and I said, "No, this is the movie!" He loved it so much, he used it for everything.

Doug:
I remember feeling very liberated when I saw it. The quick cuts were an incredible revelation—the way the images are fragmented yet still so powerfully communicative of an idea and a feeling. I felt that way about your title sequence for Woman of Straw *(1964) too, where you used high contrast photographs and color changes to create a moving-image portrait of the main character.*

Pablo:
I did the same thing for Gus Van Sant in *To Die For.* I went into Nicole Kidman's eye in these faux press photographs we made, then kept zooming into her eye in increments so the dot matrix got smaller and smaller and smaller, eventually dissolving into specks. I wanted to keep you on your toes!

Doug:
It worked! My toes were very sore after watching those scenes. Tell me, what were you thinking about when you made these experimental sequences?

Pablo:
You see, you suffer. At first most clients don't think it's going to work. But if you talked to Stanley Kubrick or Hal Ashby or people like that, you didn't get that reaction. They'd say, "Okay, so how do you think you're going to do it?" instead of saying, "Hey, get out of here. You're fired."

Doug:
What kind of content do you look for when you're working on a project?

Pablo:
With everybody it's different. When I did the title sequence for Steve McQueen in *Bullitt*, I took a photograph and cut out the word "Bullitt" so you could see through the letters—an idea that we ended up using in the title sequence where each name is gradually cut away to reveal a new scene underneath. I remember bringing the photograph right up to Steve's face to show him and hearing him say, "I love it! Let's do it!" He was really open. He was an angel, that was great. You see, I've done that with other people and gotten kicked out!

Doug:
You're not only known for your title sequences and quick cuts, you're also known as one of the first to experiment with split screens. What made you want to multiply the number of screens?

Pablo:
I've always been fascinated by magazine layouts. I like seeing all those pictures together you find in *Vogue, Life, Pose,* and all that. I thought that was so interesting and I wondered if I could translate that into film. I wanted to do a multiple but a different kind of multiple. For the film about the Singer Corporation that I did for the 1964 World's Fair in New York, I used two film projectors, each projecting twelve individual images at once so it looked like different screens. I did that for a commercial that year too. I laid it out on-screen using six multiples.

Doug:
What was being advertised?

Pablo:
Beechnut Gum.

Doug:
So, a split-screen chewing gum commercial? How do you guide the viewer through so much information in such a short period of time?

Pablo:
You have to design it with the right composition and movement so your eyes go to the right place, otherwise you don't know where to look. You have to tell the viewer.

Doug:
Was it at the 1964 World's Fair that Norman Jewison saw your work before directing The Thomas Crown Affair *in 1968?*

Pablo:

No, Norman Jewison and Hal Ashby, who was the editor of *Thomas Crown*, saw something similar at the Expo 67 in Montreal, but they couldn't afford the guy. That was the first time Jewison had seen that technique, but I'd already been doing it. Hal told him, "Look, Norman, you want to do some split screens, Pablo's done that already. They're copying Pablo." Norman was shocked. I showed him what I'd done and got the job to do all the multiples throughout the movie. When I had finished doing all the split screens, though, the film ended up being too long. I was like, "Oh, fuck," and Hal said, "Wait a minute, what are you talking about? Treat the multiples like they're rushes. Don't get rid of them, cut them up." So I took the multiples and did quick edits with them. To show off, I took the six-minute polo sequence and I made it into forty seconds. It blew them away. Then Hal said "That's amazing, but can you make it longer?"

Doug:
Clients!

Pablo:

I know! The multiple screens saved the movie. It put everything into perspective. It wasn't just another movie with pretty clothes. It made it something else. It makes something very complicated look easy and simple.

Doug:
It's a spectacular effect. Even though there were people using multiple screens before you—like Abel Gance for his Napoleon *in 1927, Charles and Ray Eames for their seven-screen film installation* Glimpses of the USA *at the 1959 Moscow World's Fair, and in underground films like Warhol's* Chelsea Girls *(1966) which used two screens—*Thomas Crown *takes it to an entirely different level. You used multiple frames on one single screen. No one had used this in a feature film before. Even Michael Wadleigh later used split screens in his documentary film* Woodstock *(1970). And you can still see its influence today in the mainstream television show* 24, *which uses split screens regularly.*

Pablo:

Everybody wanted to see the film when it came out. You know, everybody copied from *The Thomas Crown Affair*.

Doug:
To me, what really sets Thomas Crown *apart from these other films is the way the split screens exponentially expand the story at the same time that they compress the sequences of the images. It's not just about showing events simultaneously. It's that you've created a way to communicate psychological and emotional three-dimensionality. When I first saw it, I remember being really surprised to see split screens used in a mainstream film.*

Pablo:

Yeah, it's amazing when people are out there on the edge like Jewison was. He would go for anything. He'd say, "Get me out of this corner. They got me cornered, Pablo." Hal helped him a lot too.

Doug:

At the same time that you were making your work in the 1960s, there was a whole psychedelic movement going on in graphic art. There was the psychedelic poster art of people like Victor Moscoso, Rick Griffin, and the Kelly/Mouse Studios, who were all using electric colors and dense compositions full of as many references as possible. They represented a side of visual culture in the 1960s that was very maximal. But your work is almost minimal by comparison, trimming things back to the core ideas.

IT'S ABOUT AN EMOTION YOU GIVE OUT. AFTER DEALING WITH A LOT OF IMAGES, YOU KNOW WHICH ONES THEY ARE. YOU CAN FEEL IT

Pablo:
That's why I like René Magritte. He influenced me that way.

Doug:
Who else?

Pablo:
Jean Cocteau. *The Blood of a Poet* (1930), *Beauty and the Beast* (1946), *Orpheus* (1949)—all those amazing films.

Doug:
You were born in Cuba, then moved to New York City when you were twelve. It must have been a huge change to suddenly be inundated with American pop culture. What would you say were your early influences?

Pablo:
In high school I got this book called *Animation: How to Draw Animated Cartoons* (1942) by Preston Blair, who animated the segments "The Sorcerer's Apprentice" and "Dance of the Hours" in *Fantasia* (1940). I drew all the time in school, and I was an usher then too in a foreign film theater on Forty-Second Street and I saw a lot of classics, so I was influenced by that also. Then I got a job from the legendary Stan Lee, who was an editor at Atlas Comics before it became Marvel Comics. I took the money from that job, bought a camera that took single frames, and started animating.

Doug:
Do you think animation changed how you approach film?

Pablo:
When you do animation, you know each of the twenty-four frames per minute. You know how time changes and what kind of speed you need. That's what led me to do the quick cut, actually. I was really interested in the process. And animation

taught me how to take the audience where it needed to go. See, when you animate, you have to become all the different characters. You have to know how they're going to react to each other. It's not a joke, drawing a character. You have to treat it like it's a real person. That's what Preston Blair teaches you: "Here are the rules. Now go break them."

Doug:
How do you know when you've made something that will touch others?

Pablo:
It's an emotion—an emotion that you give out through certain images. After dealing with a lot of images for a while, you know which ones they are. You can feel it. I always tell people that if you want to show emotion, keep the camera moving. You have to contain the emotion, not stop it.

Doug:
It's remarkable how ten seconds of images with no introduction or conclusion can evoke an emotional response.

Pablo:
Film is amazing—all that it can do to you and to your mind. I like to see things that I've never seen before, even though I know there's nothing really new, only what has been forgotten. You know, I can do something and think I created it and realize it was done back in the 1800s or something. And then I say to myself, geez, it took me this long to get it?

Doug:
It sounds like you work very instinctively. What drives you to create?

Pablo:
It's amazing to create something. There's that moment that happens when you see something and you become aware that you are the first person ever to see it. But I'm too embarrassed to work in art! It's a great feeling, though, to say, "Wow, that's amazing. Wow!" Better than anything else we do for enjoyment.

Doug:
That's what keeps me going too.

Pablo:
Yeah, for that moment. I still try to stick to that because they always try to talk me out of it. Clients, they're amazing. They just don't know. They used to always come up to me and say, "You come up with an idea." So I'd do a drawing with four lines, and they'd say, "Your price is ridiculous. To charge so much for four lines!" And I'd say, "Well, if I had gotten it in two lines, I would've charged you more." It just illustrates that it takes time to do things, you know, to get it right—to be SHAKABOOM!

Mike Figgis

When director Mike Figgis (b. 1948, Carlisle, England) released his groundbreaking film *Timecode* in 1999, it was the first mainstream film made entirely of split screens. The film uses four split screens to depict four concurrent stories, which converge only at the end. Originally a musician, Figgis became heavily involved in avant-garde performance in the 1970s. In 1980 he founded his own theater company, for which he wrote and directed multimedia stage productions before turning to film.

Doug:
In Timecode *you explicitly play with the linear structure of narrative film. How did you first become interested in breaking from traditional storytelling?*

Mike:
I came out of music school in London and jumped right into performance art. I was influenced early on by the British performance artist, writer, and *provocateur* Jeff Nuttall, who in turn was influenced by the Happening movement going on in New York. He cofounded the performance group The People Show, and I joined them and went out on the road for ten years. I became interested in multimedia through that and started making little films that I used in performances along with lighting, music, and slide shows. So I got into film almost by accident. It was never my intention to be a movie director. I never had the ambition to go to Hollywood. I was just interested in film as a medium. When I first started making *Timecode*, I went through very old notebooks and found drawings and notes I'd made that were directly related to the ideas in *Timecode*, even though they were from twenty years earlier. I realized that those same obsessions with splitting screens, splitting spaces, running time as real time and then as distorted time were things that had always obsessed me about cinema.

Doug:
Did you see film as a way of further fragmenting performance?

Mike:
Yes, especially by using sound with images. If you can fragment and separate the visual images from sound, the overall picture functions in a really interesting way. It becomes a device for representing fragments of memory. The interesting thing about cinema is its potential for a nonlinear timing of events and the ability to revisit those events. Since the late 1990s, I've tried, albeit while staying in the mainstream, to explore this by doing things like splitting up the screen in *Timecode* or by changing the frame status from wide-screen to square, from small to large. I've been trying to find ways to observe phenomena rather than be a prisoner of linear narrative.

Doug:
It seems to me that coming from experimental theater, you figured out the structure and craft of linear narrative in film and broke away from it. For the most part in the

twentieth century, split-screen technology was largely neglected by mainstream cinema. This is interesting when you think about the early experiments that had taken place, like the large-scale triptych screens that Abel Gance devised in 1927 for his film Napoleon.

Mike:
Or Erwin Piscator (1893–1966), who was doing the most amazing performance art pieces in Berlin with a multitude of big screens, live orchestras, and fuck knows what else. There were a lot of people who said that the advent of the talkie was the nail in the coffin of cinema's ability to go sideways. The minute that synchronized dialogue came along, a very specific choice was made about where cinematic technique was going.

Doug:
What challenges do you face in nonlinear storytelling?

Mike:
One of the most interesting things for me about experimenting with split screens in film—like when I used two screens in Miss Julie (1999) or four screens in Time-code—is that I realized that if you're constructing a parallel narrative, it's still difficult to abandon linear narrative. To abandon it is a perverse statement of its power.

Doug:
It seems that you're trying to capture the multidimensional landscape of stimuli in the everyday.

Mike:
It's the nature of the way we progress through our lives. But even if you use four screens, the film will start at the beginning and, when the tape finishes, it will become another form of linear narrative by the progression of film through the projection head.

Doug:
If you showed Timecode to a cross section of a thousand Americans thirty years ago and compared their reaction to people watching it today, do you think you would dis-cover that people's ability to follow fragmented narrative has developed since then? I wonder if this kind of fragmented narrative is more accessible today, now that your average viewer has had more experience with it.

Mike:
I think so, yes.

Doug:
And sometimes I also wonder if the fragmented narrative functions as an evolutionary device that has helped us learn to cope with the barrage of information around us.

Mike:
Exactly. It's interesting, isn't it, that the fragmented narrative was an unnatural phe-nomenon to start off with and has developed organically into a sort of user-friendly device with a lot of power and a lot of choice.

I'VE BEEN TRYING TO FIND WAYS TO NOT BE A PRISONER OF LINEAR NARRATIVE

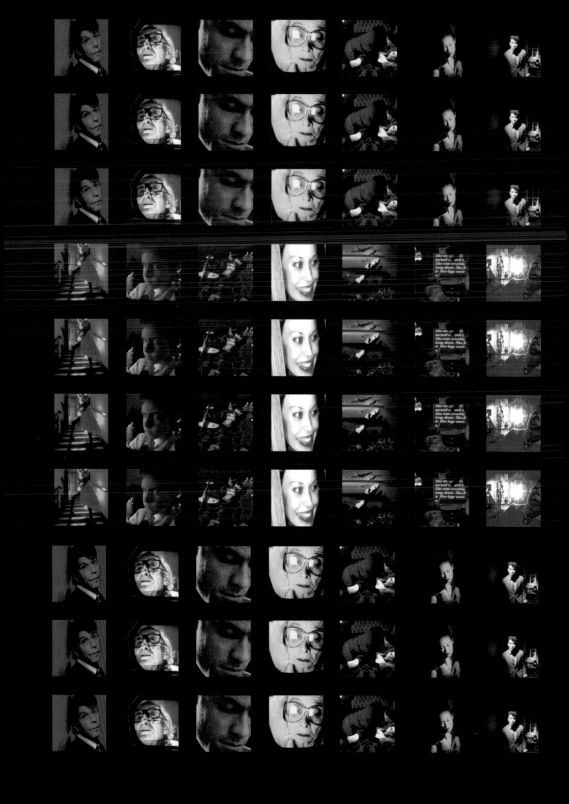

Doug:
When you made Timecode, *how much of it was scripted?*

Mike:
I actually structured the entire film on musical paper. I had to come up with four sets of instructions in order to make it work—four parallel choreographies for the camera and physical cues for the actors, with a certain amount of time factored in so the actors could improvise with the story.

Doug:
How important is improvisation to your experiments?

Mike:
When I did a multiscreen video installation at the Valencia Biennial in 2000, I was tempted at first to make everything technically perfect, to control the film to the nearest frame. We have the technology to do this now. You can get on your Mac and say, "I can make this so perfect." I have spent much of my career trying to control time, but in this installation I really let it go. I decided to set it up so that random coincidences would occur between the different projections. And once it was up and running, I made myself go into the audience to experience with the viewers the random patterns of associations that were generated.

Doug:
That story reminds me of how Warhol wanted Chelsea Girls *(1966) to be screened. Apparently, he tacked a note onto the film reels asking projectionists to run the reels in a different order every time they played it so the film could be slightly different with each viewing.*

Mike:
Much more interesting. It's interesting to look at the art scene of the 1950s and 60s, when things were loosening up and getting messy, really fucking messy, with messy materials, and the audience getting splattered with paint and such. It's really strange, but you would have thought that the iconic status of the art object would have gone in a different direction by now, somewhere interesting, and that the idea of repetitions and multiversions would have been far more assimilated.

Doug:
Was the cinema from that time a big influence on you?

Mike:
It's interesting. The cinema I fell in love with early on was not American cinema at all. I was interested in the French New Wave's influence on films coming out of Japan, and the influence they had in turn on films coming out of Poland and Czechoslovakia —things like Miklós Jancsó's *The Round-Up* (1965), Dušan Makavejev's *Love Affair: Or, The Case of the Missing Switchboard Operator* (1967), and Walerian Borowczyk's *Immoral Tales* (1974). Looking back at some of these films, they still seem quite radical and avant-garde compared to things that have happened since. Some of the more powerful Jean-Luc Godard films are still unsurpassed in terms of his amazing use of

nonlinear cinema. *Weekend* (1967) is a staggering piece of work. And funny—funny as hell, and erotic and political and indefinable. That scene with the guy in the farm-yard playing Mozart!

Doug:
Godard has this way of breaking the linear narrative when you least expect it, like in A Woman is a Woman *(1961) when he has the actress Anna Karina look directly into the camera during different scenes as if to say, hey viewer, you're in on this. And then the scenes progress and we're back in a domestic apartment.*

Mike:
I agree. This is something that I want to get back to.

Doug:
Do you think our exposure to intense editing has altered the way we see things?

Mike:
Yes, totally. Absolutely. It entirely pervades everything. Usually the way people sit in cinema theaters is Orwellian: people are slouching, drip-feeding themselves sugar in solid or liquid form, gazing at one spot in the screen. But, to my surprise, when *Timecode* began to be screened, I saw that people were sitting up. They became really worried that they were missing something. Their eye movements were up and down, not just on one place. Sometimes they checked in with their neighbor about what was going on, but even then, they weren't taking their eyes off the screen. It seemed to create a kind of attention high, which had not been a conscious thing on my part. It was fascinating to observe that if you took the linear edit out, rather than decreasing attention, it actually increased attention.

Doug:
Guided by the audio in Timecode, *the viewers switch their focus between four screens in a gridlike pattern, yet all the while, they're playing the role of voyeurs. I found myself watching the screen like a security guard on speed.*

Mike:
It's like a choreographed security guard video but with sound. Coming from a per-formance art background, my entire idea of performance has been based on the assumption that imagery is more powerful than sound. But verbal narrative can break up linearity quite successfully.

Doug:
So where does cinema go from here?

Mike:
It seems to me this is an appropriate time to completely reexamine cinema's relation-ship to the audience. In theater the idea of "suspended disbelief" is so much clearer than in cinema because there's usually a proscenium arch separating the actors from the audience. The audience knows it's watching make-believe. But in film, how much suspended disbelief does each genre require? What about the soap opera, a feature film, pornography, a wildlife documentary? Exposing this suspended disbelief is a

way of getting the audience to reexamine its relationship to film. I think there's a huge problem within cinema in this regard. The power that film has within culture is in many ways insidious. It is such a wonderful medium, yet so powerful.

Doug:
So what do you think can be done to overcome this?

Mike:
What really needs to be opened up in film is the notion of the frame-within-the-frame. I want to see the set. I love the idea of going behind the frame cinematically and then going back into it. I want it to look fake. The cinematic frame is like the proscenium arch in theater, but we get confused by cinematic reality because we're not allowed to see the frame. To me, that blows it. It isn't honest enough.

Doug:
In mainstream cinema there is a certain vernacular that is supposed to signify serious cinema, but I feel it is cinema's Trojan horse. The cult of craftsmanship and the hierarchical pedigrees in filmmaking—who the art director or director of photography is, for instance—ultimately makes it more difficult to capture the rawness of human experience.

Mike:
Reluctantly, I find myself having to acknowledge that there are still certain aesthetic rules to making feature films. But the thing that is limiting much of the work being done outside the mainstream today, in a negative way, is a very, very simple thing: the complete absence of any understanding of camera movement. I don't think that people in mainstream film ever think about why they are using a Steady-Cam, or a crane, or a tracking shot. Then when the editor puts the shots into a linear sequence, they don't make sense because no one's thought through the psychology of the movement. Because film cameras are so heavy, there is a kind of cumbersome fluidity to their movement. The equipment that goes along with the camera gives the camera's movement a steadiness, which when projected large is easy on eye.

Doug:
It's as if the seamlessness of camera technology creates an ultra-realism that in the end is impenetrable to the viewer.

Mike:
Yes, because the film doesn't jerk, the audience just goes into a narcoleptic trance as they are swished or zoomed through a series of meaningless events. Camera movement is not taken as seriously as it should be by the avant-garde. The credo that is worshipped in this industry is technical finesse.

Doug:
Yeah, it's like, hey don't cross that line!

Mike:
But I cross it all the time. I love crossing the line.

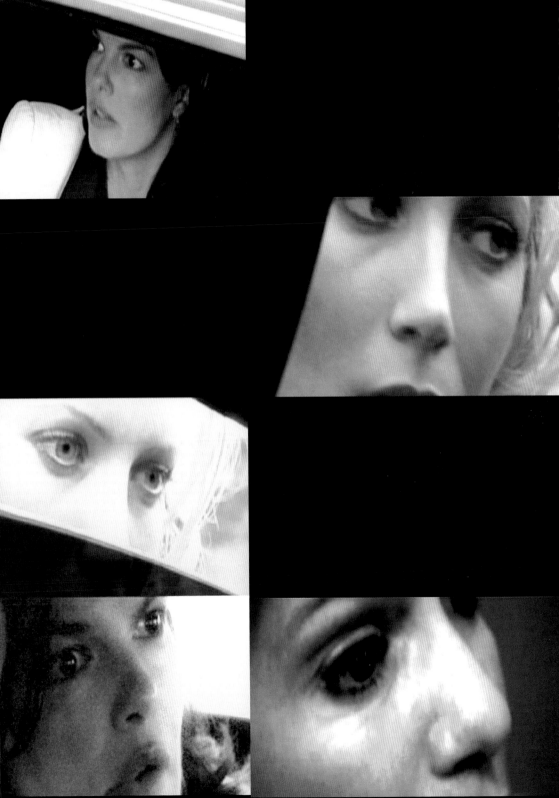

Werner Herzog

Director Werner Herzog (b. 1942, Munich, Germany) rose to prominence in the 1970s as part of German cinema's postwar revival. Over fifty films later, he remains a fiercely independent filmmaker, producing and distributing his own films. Known for his attraction to danger and adventure, he focuses in his work on heroic aspirations and obscure obsessions. Foregoing conventional filmmaking, he often allows the process to guide the story. His stylized form of documentary is a precursor of the real-world aesthetic that permeates film and television today.

Doug:
What, why, where, when...Werner? What is your starting point for making a film?

Werner:
If I don't have something physical to work with, then I don't feel comfortable. That's still how I work today. Only thirty-six hours ago, I was twelve feet away from a bear while filming in Alaska. To be in the right place at the right time, you have to physically assess the situation. It's like holding an outpost. You have to be the good soldier. You have to be unafraid—even physically, as if you're standing in front of that bear in Alaska—to make films that touch a deep truth inside us.

Doug:
So what's this film you were shooting in Alaska?

Werner:
Grizzly Man (2005), a film about a man who lived among wild grizzly bears. After thirteen summers of living with the bears, he was actually attacked and eaten along with his girlfriend. When I was in Alaska, I even came in contact with some of the bears. I don't find them fluffy, I don't find them loving. I respect them, and I would assume that, even if a bear looks friendly and nonchalant about your presence, it's still a bear.

Doug:
Do you generally improvise or do you script the narrative before filming?

Werner:
In the movie about the grizzly bears, I was trying to illuminate what had already happened. In other cases I've worked with screenplays, and then there are those times when I use a very rough screenplay and just plow into it. In films as in life.

Doug:
Cinema is a process and only a process. When the filming is over, you move quickly to the next project. There is no looking back.

Werner:
Every one of us who is really working has been there. But the real question is how you wrestle meaning from film and meaning from life.

Doug:
Is there such thing as a challenge without obstacles?

THIS CONVERSATION TOOK PLACE IN NEW YORK CITY.

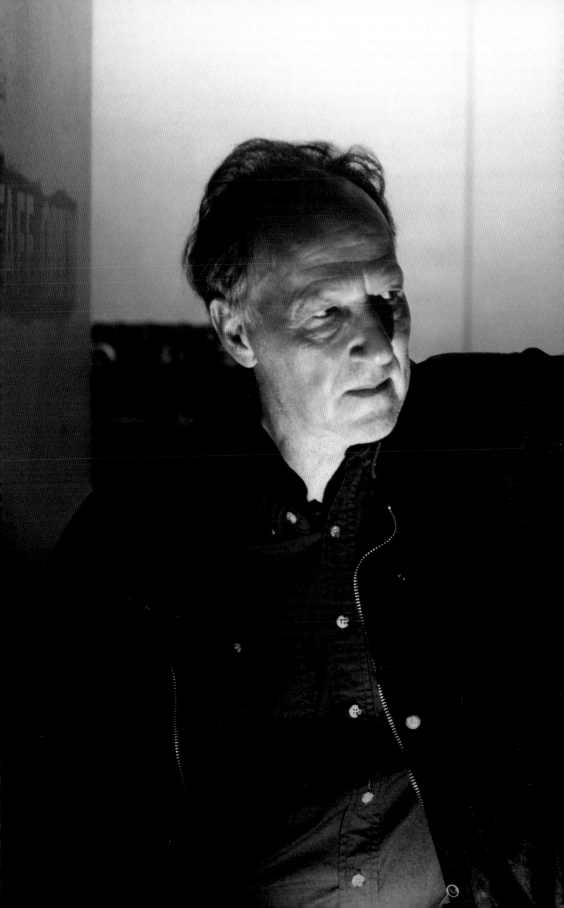

Werner:

I'm not searching for obstacles.

Doug:

But obstacles present themselves nonetheless. One doesn't have to look for them, especially in film.

Werner:

Making films always involves obstacles. It's not easy for anyone, whether you're filming in China, Iran, Hollywood, Germany, or wherever. Film is prone to obstacles. The world resists filmmaking. We are not welcome because of the kind of stuff we are doing physically. But that's OK. We can live with that. We have to accept it, otherwise we would not be filmmakers. I'm the last one who would actively seek out difficulties or obstacles. I try to minimize the risks. This is why I have survived everything that has come my way. Disease, prison in Africa—everything imaginable that could have killed me off. I just finished another film four weeks ago in Guyana.

Doug:

I filmed in Guyana once. We had to sign in with the police headquarters in the jungle because murders were so common at the time. On the wall of the police station there was a series of Polaroid photos of decapitated heads. I noticed they were all female. I asked the police chief why they were all women, and he said that it was common for that to happen when a wife cheated on her husband. Then he paused and said, "But maybe it's really because of the jungle."

Werner:

So why then am I still around at this age? Because I am professional and I avoid taking stupid risks. I don't search them out. And if they are unavoidable, then I assess the situation.

Doug:

Do you think there's a distinction between documentary and fiction filmmaking? Some would say it is all fiction.

Werner:

For me, the boundary between feature films and documentaries has always been blurred. *Fitzcarraldo* (1982) is my best documentary and *Little Dieter Needs to Fly* (1997) is my best fiction film. But I don't make such a clear distinction between them—they're all movies.

Doug:

Does that mean that anything that's filmed becomes fiction?

Werner:

Well, you're touching on a very deep question. Probably the only objective cameras are the surveillance cameras in supermarkets.

Doug:

...or a camera running live film.

Werner:
Even then, what's being filmed is being filmed from a certain perspective. There's a moment in the pseudo-documentary film about the hunt for the Loch Ness monster, *Incident at Loch Ness* (2004) by Zak Penn, when a cryptologist shows up. I'm in the film playing myself and we're talking about footage that was taken with a surveillance camera that we all think is the most frightening footage of the last decade. It takes place in a British shopping mall and you can see shoppers strolling around. Then, in the middle of everyone, you see two boys, one eight, the other ten, leading a toddler by the hand. At that moment, they're abducting the toddler and are about to commit the most gruesome murder in British criminal history for many years. But the image caught on camera is the most unobtrusive, the most unstaged, the most average shot you could possibly take with a surveillance camera in a shopping mall. Yet all of a sudden it becomes the greatest of all horrors—the horror lurking in our everyday environment.

Doug:
It also says so much about the aesthetics of the real. Pornography is being shot now with home video cameras to make it look like something from the everyday. Does removing the polish of commercial filmmaking create a greater sense of reality? Is rawness more real than reality?

Werner:
Porno films are movie movies. Karate films are movie movies. Fred Astaire films are movie movies. They are all movie movies. I scared my wife recently by saying that I should be the first one to make a real porno movie.

Doug:
I think Russ Meyer beat you to it.

Werner:
There is something ingenious about Russ Meyer's films.

Doug:
I absolutely agree, but his greatness has been obscured. His vision has been forgotten as if it were just another plastic sign on the highway of cheap strip malls and hotels.

Werner:
And nobody sees this. He'll be recognized for his work many years from now.

Doug:
Shortly before Federico Fellini died, he invited Meyer to a large private gathering in Rome to celebrate his films. For Meyer, it was what a huge honor to be acknowledged by Fellini, to be recognized by the established avant-garde. For years Meyer had lived as an outsider in the Hollywood Hills.

Werner:
He captured the vilest and basest instincts of our collective dreams. His work is all about dreams.

Doug:
And these dreams are of raw, violent, sexual energy. They're portraits of bleak and insatiable desires.

Werner:
They are deviant dreams. He articulates something that is deep inside of us that we cannot. Not that he articulated my dreams, but I saw something great in the man.

Doug:
I see a similarity between Meyer's Faster Pussycat! Kill! Kill! *(1965) and your 1970 film* Even Dwarfs Started Small *(1970) about a mutiny in a dwarf colony. In both films there's a sense of anarchy, a feeling that the tension and volatility in front of the camera is also actually happening behind the camera. These are films that possess a sense of lawlessness, restlessness, and even madness. The camera seems to lose its traditional distance and join the dance of chaos going on in the film. Scenes are fired off in rapid succession like bullets, filling the screen with anarchy and violence, and the narratives are loose and careless. It is so true to what film can be. You could never get this effect in theater. What's your feeling about theater?*

Werner:
I loathe theater. I loathe it. Theater is dead. It's lived off its own substance for two hundred years at least. Forget about it.

Doug:
But I thought you directed a few theater pieces?

Werner:
Only one, Georg Büchner's *Woyzeck* (1837). I worked with a fragment of the play. It's probably the most intense use of my native tongue that you can find. I was fascinated by it. And having Klaus Kinski and Eva Mattes onstage together gave it a texture that went beyond theater. But forget about theater. There is something not right about it. It's had its time. It's had its day and it's night now. Let's shut that door. You see, I like to read plays, but I don't like to watch them onstage.

Doug:
And cinema? Has cinema expired too?

Werner:
No.

Doug:
And why not?

Werner:
It's a medium that attracts people from every other medium—writers, composers, actors, directors, image-makers. Everyone.

Doug:
It's true that it's constantly evolving. Do you think at some point it will change so much, it will become something altogether different from what we know it as today?

Werner:
You see how far sound has evolved? Images were twenty years behind sound technologically, but now they've caught up. These days we can computer generate things that you never could with film. It's an incredible achievement of human intelligence.

SOMETIMES I JUST PLOW INTO IT. IN FILM AS IN LIFE

Doug:
When I met you for the first time many years ago at the Telluride Film Festival, you said you were about to go to Mexico to shoot video. I was surprised you were working with video.

Werner:
Yes, I did one film on video because there was no other alternative. Firstly, the environment was very hostile and it would have been really difficult to use film equipment. I was run over twice by angry people. Secondly, the light was really bad. It was very dark, and I had no chance to set up lights. The only way to film was by using a small digital camera. So, yes, I'll switch from celluloid to digital recording when it's necessary, but I'm still a man of celluloid.

Gary Hill

Video artist Gary Hill (b. 1951, Santa Monica, California) creates circuits of images and sounds that challenge the origins of language. Initially a sculptor, Hill first began using video in 1973. His video installations disrupt the screen's formal structure by challenging the constraints of representation and language. His work consists of single-channel pieces and multiple projection installations, including his famous *Tall Ships* (1992), where ghostly figures appear, move about, and disappear in synch with the viewer's movements.

Doug:
We are sitting here in this café with glass windows separating us from the noise, colors, people, and vendors that blur past us in the street. Somehow, seeing it all through the glass flattens our view of the outside world, and the flatness makes these moving images appear less real. We're sitting here safely behind the glass like viewers watching moving images on-screen. Over the course of your career, you have seen many approaches to moving images take shape. How would you describe your own relationship to them?

Gary:
Well, my relationship to images is at best ambivalent. In my work I try not to let them be present for any length of time. I move them around, interrupt them, and manipulate them with language—you know, just agitating them so they can't rest and become lodged. It is really a full-time job "deconstructing" the beast that is the image. It is its own time bomb. It continues to insinuate itself in everything. I'm excited by these new technologies, but at the same time I dread them. All of a sudden there are digital cameras and camcorders everywhere. Everyone is exchanging, capturing, recording, archiving images. But when I go somewhere now, I rarely bring a camera with me.

Doug:
Why is that? Is it a way to resist using the camera as a documentary tool?

Gary:
It is a way not to have something between me and the world. Maybe it is about preserving a space for memories and experience that is not bound by the image plane —a space that is neither fixed nor cropped. There is something almost sacred about imagination that kicks in for me. I would much rather reflect and feel the interconnectivity of the senses than thumb through a bunch of glossy pictures.

Doug:
What's kept you using video and film in your work, even while you've felt this ambivalence toward the image?

Gary:
My work has always been about thought and language. Without words and thoughts to mediate images, images occupy the world merely as eye candy, that is, as spin,

distraction, and currency. Something is going to give, and my guess is that it will be the body and its optics—eyeballs will be sentimental organs that we look back upon ...rather like the way celluloid is fading away. For better or worse, human machine hybrids are on their way, along with a whole other set of images. And they will probably be responsive in ways we can't even imagine.

Doug:
One thing that seems particularly important to you is the way perception can be highly disorienting.

Gary:
Virtually all of my work explores this issue in a number of ways. Twenty-five years ago I made *Primarily Speaking* (1980–81), an eight-channel installation of idiomatic expressions. The syllables of the spoken words are used to give locomotion to images and to the solid fields of color that are projected onto two walls facing one another, as if in dialogue. The viewer's body language becomes part of the piece as he or she passes between the two screens. The work is open to a multiplicity of interpretations about our visceral connections to the language of electronic media. Recently, I completed *Being With Things* (2004), a four-channel work that combines computer-generated models of everyday objects with images from my day-to-day existence. I wanted to level the playing fields of these different worlds of images—to see them cross-pollinate and to look for micro-narratives or narratives viewed from the side. Let's face it, death is like a plumb line that brings it all back to an inescapable linear narrative.

Doug:
I sense in your work that you want to break apart this linear structure. It seems that you create systems that investigate fragmentary ways of seeing, like the way you used several different size monitors in Inasmuch As It Is Always Already Taking Place *(1990). What was your thinking behind this?*

Gary:
Inasmuch is about arresting time in the sculptural sense. It moves beyond the standard subject-object narrative. The narrative is about how the body, media, and perception are seen in an entropic process. In 1999 I did a somewhat related work called *Still Life*, but on a much larger scale. It is a narrative about consumption and consists of over a dozen screens ranging from four inches to twenty-five feet. Computer-generated objects from everyday life in the West are projected onto the different screens that are then explored by a simulated wandering camera. As the camera circulates and its focal length changes, the projection shifts to the screen with matching dimensions to show the image in its actual size.

Doug:
Is the piece pushing the image away or is it bringing the image closer?

Gary:
For me it's a way of dealing with images in a more textual sense, that is, with the idea of those objects rather than with living color images—which are for me the husks of exotica. *Still Life* is not about playing with images, rather it's about reflecting on the

OUR GAZE IS ATTRACTED TO ANYTHING. OPEN YOUR EYES AND BINGO, THEY'RE MESMERIZED. I WANT TO AGITATE THIS

nature of consumption, something which now includes even the virtual. Not only do we want a thousand and one things and their images, but we want the virtual counterparts too! The way we prioritize what we see and focus on is so powerful. At any given moment our gaze is attracted to anything. Open your eyes and bingo, they're mesmerized.

Doug:
How does this idea surface in Still Life?

Gary:
I'm always looking to throw the viewer into an active thinking space rather than a passive seeing space. In *Still Life* I wanted to agitate our gaze by making the visual "take" interactive, so to speak. These things are very consistent in my work: changes in points of view, the abrupt change in the physical location of the image, and the obliteration of the images by pulses of extreme light. Anything to bring the question of perception to the foreground is essential. It's really an epistemological issue that I'm pursuing.

Doug:
In this piece you're overtly fragmenting what the viewer sees, and in other works like Tall Ships, *you create a space that engulfs the viewer. The darkness of the installation and the way the apparitions suddenly appear and disappear as you move around strip you of any sense of perspective.*

Gary:
Tall Ships, like several other pieces—*Reflex Chamber* (1996), *Storyteller's Room* (1998), and *Midnight Crossing* (1997)—takes place in a very dark space so there's an initial challenge to the viewer to locate him or herself in the space. This is the groundwork upon which the piece begins to emerge. In *Tall Ships* there's no complete panoramic view because you don't know what kind of space you are in. A small smear of light begins to move, and you see it's a person and you hold on. Then you meet this stranger, which in a way triggers a resonant reflection of the self. Perception for me is based on the adjustment that takes place within the viewer. It's a process that embodies the question of what it means to exist.

Doug:
Do you see your work as a way to mirror back to the viewer a warped reflection of reality?

Gary:
I think I try and make a space for the viewer to enter. I want them be part of a circuit that is dynamically available to them for decoding something. This can be something phenomenological but also something very visceral. To me, this is definitely something like a mirror, but not a traditional mirror that one can get lost in. One of the all-but-forgotten fundamentals of video is the possibility to see how others see you in real time. In other words, the image is not reflected back in reverse like a mirror. A subtle distinction when described in words, but a powerful experience firsthand. A video of yourself is how someone else sees you, and it enables you to see yourself as the

other. The first video installation I made, called *Hole in the Wall* (1974), is about feedback, architecture, and electronic space. I recorded the process of cutting through layers of an external wall, through the muslin, sheet rock, the layers of insulation, and the studs, and then jammed a monitor in there that played back the tape. It was a feedback narrative...or a narrative on feedback.

Doug:
Its raw quality makes me think of one of Gordon Matta-Clark's holes caught in a video loop. As you move through urban spaces, you see more and more electronic moving images incorporated into commercial architecture. This may or may not affect our minds, but it's definitely altering our physical world.

Gary:
Let us not forget that 99.9 percent of these images begin and are disseminated with the intention to sell you something—not just things but also behavior and emotion. People can get lost in the surfaces of the world. I try to offer an antidote, an alternative—a space with a still point from where one might reflect upon what it is to be human.

Carsten Höller

Artist Carsten Höller (b. 1961, Brussels, Belgium) creates environments that challenge perception and provoke feelings of doubt and uncertainty. He received a doctorate in biology before working in art, and his interest in interpretative science can be seen in many of his installations, sculptures, and videos. Focusing on the emotions triggered by perceptual experiences, he calls attention to the separate experiences of the mind and the body. This conversation focuses on his installations that deal with these phenomena.

Doug:
We're in Seydisfjordur, Iceland. The sun is setting, the sky is turning dark, and we're sitting here discussing the idea of nonlinearity in art-making. Carsten, I'm interested in how you've explored this in your work.

Carsten:
I'm interested in confusion, and confusion is obviously a nonlinear state. In a confused environment the unexpected can happen at any time. It's a very productive and beautiful state of mind to me, yet it's something that we often have difficulty appreciating. In fact, because it can connote danger, there have been great efforts to keep confusion to a minimum. But maybe that's what we need right now—not danger per se, but the possibility of exploring confusion's benefits. If you're able to give in to it and appreciate its beauty, it can be quite a fruitful ground for change. It doesn't have to mean total confusion. It can mean succumbing to a specific form of confusion where you don't know as much as you did before. Paradoxically, that can be very productive.

Doug:
Confusion can also give one's work multiple entry points and create open-ended encounters for the viewer. For instance, in your 2003 show Half Fiction *at the Institute of Contemporary Art in Boston, you built a slide between floors as well as corridors that led viewers into the galleries at different points. It interrupted the one-way circulation pattern that is standard to many exhibitions.*

Carsten:
In Boston and elsewhere, I've wanted to allow for the possibility of experiencing a confusing environment, where you have to give up control and let the space take over. In the slide, for instance, its curved shape determines your trajectory. As a working method, I believe in constructing influential environments. I think your work does this too. A video installation is sometimes an extremely influential environment. You don't have a choice but to respond to it in some way. It's something that takes hold of you. It's not like an image, which you can choose to look at or not.

Doug:
Are there ethical questions that surface for you when you create an influential environment that, as you say, blurs the distance between the viewer and the work?

THIS CONVERSATION TOOK PLACE IN SEYDISFJORDUR, ICELAND.

Carsten:
You can experiment with yourself only when the work's influence becomes part of your condition of being. That's when different parts of yourself can talk to and observe each other. In this way an installation can be a field for self-communication. It's similar to when you go to the cinema and are transported by a film. When this happens I feel so differently afterward that I tend to forget the film itself completely. I often stand there afterward not remembering a thing. It's as if I'm no longer the person I was when I was watching the film. It's like having cinematic amnesia. The memories of it are gone.

Doug:
It's the same for me actually, even in the most unlikely places, like when I'm stuck sitting in an airplane watching a Hollywood film. Even then I find myself transported to a quiet melancholic state. Film is like quicksand for me or like a rabbit hole that leads to another state of mind.

Carsten:
I often find myself falling into those holes too. Sometimes I manage to get out, but to get out is to realize that I've fallen into a hole and that it won't be long before I'll fall in another one. Before I fall into one of these holes, I have a certain idea of myself, but when I find myself suddenly in an influential environment, like the cinema or an installation, this idea of myself falls away. The whole space makes me feel differently. It makes me unsure of what really is, of what's a hole and what's not a hole. It is about losing certainty, about not knowing anymore, or knowing too much to handle. And then the real film starts, the inner film. But I have the feeling that it's not really the same for everybody. I think many people must have a much more stable way of looking at themselves. Maybe they don't have to think about this all the time, but I do.

Doug:
I'd like to talk more about this idea of the inner film. I feel like this plays an important role in your work.

Carsten:
Yeah, I use very different techniques from those in film, but they get at a similar thing. When I see people coming out of the cinema, they all have the same facial expressions—they look sad, or touched, or happy and giggly. You get a uniformity by creating an environment that makes people feel similar things. It's interesting to consider creating this environment sculpturally—without film at all.

Doug:
When you make an installation, you're dealing with a space that shares an affinity with the cinema. You have to consider the viewers' physical engagement to the work and how immersive you want their experience to be.

Carsten:
I agree. I try to have my work induce a similar kind of cinematic amnesia that I get from watching films. I'm very interested in the moments that deliver other ways of experiencing being alive. I just can't accept that the ways we've discovered so far to do this are all there is. There must be more. It's up to us to find out what they are. But there must be more because we've found so many ways already, right?

Doug:
I think that's what keeps one making work. The motivation to make work comes from the inadequacy of the answers you find around you.

Carsten:
It's knowing that the knowledge you have is not the only knowledge there is.

Doug:
It goes back to what you were saying earlier, that confusion allows you to explore a multiplicity of experiences. What are your thoughts about the potential confusion to be found in our media-saturated world?

Carsten:
Cacophony is what I would call it—many voices, all at the same time. But you can't listen to it anymore, it's too much. It's not possible to understand anymore—which is a very good thing, actually, because that way you can just switch it off. And then suddenly it gets quiet again and you don't understand anything.

Doug:
Speaking of a cacophony of sound, could you talk about your bird piece, the one where you trained the birds to sing a certain tune?

Carsten:
Yeah, *The Loverfinch* (1995). You liked that piece?

Doug:
Very much, yes.

Carsten:
Why?

Doug:
I find this kind of orchestral repetition attractive and strangely poetic. So you trained bullfinches yourself for the piece?

Carsten:
It was inspired by this incredible eighteenth-century love story. A baron fell in love with a woman who lived near his castle in Rosenau near Coburg, Germany. At first the girl didn't really take his love seriously. So he decided to serenade the girl from beneath her window at sunrise every day, but the girl continued to rebuff him. He then

IN A CONFUSED, NONLINEAR ENVIRONMENT THE UNEXPECTED CAN HAPPEN AT ANYTIME. IT'S A VERY PRODUCTIVE AND BEAUTIFUL STATE OF THE MIND TO ME.

came up with the idea to gather all the young wild bullfinches nesting on the castle grounds and teach them to whistle a melody. If you train them the right way, bull-finches are very gifted at whistling melodies. So he trained the birds, released them, and invited the girl to come for a walk in the palace gardens. The birds were every-where and were singing exactly the same tune he had played on his guitar beneath her window and, of course, she fell in love with him. If you go to these gardens today, you can still find traces of this love song from over 250 years ago in the birds' melo-dies. It's been transmitted through time. The love has become eternal. It's very touch-ing. I read about this story and told it to a few friends, and then later someone came to me and told me the same story. It had come full circle back to me, and I thought, it's such a good story, I should use it. So basically, I replicated the baron's behavior and trained bullfinches to whistle a melody. I showed the whistling birds in a gallery in 1994. The piece also exists as a video work, but unfortunately the film I was doing about it was never finished. The birds flew away, except for one I saw sitting on a neighbor's roof whistling the song. But then it flew away and I never saw it again.

Doug:
Perhaps that's the perfect ending for the work—the acculturated bird returns to the natural environment.

Carsten:
It was a lot of work! You have to train the birds twice a day, in the morning and evening.

Doug:
The Loverfinch, which is essentially an ephemeral piece, is really different from the Light Wall installations (2001–03) you've done, like the huge wall of strobing white lights you showed at the Prada Foundation. You explore a lot of diverse aesthetics in your work.

YET IT'S SOMETHING THAT WE OFTEN HAVE DIFFICULTY APPRECIATING

Carsten:
The Prada *Light Wall* was set up on a 10 x 80-foot wall, and we had the floor waxed to look very shiny. It's actually thousands of normal light bulbs going on and off at the frequency of 7.8 hertz accompanied by stereo sound. After a while, you start seeing all kinds of things, especially if you go in, watch for a while, then close your eyes. You can see color fields. It's amazing what you start to see.

Doug:
So the viewers create their own personal hallucinations?

Carsten:
Yeah, it's a hallucination-inducing environment. It's like a dream machine. It's very influential in the sense that you can't escape the visions once you're in the installation. Most people can't stand it, actually. They run away immediately. But the people who can stand it, they get to see the most fantastic visions. You can even start to see things coming out of the wall—all kinds of colorful shapes.

Doug:
It's as if Light Wall *creates a pure form of imagery out of white light. It empowers the viewers to generate their own imagery. What they see in their minds is a private interpretation of what they're being exposed to from the outside.*

Carsten:
It's really something that should be felt. I'm interested in getting down to feelings. The experience is like music, but made of light rather than sound. The piece does have a sound element, but it's just to reinforce the light's effect. I like the fact that there's no hidden meaning or metaphor, it's just light bulbs blinking. It has roots in abstraction and in Minimalist sculpture, but in the end the hallucinations are really quite baroque.

Doug:
It also has roots in the strobe effect that's the basis of film technology. When projected at twenty-four frames per second, the frames create a seamless moving image, which in slow motion is stroboscopic.

Carsten:
In *Phi Wall* (2002) I played with this idea more directly. When you have two light projections at a short distance from one another, you can see an "image" jump from one side to the other as they alternate on and off. The Gestalt psychologist Max Wertheimer discovered this in 1912 and called it "apparent motion." I recreated this idea using multiple disks mounted onto a wall. It leads to a very interesting theoretical question of how time is reconstructed in order to produce a certain perception, and the same is also true of cinema.

Doug:
Do you think your work is moving more toward abstraction?

Carsten:
I don't know, I never thought about it like that. If I think about it now, yes. The works that I've been speaking about are meant to produce a certain state of mind. I don't really believe in objects that just stand there and are supposed to be meaningful, like sculpture. If it's a tool and it does something to you and causes a revelation, then it's a psychological intervention. It's stronger than you. You cannot do anything about it. It's not something you just look at, it's something that looks at you in a way.

Doug:
Your recent work seems to investigate perception on a more primal level by shocking the viewer into an altered mental or physical state.

Carsten:
My work is getting more physical, that's a good point. And it's getting evil too. I want to give people the possibility of exploring their dark sides. I don't want it to be a nice little trick. I want it to be something you can hardly escape from.

IT IS ABOUT LOSING CERTAINTY,
ABOUT NOT KNOWING ANYMORE
OR KNOWING TOO MUCH TO HANDLE.
AND THEN THE REAL FILM STARTS
THE INNER FILM

Hello Huyghe

Artist Pierre Huyghe (b. 1962, Paris, France) explores the way media representations arbitrate our experience of ourselves. He extracts fragments from news events, animation, literature, and Hollywood films, and recontextualizes them in video and film installations and sculpture. The fragments are charged with multiple layers of meaning and create nonlinear experiences for the viewer to navigate. Huyghe's work acknowledges the shared experiences that media offers, yet simultaneously challenges its illusions.

Doug:
I've always associated you with motion and travel. I think of you moving from place to place in a very kinetic way. Yet you've been staying put in New York City recently. Will you be staying there for a while?

Pierre:
Yes, I'm staying here. I'm a bit fed up with moving around. This idea of being everywhere is a fantasy. I come back from being away with fewer ideas than I had before I left. Maybe elsewhere is becoming everywhere. I decided to spend more time on one project in one place for the moment.

Doug:
Could you describe the difference for you between working in one place and working on the road?

Pierre:
I like working on the road, but sometimes you just don't have access to the things you need, like friends and books. The last three months, I spent three days in each town I visited. At some point you don't know where you are anymore. Moving around nonstop makes me sick in the end. I think part of this nomadic life is a capitalist fantasy.

Doug:
I would say it's also an experiential one. It's a desire to constantly be fed by new experiences. Yet everybody has a different threshold for motion.

Pierre:
To me, this idea of mobility is about more than just the opposition between a horizontal and vertical journey. There's another kind of motion where you are trying to break the binary. I guess I'm looking for this oblique alternative—the diagonal in the mix, the indirect route. I was lucky that my father was a pilot so I used to travel for

Pierre:
It's true, in the work and in the practice. I'm more interested in looking for the transitory than in producing a conclusion or turning a resolution into an object. It's the set of stations as a whole that I'm looking at: a dynamic chain of events.

Doug:
So the concept is the basis for the work, and all the decisions about its aesthetic and medium follow.

Pierre:
Exactly.

Doug:
Can you describe what kinds of ideas move you the most in your work these days?

Pierre:
I'm more interested in open scenarios. Douglas Coupland once told Disney that the problem with their films is that they're too efficient, too seamless. Recently I've felt like every film or narrative structure is becoming too efficient. There's no time to be distracted, you know what I mean? There's no time to find your own time in the narrative. Rather than becoming a part of the film, you are held at a distance from it. It then becomes only an icon. It dominates. There is no possible dialogue between it and you.

Doug:
This idea of cinematic seamlessness surfaced in your piece Snow White Lucie (1997), in which you filmed the woman who was the voice of Snow White in the original French version of Disney's animation. She's now quite old and has sued Disney for the rights to her interpretation of the part, claiming that her voice has been stolen. It's almost like you went in and, like a miner, excavated this miniscule flaw in Disney's fairy-tale perfection and brought it to the surface. Maybe we're at a point where there needs to be something more to disrupt cinema in the face of its ever more pervasive and powerful seamlessness.

Pierre:
Exactly. I believe in a nonlinear way of editing fragments, but not so much in the postmodern idea of collage. We are not talking about process, but about jump cuts and vibrating time. The notion of time has crashed into this immediacy, the now. We act in this fold of the present, an exponential present.

Doug:
The idea of being surrounded by a physical landscape has been replaced by a landscape of information. For me one of the key questions is to try to understand how we can sustain ourselves, and perceptually maybe even thrive, within this fragmented information.

Pierre:
You have always dealt with the fragmentation of time in your work. The viewer is a kind of nomadic flâneur who goes through some kind of adventure and then edits the experience. It is subjective editing.

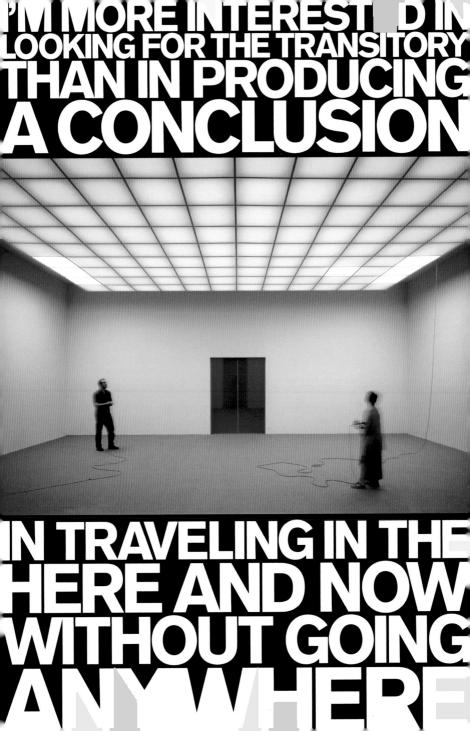

I'M MORE INTERESTED IN LOOKING FOR THE TRANSITORY THAN IN PRODUCING A CONCLUSION

IN TRAVELING IN THE HERE AND NOW WITHOUT GOING ANYWHERE

Doug:

I think this is probably why I feel a particular affinity to your exhibition L'Expédition Scintillante, a Musical *at the Kunsthaus Bregenz in 2002, because it hints at a narrative that is actually open-ended and interpretive.*

Pierre:

This exhibition was a prevision of what might happen on an expedition. It's all about describing a situation that has not yet happened. It's a bit tricky. You envision and experience a situation—in this case, it's a collective journey in Antarctica. You're in a visual translation of hypothetical situations, of what could happen.

Doug:

I like that you created real artifacts out of this imaginary experience. On one floor of the museum, viewers discover handmade topographical books about the Antarctic; on another they feel snow falling from the ceiling and watch a large ship made of ice slowly melt in the middle of the floor.

Pierre:

Yeah, it was a series of temporal experiences. For example, on the first floor was a weather room based on Edgar Allan Poe's 1850 novel *The Narrative of Arthur Gordon Pym of Nantucket.* I took all the weather mentioned in it and made a logbook. It was a metaphor for the mental journey of the main character. I took the weather report and I set it in motion as you would a musical score. From the ceiling of the museum, I created an authentic climate: real falling rain, snow, and fog. But all the while, it's fictional weather, a romantic time capsule.

Doug:

Yeah, as the pieces slowly changed, the viewers were affected by their transformations. You could feel the climate change—the cold air, the rain, the snow. To me it undermines the idea that sculpture and the space around it, which the viewer occupies, are separate from one another. In L'Expédition Scintillante *one literally melted into the other, and even though the viewers' movements remained invisible, they are incredibly important to understanding—and feeling—this collapse.*

Pierre:

The viewer's movement inside the space is important. The viewer's perception is linked to space and to motion.

Doug:

One of the things that works so well in L'Expédition Scintillante *is that it creates a filmlike narrative without the use of film. Is that something that you were thinking of?*

Pierre:

That's right, there is no cinematic or photographic image in this exhibition. You can almost think of it like an opera or a musical in three acts. The viewer has to traverse floor one, then two, and then three, creating a sort of classical linear play. And it is reversible—you have to ultimately go down from floor three to ground level again. But there's also a sense of narrative in the ice melting, the rhythm of the music, and the

and becoming a pile of ice surrounded by snow. By the end of the exhibition, the ship literally turned into landscape. It is filmic without being a film.

Doug:
The time-based elements in the exhibition, the ice ship, the snow from the ceiling, come out at the viewer unexpectedly. It seems to be a conscious attempt to move past formalism to create something that is a living image.

Pierre:
A living entity. You're speaking about an idea of impermanence, in opposition to the idea of stability. It is an expression of something that is still unclear and unresolved. The show itself was a kind of organism. *L'Expédition Scintillante* can be translated as "The Blinking Expedition." When I did the French pavilion for the 2001 Venice Biennale, the whole exhibition was a set of events taking place and then disappearing again. It was a blinking, pulsating exhibition with glass doors separating all the rooms. Sometimes you could see through them and connect things and sometimes you couldn't. One situation can be transformed into another without losing something in the translation. It can be different but also equivalent. Something may appear, then reappear somewhere else. So it's a blinking organism.

Doug:
A mutating organism—alive and breathing?

Pierre:
Yes. Things have to breathe, to grow, and die somehow.

Doug:
Our culture often views itself in filmic terms. Our actions and ideas are in continuous reference to media images and the stories that circulate there. Yet these areas are limited in the range of narratives they present, and their structures are often predictable. Do you feel that the relevance of cinema has died in a way?

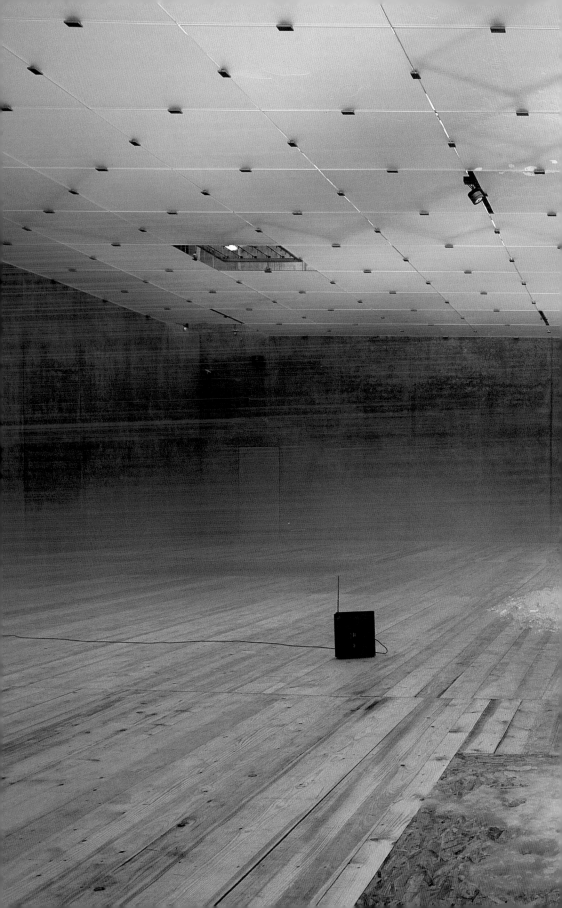

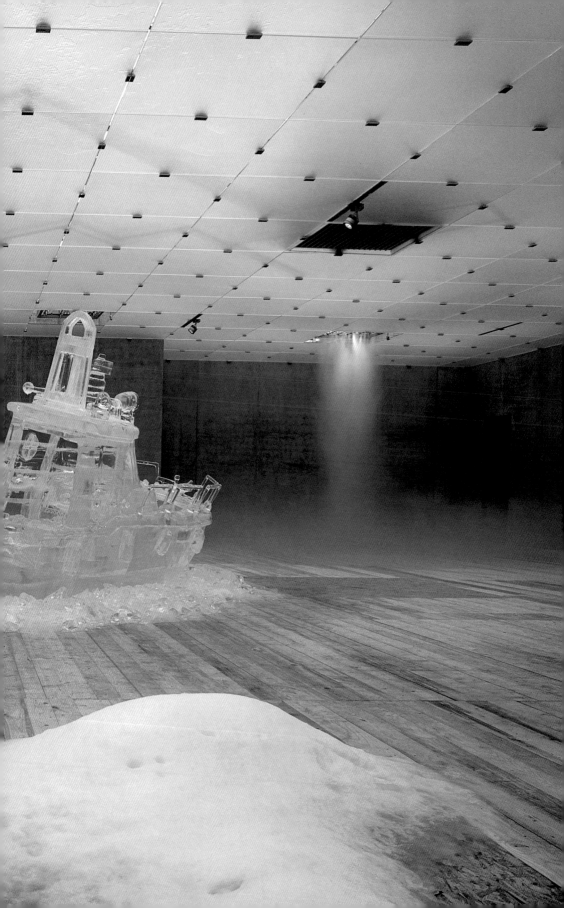

es, in its actual form, it's dead. It's too dramatically straight and well controlled. I'm interested in situations—in the here and now. In traveling in the here and now without going anywhere. It begs the question of how to reorganize sequences of events in reality, to reschematize the real.

Doug:
It sounds like one of your main objectives is to bring the viewer into the present.

Pierre:
Yes, in a way, but not into one single idea of the present. There are many different present moments possible. I'm interested in subjective viewpoints, in a multiplicity of viewpoints.

Doug:
It's like the project you did with the manga character, Annlee, in No Ghost Just a Shell *(1999–2002). I like the idea of sharing this character with different artists and filmmakers so each person could stamp his or her idea onto it, change it, and extend its life. How did the project start?*

Pierre:
We bought the copyright to an existing manga character that hadn't yet been used in any stories. We freed this sign from the fiction market and brought it into another reality. It was a polyphonic project: it was inhabited by different authors before disappearing. We gave back the copyright to the character. This sign belongs to itself now. There were about sixteen artists involved, each using different forms and formulas: films, objects, books, posters. And exhibitions of its different manifestations were always appearing and disappearing in different places. Annlee had a blinking existence too.

Doug:
The idea of creating a modular narrative that can be passed around the world seems very much of its time.

Pierre:
It's a sign around which a community established itself. It turns around the questions, what is common in the singular and what is singular in the common? Each time it was passed on, you had to renegotiate the condition in which it was exchanged. Each time, you saw how a group of people handled this one sign.

Doug:
What was the best encounter you had this week?

Pierre:
Oh, I don't know. I've been staying home, but just thinking about it now, it's probably all I came across on Google. The saddest answer ever. I would say Philip K. Dick's nonfiction writing, particularly the essay "If You Find This World Bad, You Should See Some of the Others" (1977).

Alejandro Jodorowsky

Filmmaker Alejandro Jodorowsky (b. 1929, Iquique, Chile) stunned audiences with his films *El Topo* (1970) and *The Holy Mountain* (1973). In addition to writing, directing, and performing in them, he composed the sound tracks and designed the costumes. His films combine an explosive mix of Surrealist symbols with science fiction, dream sequences, horror, religion, and satire. He was involved in avant-garde theater in Chile before moving to Paris in the 1950s. He has performed in and directed theater productions, cofounded a post-Surrealist movement, and written graphic novels.

Doug:
In your films El Topo *and* The Holy Mountain, *minutes pass and centuries pass with equal ease. It's a very unusual approach to time. You don't seem concerned at all with adhering to the idea of a straight narrative.*

Alejandro:
I think time is a totality. I don't live with dates very well. I am very bad at discerning if something happened five years, ten years, or twenty years ago. In fact, I am no longer certain of my own birthday, and I don't know exactly when my children were born or when I was married. I just don't see any reason to enter time into clocks or put things in a calendar. The past and the future are here with us now.

Doug:
That's interesting because your films really do seem like meditations on the "here and now." They allow us to enter a version of time that's open to interpretation.

Alejandro:
Yes, absolutely. I wanted to break time in my films. I wanted to break the norms of constructing the narrative and the edit. In *The Holy Mountain* I tried to throw out all the rules of narration. It's not a normal picture! I wanted to tell a new kind of story. And in *El Topo* you don't know if time has passed. You don't even know if the protagonist is dead, or if he has been born or reborn. It is the story of illumination. It is a spiritual story. All these things are done to break the linear notion of time.

Doug:
How did you get started in film?

Alejandro:
I started in avant-garde theater first so I could figure out what I wanted to say. Then when I was ready to say something personal, without copying the others, I did it. It was a long preparation of many years to do that. When I felt able to do it, I did it. When I make a film, I do everything. I have an idea, I direct, I do the montage, the music. Doing a film forces you to engage in an enormous battle. In film everyone has an idea and you have to be able to listen, but still to be able to say no to them all.

THIS CONVERSATION TOOK PLACE IN PARIS, FRANCE.

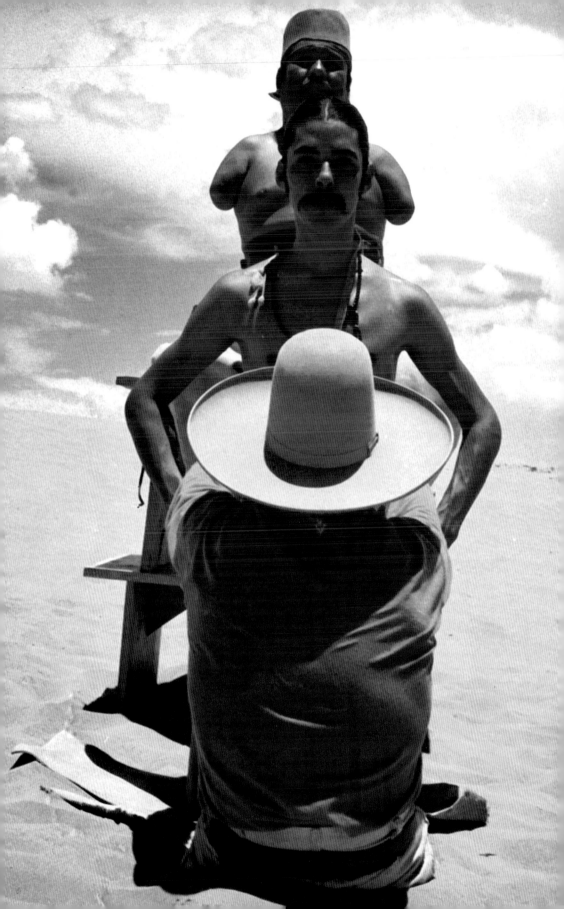

Doug:
Given how different your films are from traditional genre films, what kinds of problems did you face in the industry?

Alejandro:
I was an idealist. I was shy. When I first started, I viewed film as an art. I made pictures for myself. I was never thinking about the others. I was naïve then. But I soon discovered that film is an industry of idiots, and so I made my pictures against the industry. I was dangerous. I was not Hollywood. Then the industry rejected me, so I could not continue to make pictures. Nowadays, it is very difficult to make an artistic picture like you want to. America is the master of this business—and it is a business. Now, the masters are no longer the artists or the producers, but the distributors and the theater owners. And those owners do not show your little pictures because they don't make them any business.

Doug:
Your films have always felt to me like a road map of your subconscious. Was this what you intended?

Alejandro:
You are asking a very metaphysical question. When I studied with a Zen master, the central question he asked me was, "What is it that does not begin and does not end?" At the time, I didn't know how to respond to this. Now I would say that the notion of a beginning and an end is a rational formulation that I don't use anymore. For me, life is not continuous. If I have a beginning and an end in one of my films, it's not a real beginning or end. These things do not exist.

Doug:
You have said that your work is a form of poetry.

Alejandro:
I pursue poetry in cinema, but it is very difficult to do this because making a film is a collaborative work and poetry is the most individual thing there is. Everyday it is a chess game. One never does what one wants. Cinema is an approximation of poetry, but it is not poetry itself.

Doug:
It's interesting that you say you strive to make poetry in film since poems are individual, condensed moments of thoughts and emotions, and film is a continuous stream of images and audio. How do you go about bringing poetry into film?

Alejandro:
I wanted to make images so full of details that it would be impossible to see everything the first time you watched the film. I wanted you to start seeing other things the second time.

Doug:
In the film industry most directors build narrative sequences out of shots that lead one into the other. But you don't do this.

Alejandro:

I wanted to address consciousness, subconsciousness, and superconsciousness—
that is, a surrealistic consciousness where you can comprehend the universe. For
me, film is a metaphysical search. I worked within an esoteric tradition, but above
all, I tried to seek out the archetypes of my subconscious. You have to go deep inside
yourself in order to see who you really are. I did this by profoundly reentering my
subconscious—my research was absolutely irrational.

Doug:
You've experimented with LSD, which is one of the more extreme ways to embark on
this quest. When was the first time you took it?

Alejandro:

In the 1970s, when I was forty. I went to see a Bolivian guru in New York while I was
making *The Holy Mountain.* I remember I paid him $17,000 from the picture budget
to get enlightened for my part as the guru in the film. So he came with an orange
colored powder. Pure LSD.

Doug:
$17,000 for a guru and orange powder?

Alejandro:

Yes! And then he asked me for a thousand dollars, a good hotel, and a kilo of mari-
juana. I showed him a good hotel, brought the kilo of marijuana, and he gave me the
LSD. After one hour he made me smoke marijuana and I started to have the hallucina-
tions. And then he directed me for eight hours and did all kinds of initiations. So then
after that, I could play the guru in the picture. I knew what I was doing.

Doug:
A bit of method acting.

Alejandro:

Yes, but in *The Holy Mountain,* all the people in it play themselves, they are not
actors. I did not look for heroes or universal truths. I see film as a research tool
that comes out of mythology. The kind of work I did can go further because of the
symbols I used. For me, the enemy of cinema is Hitchcock because everything in
a Hitchcock film is already thought through. The same with the image. I do not play

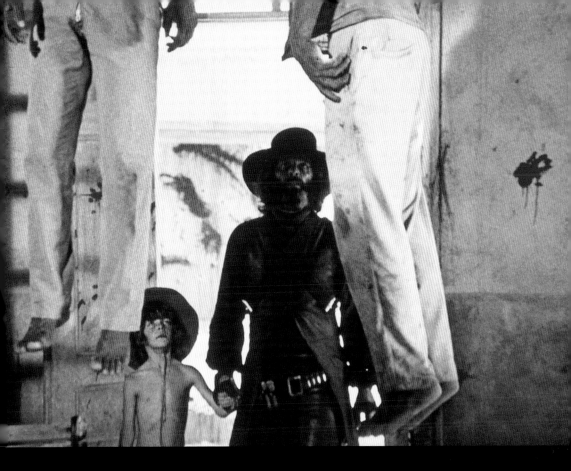

aesthetical games, or make preconceived jokes, or things like that. Several times I risked my life for a film. When I make a film, I don't see my friends, I don't remember anyone, and I don't sleep. I go to bed at midnight and get up at 6 A.M. I eat very little. I don't see my wife or mistress. I no longer have a sexual life. My existence in these cases is entirely devoted to the film.

Doug:
Have you ever thought about films detaching themselves from the confines of the screen and moving outside the cinema?

Alejandro:
Bauhaus artist László Moholy-Nagy was a good precursor of all of this. More than sixty years ago, he was thinking about things like projecting a picture onto steam! I agree, we need to take the image off the screen like he envisioned. We can do it. One day you will see it everywhere.

Doug:
We're working on it. So you knew Dennis Hopper when he was making The Last Movie *(1971), right? There are qualities in that movie that resemble the self-reflex-ivity so characteristic of your films. I'm thinking in particular of the final scene in* The Last Movie, *when villagers in the Peruvian Andes build massive effigies of the film camera and the film set and then burn them. In the end, the film destroys itself*

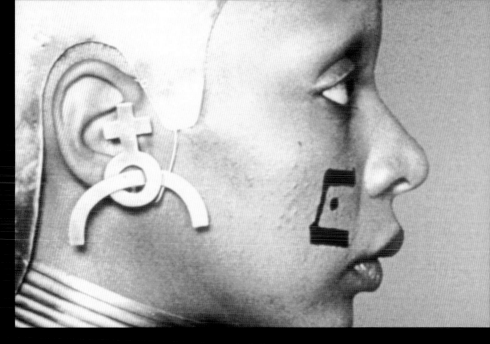

Alejandro:
When I made *El Topo*, Dennis Hopper wanted to know me. He was not famous then. He was living in Taos and he came to see me in Mexico. He was going to the Belgrade Film Festival in Yugoslavia with Peter Fonda and invited me to go along as their astrologer. We stopped over in London and ran into Kenneth Anger. Kenneth opened up film, you know. He's an underground genius. They were taking all kinds of drugs there all the time and I was taking nothing. I was the astrologer. Then one night Peter Fonda called me and said, there's a serpent, a big serpent. I had to calm him—Boom! And then I went to Taos because Dennis had a lot of problems editing *The Last Movie*. He had four machines with the crew trying to do it, and then I worked three days myself editing it. I don't know if there are any copies of this anymore. I am sure I made a genius picture because the material was fantastic. But it was too much at some moments. Hopper would have a romantic scene, then a political scene, et cetera. The institution of reality in the movies is a metaphysical problem. It's a problem because people start living in a virtual world.

Doug:
It sounds like it's been a long journey for you.

Alejandro:
Yes, but we're mortals. We have to live. Life is impermanent. Why take life seriously, no? Everything is a game. Art is a game. As the Chinese say, if we play to die, we will die. And what they do before they die is write a poem. You cannot die without writing your last poem. Yes, a little poem inside, that is all.

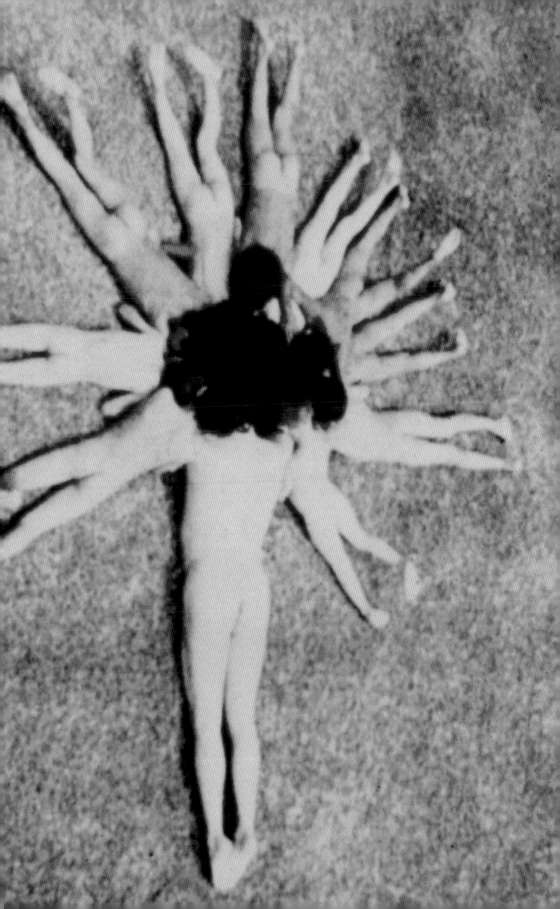

Rem Koolhaas

The architecture of Rem Koolhaas (b. 1944, Rotterdam, Netherlands) is critically informed by the study of urban planning, informational systems, and social structures. He designs buildings that interpret the way we live and how we relate to one another and our surroundings. He first worked as a journalist and scriptwriter, and has published many books, including *Delirious New York* (1978) and *S, M, L, XL* (1994). He cofounded the Office for Metropolitan Architecture (OMA) in 1975, now in Rotterdam, and is a professor at Harvard University's Graduate School of Design.

Doug:
I've always felt that there's an affinity between film and architecture in the way they both guide the viewer through narrative situations, one via illusion and the other via a built environment. What's been your relationship to film?

Rem:
I consider this discipline to be the essential mechanism of basically everything. I was very interested in film when I was younger and at some point, at like seventeen, I formed a film group. It eventually evolved into writing scripts for people who made films.

Doug:
How would you describe cinema's influence on your work?

Rem:
The intelligence that goes into filmmaking can sometimes be surprising. When you see something you think is amazing, it's kind of embarrassing when you realize you didn't immediately assume that intelligence before, for example, like all the thinking that goes into costumes or set design. This has always been much more appealing to me about cinema than cinematic space. When I think of cinema, I only think of fragmented moments of intelligence that are manipulated and then tied together in a sequence. It is montage. In that sense, the book that has been by far the most influential to me in terms of my—if I can really be so pompous—my artistic process, is François Truffaut's *Hitchcock* (1967). It is incredible, the meticulous composition and intelligence that went into every scene in a Hitchcock film. You know in *Suspicion* (1941), the way Hitchcock put a little lamp in that glass of milk so it glowed when Cary Grant brought it to Joan Fontaine? That for me is the ultimate paradigm.

Doug:
It's interesting because that glass of glowing milk wasn't engineered in isolation. It's the product of a highly collaborative kind of production, which film and architecture share. They both produce seamless images, but this seamlessness is really only possible because of the specialists behind the scenes. For me, it's this complex system behind the whole that offers so much potential for exploring different directions.

THIS CONVERSATION TOOK PLACE BOTH IN SEATTLE, WASHINGTON, AND VENICE, CALIFORNIA.

Rem:
And in genuinely different ways…

Doug:
One thing that interests me is the capacity of the moving image to absorb nonlinear information. Do you think architectural structures can do this?

Rem:
These are a really interesting series of issues. I think nonlinearity happens every-
where but manifests itself in completely different ways. Nonlinear architecture is
to some extent a given because a building is itself completely independent of how
it will be perceived as architecture. You cannot force anyone to be linear. But in terms
of architecture's structure, that's one of the key areas where nonlinearity is starting
to exist now. I think we're really beginning to see new ways of structuring architecture.

Doug:
How do you see that manifested?

Rem:
Well, there's no longer as much loyalty to homogeneous solutions, to the grid, to
efficiency, and to straightforwardness. And there's an increasing ambiguity toward
structure. The deputy chairman of Arup who works with us, Cecil Balmond, published
a book called *Informal* (2002) about nonlinearity and these discontinuities.

Doug:
I find the Seattle Public Library (1999–2004) remarkable in its accessibility: the façade is transparent, the space inside is open and saturated with light, and open stacks of books are everywhere. When you ride up the escalators through the open middle space, it's a smooth transition upwards. But because everything is a little bit off-kilter from the central axis, you get the feeling that the different floors and compartments around you are shifting. Were you thinking about the idea of narrative at all—of how the building would be felt as an experience—when you were working on the design?

Rem:
Of course. Narratives are the driving force behind everything I do. Every building is defined by a systematic deployment of certain sequences of circulation. In architectural terms we call these sequences programmatic, but in more general terms they are completely narrative. In the case of the Seattle Public Library, this is particularly strong. Although the building is stable, the process of moving through it exposes the instability of the building. The building destabilizes your perspective.

Doug:
It's a building you can get lost in. It's pretty easy to find private psychological spaces in it. You come out of one passageway and find yourself suddenly on a mezzanine. These unexpected spaces are important because they let you personalize your experience.

Rem:

I think part of that informality is because the most important spaces in the building are residual. Their aim is never straight. And coverage and exposure are largely accidental in the whole thing. We didn't think so when we did it, but we realize now that there's nothing overmonumental about the building because everything is mismatched in a way. If monumentalism were really the point, it would have had a center.

Doug:

There's a certain genre of architecture that, because of its visibility, its scale, and its form, functions like pop signage. It has the ability to emit information and provoke a response. This new architecture seems less defined by formal architectural concerns and more by the message that it's resonating within a public space.

Rem:

I think building shelters is becoming ever more rare. You still have architects like Frank Gehry deeply embedded in what architecture thinks of itself, but it is rarely ever realized. Even though our China Central Television (CCTV) broadcast head-quarters (2002–08) is a private building, it is totally about communication. That said, the majority of the work we've done in the past is, of course, about accommodating people in recognizable, functional conditions.

Doug:

The CCTV broadcast headquarters in Beijing is an interesting example of what we're talking about. It's literally like a Möbius strip made out of steel, glass, and concrete.

Rem:

The structure itself is much less rigid than would normally be the case for that kind of high-rise building. It's like a feedback loop. You could say it's even hyperlinear or circular-linear. It appears to go beyond linearity. That's why nonlinearity is different in architecture than, for instance, in film.

Doug:

Maybe it has to do with the idea of lightness too. A year before Aldous Huxley wrote Brave New World *(1932), he defined speed in* Music At Night and Other Essays *as the twentieth century's one truly unique pleasure: speed as mental lightness and physical weightlessness. Perhaps in the twenty-first century a language of lightness and communication will open up an architectural practice based on the flow of information rather than on concrete and glass solids.*

Rem:

Yes, the fascinating thing about architecture is how it has to support these flows, and how it frames and sustains them. There are some very nice examples of it, for instance, all the advertising along an escalator in a subway. I love it when people are exposed to completely random visual languages. We tried to use an escalator in one of our buildings as a kind of informational element, but it was impossible to convince people to use an escalator that way.

Doug:

Are the earliest examples of this experience the successive billboards on highways?

THE FASCINATING THING ABOUT ARCHITECTURE IS HOW IT HAS TO SUPPORT FLOWS OF INFORMATION, HOW IT FRAMES AND SUSTAINS THEM

Rem:
This idea is not necessarily unique to our time. If you look at a Roman city, the graffiti and mark-making in the streets are totally informational too. You can find messages and images about sex, commerce, politics. There's an amazing modernity to it.

Doug:
That's something interesting about the present, how all these different media are influencing each other. It's like we're reaching a dead end with linear structures.

Rem:
I totally recognize what you're saying. And representation is equally important in this question. The dead end of representation is a total nightmare.

Doug:
What makes it a nightmare for you?

Rem:
The irony is that you can experiment as an artist but not as an architect. Everyone is so professionally on edge now when they're doing a building that experimentation is actually a disturbing factor for many people. People think that the time you spend on experimentation is time that you should be investing in making sure the building will stand up.

Doug:
How do you normally approach your work?

Rem:
In architecture there are two ways of working: competitions and direct commissions. The opposition between the two is so fundamental, it's incredible that it's never really been analyzed. They're totally different in that in the first case you have to generate a finite thing in, say, four weeks without input from anyone. You intuit real needs and then synthesize them into your own form. The end result may be convincing or unconvincing, but your presentation is always masterful. With a commission the process takes years and involves intense input. It can be crazy. You never really know what people are going to ask of you, so there is an essential randomness to everything you do. The difficulty is to impose and maintain at least an intelligent connection between the different parts. In either case, though, you can never entirely set your own agenda in architecture. Moving to the left and to the right of an idea is implicit in the process because you never know on which side you have to bet, so to speak. In that sense it is completely disorienting. Architecture is certainly nonlinear in terms of the process.

Doug:
Have you ever integrated moving images into your work?

Rem:
In the early 1990s we submitted a proposal for ZKM, the Center for Art and Media in Karlsruhe. In it we proposed one entire wall of moving images. We won the competition but for various reasons we decided not to do it. And for the CCTV broadcast headquarters, we're integrating moving images and still images into the architecture.

This question about the moving image is always a preoccupation, but it's been done by so many of the wrong people that it can sometimes destroy the attraction. It's inevitable to think about though.

Doug:
Your Prada store in Los Angeles (2000–04) is your third design for the Italian fashion house. The architecture itself is very interactive. For example, in the changing rooms you installed Privalite glass walls that let the person trying on clothes switch the glass from translucent to transparent. And there are the "magic mirrors" that let you see yourself simultaneously from the front and back. These architectural details seem to fit the function of the space so well. What attracted you to working with a fashion house?

Rem:
One of the exciting things about working with fashion is that clothes, as informational elements, are distributed with such porousness that you're able to actually read the information clearly.

Doug:
Fashion is both transient and very personal. It is defined by materials and colors that have different emotional registers and by cuts that are designed to symbolize certain cultures and countercultures. To me, shopping is about creating a collage of your personality with the knowledge that you always have the possibility for radical change.

Rem:
Fashion is an incredibly interesting form of nonlinearity to me. It's the perpetual advent of internal atavistic desires. It can really be almost tragic in intensity. And seeing how fashion designers work is, for me, one of the most impressive creative moments because it happens in an unbelievably short period of time. You assume that they work on things for six months, but they can sometimes work on a collection for three weeks using the barest informational teams. Really the barest. I find it incredible what comes out given those conditions. And sometimes it doesn't come out and that's interesting too.

Doug:
How do you feel about the fact that in many ways architecture has become a general language in popular culture for understanding both urban space and information?

Rem:
It's incredibly exciting that everyone is seeing architecture now not only as a metaphor but as a fundamental organizing principle. The only problem is that the people who are benefiting from it least are architects.

Doug:
...just as I'm sure you've found inspiration in everything other than architecture.

Rem:
Yes, in everything but! My moments of deepest enjoyment come from the luxury of not having to do anything with them—from being able to keep them totally private.

an artist but not as an architect. Every
one is so professionally on edge now w
hen they're doing a building that exp

I CONSIDER FILM TO BE THE ESSENTIAL MECHANISM OF BASICALLY EVERYTHING

erimentation is actually a disturbing fa
ctor for many people. People think tha
t the time you spend on experimenta
tion is time that you should be investi
ng in making sure the building will sta

Greg Lynn

Architect and theoretician Greg Lynn (b. 1964, Vermillion, Ohio) advocates a dynamic architecture that absorbs external cultural influences such as film and pop culture. His theory and designs explore architecture as a bridge between the built environment and mass culture. In his seminal book *Animate Form* (1994), he focuses on innovative design practices that incorporate time and movement, forces that have traditionally remained outside architecture. He founded the architecture firm Greg Lynn FORM in Los Angeles in 1994.

Doug:
When I think of your architecture and the forms you create, I think of movement. Like highway overpasses that twist and overlap, your work seems to take the viewer on a fluid journey. Have film and time-based media influenced you?

Greg:
Totally. Everything I do usually starts from pop culture, not from high culture, and that tends to mean music and film, rather than other fields like painting and sculpture. It's funny, but film is a better source of inspiration and technique in architecture, especially being out here in Los Angeles where the industry is so dominant. You bump into it all the time. I always tell my students when we start a project not to think about what kind of lights to design, but to go see a film, like Ridley Scott's *Blade Runner* (1982), to see what kind of lighting was used. I'm also really interested in animation. For ten years I've been bootlegging animation programs and other software to use in my architecture, so on the technical level too, there's a really tight fit between time-based media and my work.

Doug:
I'm struck by how some of your work seems to be about wrapping the moving image around architectural form. How intentional is this?

Greg:
Unfortunately in architecture, there seems to be a split between two kinds of architects: those who totally ignore things like lighting, color, materials, structure, and surface, and then those who assume that being interested in materials means being interested in some exotic concrete mixture or unfinished wood from a North African forest. There's no sense of creating a space through visual effects. There are artists who are doing exactly this, like you and Olafur—looking at atmosphere as film atmosphere rather than as something that has to be natural—but there are only a few architects who are on to this.

Doug:
I think we are all trying to create an environment that triggers responses. I like to think of it as a three-dimensional topography that's open to interpretation so the viewer can use his or her own experiences to create a personal narrative.

THIS CONVERSATION TOOK PLACE IN VENICE, CALIFORNIA.

Greg:

Well, in architecture at the level of space alone, there are immaterial cues you can enlist to elicit a specific vibe. In almost everything else it's impossible, but in architecture there are techniques to do this. For example, it's really easy to make a space look religious and sacred. You backlight it and use soft articulation. The key is you have to always be open to the different things that people are going to bring to their experience of the space in a way that you don't have in most other fields.

Doug:
Film is one of the things that does this too. In what ways do you think film has influenced architecture?

Greg:

More and more architecture is functioning at that level of...I don't want to say as entertainment exactly...but as spectacle. In certain extreme instances, like Frank Gehry's Disney Concert Hall here in Los Angeles, it's like a Hollywood blockbuster, like *Godzilla* or *Jurassic Park*. It works like a film to me in that you move through it and consume it like you do a film. It captures people's imaginations in the same way. But, you know, before film, architecture was the primary spectacle-making machine. People don't know this, though, because most people don't know architecture's history. That said, moving images have changed our expectations of traveling through space. It's not even so much that a building has to incorporate moving images now—which is another facet of it, certainly—it's that you have different expectations of architecture when you've been raised on film. You expect it to move you. You expect the spaces to be dynamic and animated.

Doug:
It has raised the stakes for architecture, hasn't it? What challenges do architects face now?

Greg:

As an architect, you've got to get them out of the experience of the space to then draw them back into it. With film, the minute viewers are in the theater, they're in the film experience. With architecture, it's never quite clear when someone is in the experience in the same way because everyone lives with it all the time.

Doug:
How film and architecture present experience is somehow connected. You could say that walking inside a building is analogous to watching the first scene of a film—it's the obvious entry point. Then going down a hallway is like the transitional sequence. And then you might go into the first room, and there you maybe have the first encounter with the protagonist, et cetera.

Greg:

Totally. How many doors have you walked through today, literally? It's probably a couple dozen. And how many did you experience in a state of narrative attention? In architecture you have to make people understand that you want to communicate with them on that level. In film, on the other hand, the viewer's response is automatically attentive.

They're prepared to think, "Okay, I'm about to be told a story. I'm about to see images that are going to make me feel different emotions." With architecture the average person won't experience it that way unless you do something to indicate that the curtain is rising, so get ready. Even with great architecture, most people won't even know they're in it. Architecture is more everyday and diffuse then film.

Doug:
What kinds of things do you incorporate into your work to catch people's attention? I am thinking of architectural devices such as escalators, which give the viewer an experience of moving images as he or she moves from place to place.

Greg:
In the 1970s there was suddenly a lot of attention being paid to all these spaces of transit and motion. People were picking up on their filmic qualities, and these are still really interesting territories for architects today. Unfortunately, all the experiments in the 1970s carried with them the ironic banality of modernist architecture.

Doug:
In a lot of ways, transitional spaces, or what people might think of as non-sites, have become the sites for narratives about modern living.

Greg:
Exactly—using transitional spaces as opportunities to think about design in a new way and to fuse it with film. When we did a proposal for the façade of the Museums Quartier in Vienna with the L.A.-based design group Imaginary Forces, it was fabulous because they approached it like it was going to be a movie title sequence. They were like, "How do we get people in the mood for architecture? How would you prepare them for a movie?" They were driving at this idea all the time during the project, and not just in relation to the façade's form but to its color, text, and signage. Everything. With a façade it's really important because you've got to announce to people that they are about to start—that they're about to enter something special.

Doug:
We're encountering an urban landscape where the moving image increasingly puts these kinds of façades in motion. It makes me think of Robert Venturi's book Learning from Las Vegas (1972), but things are even more extreme now. You go to Vegas nowadays and you realize that all the neon and electric lights of Venturi's vision are now images flickering across outdoor LCD screens.

Greg:
This whole question makes architecture more interesting to me. Venturi said architecture was defined by the first twelve inches of a building. And now in Vegas, it is absolutely everywhere. Image and space are seamlessly mixed, and I'm not talking about just the billboards, but on tabletops and video screens too.

Doug:
With all the advanced LCD screens, projections, and other media, it's like the surface of this electric architecture is a representation of a dream state you can physically walk into. And this new digital Vegas, or new Times Square for that matter, can be

geared to a targeted audience at any given moment simply by programming different images on the screens.

Greg:

Those spaces are definitely petri dishes. You go to Vegas and you think, this is where they're working out the future. But I actually don't really like Vegas. I see all the raw materials there, but every time I go I am just sick. There's just so much squandered opportunity. When you think about Baroque and Classical architecture, most of those architects back then were painting, sculpting, and making buildings all at the same time. They integrated so many different kinds of images. Although examples of it from that period can be overly romantic, it's the fusion of architecture and media that I love, from the shapes and the textures of building materials down to the images.

Doug:
Where do you see the ideas behind the dematerialized architecture of Vegas going?

Greg:

Recently Volvo gave me a tour of their factory and I met their designers while I was there. You know what those guys said? "We need car architects. We want to do a

one-of-a-kind car made from mass-produced parts just like you architects do."
That was a major wake-up call: that architecture wasn't just about making buildings.
If you relax the boundaries a little, architecture can move into so many other fields.
I think this will happen more and more. A lot of people have gotten interested in
architecture over the last ten years, and equally so, architects are mutating into
other fields. It's the same thing as when an insect goes in and pollinates a flower
because it doesn't have the ability to reproduce itself. It's like the way things were
in the sixteenth, seventeenth, and eighteenth centuries, where there weren't these
clear boundaries between people who made buildings and those who made other
things like sculptures.

Doug:
Your studio is on a busy boulevard in Venice, Los Angeles. I used to have my stu-
dio across the street, so I know what it's like. You open the door to go outside and
cars and trucks are flying past you down a four-lane street. The street is littered with
signage. There are more billboards than you can imagine—new signs mixed in with
older ones dating back to the 1950s. With all this around you, how does the media
landscape affect your work?

Greg:
In almost every project we do, we're thinking about some kind of a moving image
surface. You can't really think about architecture without thinking about it. Jacques
Herzog once said to me, "You know, we are exactly the same." I was surprised and I
told him I thought we were actually totally different—that I'm more interested in form
and space and he's more interested in material, image, and façade. But he said we
both understand that in architecture you need to compete with media. Architecture
has to be more like the experience of film if it's going to get people's attention. Other-
wise it's going to be experienced like a mass-produced house, where even though you
might live in it every day, you never really pay attention to it.

Doug:
So how do you make the architectural experience a conscious experience?

Greg:
Architecture needs to participate in the moment we live in. It needs to participate in
the pop culture of its time. If architecture can't connect with that, then it's just going
to be like any other dead field. And there are lots of them. There's so much stuff that
people don't even bother to notice anymore. So it's got to technically and creatively
engage with what's going on around us. You look at a film like Todd Haynes's *Safe*
(1995) and suddenly you're ashamed of every fluorescent light you've ever designed
because you've never really thought about fluorescence as a visual effect and as
a color. You see the movie, and you go, "Oh shit, there is somebody who actually
noticed this." Film's influence works on that level too.

Doug:
Nowadays the internet has also become a major player in how we experience the world
and new ideas. Surfing the internet is no big deal anymore. How do you assess how
these developments change the way one might engage with architecture?

Greg:

In a funny way, I think architecture is inherently connected to the internet. Both are based on spatial organization. So, what is the cause and effect? For me the question is, will people take the time to reconfigure their spaces if they've used the Web?

Doug:

Talking about interactive spatial environments makes me think of the 160-room Winchester Mystery House in San Jose, where for over thirty-eight years the owner kept adding rooms onto the house in a really arbitrary way. The structure became a rambling labyrinth with nearly a thousand doors and random stairs leading to the ceiling. It's the difference between building organically and following a pre-determined plan.

Greg:

True, although you still have to think about an overall system. Like in Saõ Paulo, a forty-story concrete building is built right next to a favela and then they build another building in another part of a favela. And the favelas just keep creeping along around the development. It's like the suburbs of Las Vegas, only favelas. What's wild is if you look at the urbanization process that goes along with this. All the roads, gas lines, and electric lines are actually determined by the favelas. Someone just builds a dirt road, then someone lays down a plumbing line along it, and eventually those become ad hoc official lines of development.

Doug:

What is one of the most interesting areas that architecture or design is crossing over into these days?

Greg:

You know, I'm really into all that's happened to toothbrushes.

Doug:

What's happened? Is there a toothbrush revolution going on?

Greg:

It's amazing! I went to the drugstore the other day to buy a toothbrush and there were about fifty feet of them. It was insane. There used to be only just like three kinds to choose from. Now every week, half of what's on display are new designs. One toothbrush looked like it had been designed with Auto-Cad; one like it was from the television show *Alias*; and another like someone had used the design software Form Z. Do toothbrush designers get together and have conferences? No, it's just random variety. Later, can you believe it, I saw a feature on software design and toothbrushes in *I.D.* magazine! I realized I had nailed it: the whole signature of these things wasn't coming from a designer but from their software. There's no discourse, it's just happening in a vacuum between designers and their software. For me, that's the same as if you were to make ten thousand mass-produced homes, each one a different design. As an artist or a designer, where is the signature in that? It's empty. There's no overall coherence. Under those conditions, how can something be read as a critically designed object rather than just another...toothbrush? That's not the world I want to live in.

Carsten Nicolai

Artist and musician Carsten Nicolai (b. 1965, Karl-Marx-Stadt, Germany) fuses sight and sound in minimal installations and sculptures. His work suggests the atmosphere of an alchemist's labora- tory where sound is converted into frequencies, pitches, pops, and pulses. Working outside the bounds of representation and art history, he often composes arrangements from the electronic sounds of mass communication such as telephones and faxes. Known in the music industry by the name alva noto, he originally studied landscape design before working with sound.

Doug:
I thought of you the other night. I was working in my studio and heard a haunting electronic sound emanating from some equipment. I unplugged everything, but the sound continued. It was the kind of sound that you can't stop hearing once you notice it. It made me think of your work and the way the sounds lodge themselves in your memory. How did you first start getting into art?

Carsten:
In high school we had to decide really early on what we wanted to study, but at fourteen I wasn't really sure what my interests were. I only had a notion that I was interested in nature, in drawings, and in design. In the former East Germany we had to use these certain books, and one day I was looking through them and I found something I'd never heard of before: landscape architecture. I knew right away that I wanted to study it. It was at about this same time that I first started thinking about art, but I was told that you could only study art if you were very old and experienced. Well, not being old or experienced, I didn't even touch the idea of studying it. I spent many years doing a lot of different things. The first time I felt like an artist was when I went to my tax office to get a tax number and they told me I was what we call in German a "free working artist."

Doug:
Did you start out making visual art or sonic art?

Carsten:
I started out in the visual arts. But I've always loved music and at some point I just got really fed up with visual things and wanted to take a step back. That's when I started working with sound. I became completely fascinated by it. It was really difficult at the time, though, to get computers and other equipment in East Germany. The technology just wasn't available. But after the fall of the Berlin Wall in the early 1990s, more things started becoming available. I was at the Technical University in Chemnitz at the time and I remember going through these dumpsters once to get the old test-tone equipment from Russia and Hungary that was being thrown away. I brought the equipment back to my studio and that's when I started building my own little setup.

THIS CONVERSATION TOOK PLACE IN VENICE, CALIFORNIA.

Doug:
What were you trying to do with sound that you felt you couldn't do with visual images? Was it about moving away from two-dimensionality?

Carsten:
Absolutely. I was much more interested in the kind of time that you find inside small narratives. It's something you don't have if you work with stable or frozen images like in painting or photography. Even though with sound you can't freeze moments entirely, my greatest desire is to try to arrest sounds that I want to make visual. And you have to deal with time to do this. This has always been a really important factor for me, along with the fact that sound is nonmaterial, nonphysical...literally untouchable. This I like a lot.

Doug:
Yeah, there's no such thing as a "sound still." You can't put sound on pause like you can film or video. You can only repeat it. As an art form, it's something really specific to the modern age.

Carsten:
It's this contradiction that's so interesting. I see myself as part of a totally fragmented world where all this information is just being carried around. But I believe that these sorts of fragments can also carry the main idea. Working with sound is an experiment with this kind of fragmentation. I think there is a certain feeling about this going on in a lot of places right now. There are people working in different cultural arenas all thinking about these questions.

Doug:
It sometimes feels like we work with these fragments because it's the raw material we're given.

Carsten:
But do you believe in a logic to it all?

Doug:
No, I don't really believe in an overall logic. I'm more inclined to believe in things occurring randomly and occasionally overlapping and synchronizing.

Carsten:
I do. I believe in an overall logic—that there's a reason why everything is the way it is. I find that when you believe in this, you have much more freedom to be radical.

Doug:
It's difficult for me to believe in any absolute truth or structure. I think we live in a very random world and that human consciousness tries to bring order to it. But I also think that we experience inexplicable, sublime moments that transcend definition. This brings us back to the idea that the linear narrative is one of the philosophical tools we use to identify patterns in what's around us.

Carsten:
But what is a linear narrative, really? A good narrative needs a gap. It is not the

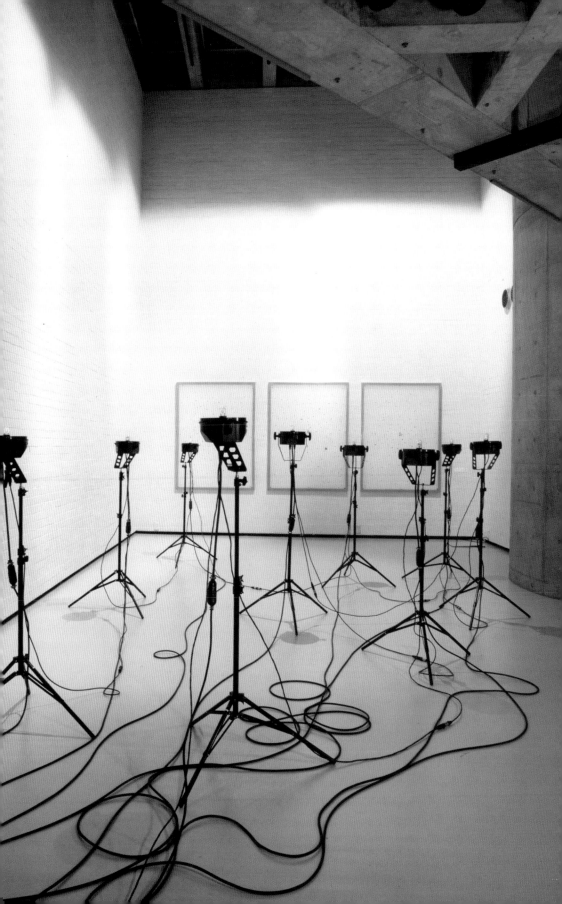

I SEE MYSELF AS PART OF A TOTALLY FRAGMENTED WORLD, BUT I BELIEVE FRAGMENTS CAN CARRY THE MAIN IDEA TOO

linearity that makes us think. It's the unexpected gap in between, like the silence between sounds. That's what makes it all really interesting. Sometimes when I talk about this stuff, I realize that I'm not talking about art so much anymore. It's really about philosophy, about identity, creativity. And the question for me is, why do we feel better when we do certain things than when we are not doing them? Why are there certain things we feel we have to do?

Doug:
So, Carsten, why do you do the things you do?

Carsten:
I make work to orientate myself in this mess. Maybe I'm scared and I'm trying to locate myself in a certain space. It's funny, you develop a kind of fury in the process. I think it's a model of how our life works. And I think that I am probably very afraid of this whole thing.

Doug:
Afraid of what whole thing?

Carsten:
Afraid of getting lost. Afraid of not existing, of not being here anymore. I mean, you can touch yourself and say, okay, I'm still here. One can discuss this as a physical question, but there's also the spirit. Maybe thought is something that can exist beyond life. Maybe this is the reason we try to manipulate time. This is what we would love to do, right? I always think about Andrei Tarkovsky's film *Solaris* (1972). There is this ocean, but the scientists have no idea if it is a living thing, a material, or a liquid. And every time they do research on it or observe it, it changes. And in the end they all go kind of crazy and end up just asking, who am I?

Doug:
I love that movie. I think that has to do with the sudden recognition that their world is a reflection of what's inside of them. It's a material manifestation of an internal investigation, which in a way is part of the motivation for making work. But it's also interesting to think about in terms of your work because your sound pieces are weightless soundscapes. They're about an intangible, invisible aesthetic.

Carsten:
This has been one of my goals over the last few years of working with sound: to be light. It's a funny situation to be in. When you are working with light, minimal things, you cannot isolate yourself from your surroundings. Space and time become such important issues. I see art as research, and you need certain elements to make it happen.

Doug:
You make visual art, sonic art installations, and music...which might mean a night on the DJ stand. Do you sample?

Carsten:
I don't do much sampling. I still believe in the old-school idea that I can create new things. For me, I work more with silence than with sounds. When working with editing programs, if you want the sound of nothing, you have to add it. This is quite different from sampling or even using sequences from work you may have done years ago. The actual sample is not that important. It is more about the spaces in between, and you have to create and define exactly what that space is. Silence is a very clear decision.

Doug:
Do you see the structure of architecture as similar to that of music?

Carsten:
Yes, definitely. I build songs like architecture. I build layers. I build grids. It's like being Pier Luigi Nervi or something, where you have to have very strong ideas about proportion in order to put things together.

Doug:
Do you see your works as being formalist then?

Carsten:
No, not at all, because there are strong ideas about fragmentation behind them.

I've started becoming really interested in random notational language and in sounds that are so short, you don't realize what they are about. It's similar to when you see just one frame from a film. You don't know what it's from exactly. For me, it's about looking at the kind of information these short sounds can still carry.

Doug:
Even though snow noise *(2001) is not a sound piece, you seem to be working with the idea of making repetitive frequencies visible in the way the contraption literally grows snowflakes. It's a very quiet piece. It's like making the frequencies of a whisper visible. In sound design programs now, you can literally sculpt the sound on visual graphs. Sometimes those visual patterns are even more interesting than the music that's making them. It seems to have really changed how we work with sound. The act of seeing is part of composing now.*

Carsten:
Yes, over the last ten years, sounds have become much more graphic oriented and I think you can really hear this. Now that everyone's cutting and editing sound waves on computer screens by sight more than by sound, I think a new relationship to sound is evolving. For the first time, you can really freeze music, study it, and readjust it on a visual plane. You can work with sound now in three ways: on an audio level, an audio-visual level, or a purely visual level by muting the sound and just working with the graphs. It's really not just sound anymore. And we don't trust our ears quite as much anymore. We have this belief now that if we can see it, it's more real.

Doug:
What do you think about the degree of visual and aural stimuli that we take in on a daily basis? Sometimes it feels like it just keeps accelerating, and in response we have to develop new ways to think, to process memory, to relate to others.

Carsten:
This is the question, isn't it? How fast can it go? I think as humans we are limited in our perception. You can see this in advertisements. They know at what moment you are overstimulated and can be taken in the wrong direction. They know it's a spell.

Doug:
How do you deal with it?

Carsten:
I try to isolate the problem first. I try to see what I am interested in and then I try to cut away everything that disturbs me. But maybe being an artist means you are a filter. Maybe you just filtrate things like filter paper, taking the essential fragments out. It's about editing perception. It's like when you arrive in a big city in the middle of the night and you're driving and you see these huge billboards with nothing on them. They are just white rectangles. It is fantastic. I love this so much. We live in a time where these blank billboards make a bigger impact on us then advertisements. We react. But being a filter for these kinds of things is becoming more and more important. We have to be very good filters now just to survive.

Richard Prince

Artist Richard Prince (b. 1949, Panama Canal Zone) began rephotographing advertising images in the late 1970s. In treating these images as found objects and photographing them without their text or logos, he shifts our reading of the photograph from its subject to its truth-value. He digs his heels deep into the flat surface of pop culture, questions its authorship, and shows its images to be flexible and devoid of meaning. While his work reminds us that the commercial landscape is constructed, they also remind us that our experience of it is nevertheless real.

Doug:
It's hot out and the sunlight is flat. We're sitting here in the Beverly Hills Hotel watching people walk by who look like they're straight out of Paul Schrader's American Gigolo (1980). *To me your photographs are like frozen moments from film. They look like stills pulled from fictional narratives. By appropriating images from pop culture, your work seems to put the original sources on pause. How did you first get interested in appropriating images?*

Richard:
I had been working at a nightclub and a friend recommended me for this job at Time-Life's employee bookstore. I was lucky because it was just the boss and me, and he would always take these huge long lunches. While he was gone, I'd go down to the company storeroom where nobody ever went. I'd find some magazines, experiment with putting four together on a table, and take pictures of it. My art supplies were the magazines. After that, I got this job at a place called Tear Sheets, which was great. My job was to rip up magazines page-by-page and give the hard copies to the people who wrote the articles. At the end of a day of cutting, all that was left were advertising images. That's how it all happened. My subject matter became what I was working with eight hours a day. It was about taking advantage of the situation. It was using what was given to me rather than making it up.

Doug:
What was going on in the art scene at the time?

Richard:
To me, John Gibson's was the most happening gallery. Vito Acconci and Dennis Oppenheim showed there. Those two have since become very well known, but there was also this whole other narrative art thing going on at the gallery. It was a mini-movement with guys like Peter Hutchinson, Bill Beckley, and James Collins all working with photography as non-photographers. Have you ever heard of any of these guys? It's amazing to me that nobody has, yet at the time in the mid-1970s, they were all over the place. They would make pieces using photography and text mounted onto matte board, and Gibson would take them to Europe to sell. So I began fooling around a little bit with photographs and text, but the text part never worked out. The idea of making a pure photograph appealed to me more.

THIS CONVERSATION TOOK PLACE IN BEVERLY HILLS, CALIFORNIA.

Doug:
It seems like you ultimately achieved something similar to narrative art but without using text. If we think of pop culture as a stream of accelerated media images, it's as if you're taking some of this visual white noise, isolating it, and amplifying its parts. And by doing that, it becomes your own.

Richard:
I always thought that advertising images had a life of their own to begin with. When I was ripping up magazines at Tear Sheets, there weren't any authors calling me up at the end of the day for their advertisements. Week after week, whole new campaigns would come out and I had this fantasy that they were all mine. It was like beach-combing: you could claim anything you found and it was free. The advertisements were all really art-directed and manipulated and saturated, but each month you could

see the colors changing as the technology got better. All of a sudden you'd get a magazine and it would be like, "Wow!" The colors were like sunsets. That's when I started noticing how many sunsets were used in ads actually. I never cared why they were there, I would just notice them. So I'd take all these images and make a body of work called *Sunsets*.

Doug:
Some people use the camera to capture what's going on around them. For you, was rephotographing the ads a way to personalize them and make them part of you?

Richard:
Well, when you tear an image out of a magazine, that's the start of a collage. But for me, taking a photo of it was even better. A photograph has all the ingredients of believability, yet it's still an object. By photographing the image, I turned it back into the original object it was before it went to press. I use glossy paper, so the plastic coating somehow trapped the image inside it, but in a seamless way. My aim was to present the images rephotographed, matted, and framed in a traditional way, like real photographs. I wanted to normalize them. Not only did they look like real photographs, they were real photographs. They were just photographs of photographs. There was no need to get nutty with them. I didn't need fireworks. I always liked the way that Rod Sterling presented *The Twilight Zone* in a black suit and tie. Very normal, and

GOING TO THE MOVIES WAS **ALWAYS** IMPORTANT TO ME. I LIKED GOING ALONE. IT WAS A WAY OF ESCAPING FOR A FEW HOURS, AND I ALWAYS HAD MY BEST **IDEAS** WHEN I WENT THERE.

the normality gave the science fiction a believability and sucked you into the narrative. That show was really inspirational to me. At first nobody knew what my photographs were. They had a strange reaction to them. To this day I still have people asking me where I went to photograph the cowboys. It's kind of bizarre.

Doug:
It's as if you were treating the photograph as a photocopy of the world around you. Once you started honing in on the subjects you were interested in, what led you to make editions of just two prints?

Richard:
This was deliberate. It was a reaction against all the open-ended editions that older, so-called "real" photographers were making then. I wanted to really limit it, and making two was a great way to have the photograph be both an object and a reproduction. It wasn't about selling or marketing them then because nobody bought them.

Doug:
Your book Spiritual America *(1989) seems to be a random compilation of images. It jumps and skips from your joke paintings to photographs of your studio to the cover of a Trix cereal box. It's like a collage film in book form.*

Richard:
I think *Spiritual America* was maybe the first attempt to do that. It is a way to cannibalize the images. The idea of jumping around in my work—putting a joke painting next to a photograph—took years. It's similar to what I did in my show *Women* (2004). Putting the images in book form was a way to get them into the hands of an audience that might not normally see them—of someone who might glance at it for ten minutes one day and maybe pick it up five years later. It is a physical object that will not change. You can't put it into storage or rehang it.

Doug:
Do you remember the first time you saw a music video?

Richard:
I used to live with this girl in New York, Paula Grief. She did a video of The Smiths song "How Soon is Now" for MTV and when she showed it to me, I was shocked. She'd never met the band, she'd just taken footage that the manager had sent her, reshot some of the color film in black and white, and collaged and spliced it all together. She took what I had done with still photographs and did it with the moving image. I thought it was fantastic.

Doug:
You were both creating new artificial worlds from artificial content. Were you very aware of music videos before then?

Richard:
Oh yeah, because of her. She had the first big screen cable TV I had seen in a private apartment, along with a Betamax machine and a VCR. And the very first video store in New York, The World of Video, opened up in her building. I died and went to heaven! Everything was there. She also had a lot of connections in the music industry.

I never had a penny to my name, so I changed my name.

Black Bra
Friend? Terrorist
Freind Friend?
Friend? Friend?
I'm sorry I let him do it.
I'm sorry I made her do it.
I'm sorry I did it.

Nancy to her girlfriend: "He said he was interested in humiliation, so I stood him up."

I never had a penny to my name, so I changed my name.

Black Bra
Friend? Terrorist
Freind Friend?
Friend? Friend?
I'm sorry I let him do it.
I'm sorry I made her do it.
I'm sorry I did it.

"Like a Virgin" was shot in my bed. I came home one day and Madonna was in my bed. Steven Meisel was there too taking her picture for the cover of the video and I got to edit it later that day. Living there that year was a lot of fun. Paula had friends in the art world too. She was friends with Basquiat and had a big Basquiat painting hanging in the living room—which I immediately told her to take down because I didn't understand it then.

Doug:

This period in New York was right after Warhol's influence subsided and right before use of the moving image exploded in pop culture. The onslaught of VCRs, music videos, and video games was just beginning. In your book Why I Go to the Movies Alone *(1983), the short stories are transparent and textural, and the characters seem to thrive on surface. You seem to be describing a new generation of voyeurs that can no longer be shocked. As part of this generation, how important was film to you?*

Richard:

Going to the movies was always important to me. I liked going alone. It was a way to escape for a few hours. I always had my best ideas there, especially in the afternoons. It was like giving yourself up right in the middle of the day when you should be working. I never considered it goofing off, though, but I guess some people would think it was a big waste of time. I like that idea actually. What's interesting to me is the physical transformation that happens to you when you watch a movie. Christian Metz has described it as a general lowering of wakefulness. I agree with that, especially if it's a successful movie. But cinema has been an influence on me not so much in terms of making sequential images, for example, but in making a piece effective, like when I realized putting four, six, or nine similar images together would work. That could be called cinematic. And with film, the narrative is always about the person who wrote it, and I feel that's the same with me. About the time I wrote *Why I Go to the Movies Alone*, the VCR was invented. Then that title really became true for me. I really could go to the movies alone by watching them at home by myself. I could be the distributor, the projectionist, and the on/off button.

Doug:

Owning a VCR meant you suddenly had a device of nonlinearity at your fingertips. You could rewind, fast-forward, and pause the narrative, essentially breaking the time signature of the film. Do you feel there's been a shift in the way we read film narratives because of that?

Richard:

I think for most people, dealing with all these different media is very frustrating and complicated. Like with the Web, you spend twenty minutes trying to get connected and you still can't get online for some reason. In general with this stuff, it's not like there's just one person telling the story anymore. The idea of just one author seems really old. What's interesting is that in the art world now, you have people going back to the artist, going back to the singular loner and the easel in reaction to all of this other type of media activity. The romantic author has become appealing to people again. But that will change, you know.

Pipilotti Rist

In her video works and installations Pipilotti Rist (b. 1962, Rheintal, Switzerland) wrestles with the formal properties of video, purposefully emphasizing its pixels, colors, and visual texture. Drawing on the traditions of performance and self-portraiture, she creates shape-shifting psychological dreamscapes in which she often plays the protagonist. By manipulating both the medium and the camerawork, she treats video like a soft, three-dimensional material that can be pushed, pulled, telescoped, and collaged in ways that best befit the subject matter.

Pipilotti:
Hello colleague.

Doug:
Hello secret agent.

Pipilotti:
City of Zurich reporting to colleague in Venice, California. Hey, is everyone using flat screen televisions over there these days?

Doug:
Quite a bit...how are people in Zurich getting along in the television world?

Pipilotti:
People here haven't switched to flat screen TVs and home projectors yet like Americans have. They're still using those boxlike things from the 1950s and 60s.

Doug:
It seems you've always resisted making work within the restrictions of a "box." I like how you approach the moving image in a very restless way. You can see this in how you sometimes fight or provoke the frame. I'm thinking of Open My Glade (Flatten) *from 2000, where you press your face and body against a sheet of glass that you've put in front of the camera so it looks like you're pressing against the video screen. Are you intentionally trying to break out of the frame in defiance of formalism?*

Pipilotti:
It's part of trying to keep the moving image from being reduced to the flat square of the screen. Whether the viewer reads the screen as a two- or three-dimensional object is only a question of his or her awareness. Both CRT and LCD television screens have a third dimension: the CRT's glass screen and the LCD's liquid crystals. It's easy to ignore their physicality because we're so fascinated by watching the images move across the screen.

Doug:
I often get the feeling when I watch your videos that the images are metaphorically exploding the screen and that the picture plane is disintegrating.

Pipilotti:
I try to explode the screen by using either a lot of little screens in conjunction with

THIS CONVERSATION TOOK PLACE BETWEEN ZURICH, SWITZERLAND, AND VENICE, CALIFORNIA.

sound boxes, or I sometimes just project images with sound. I want to reconquer the space in and around the viewer that we forget about when we're watching a two-dimensional computer, television, or cinema screen.

Doug:
It's as if you're bringing moving images into physical space, making them come to life. How much do you consider the way the content will interact with the space it will be shown in?

Pipilotti:
I conceive of my installations like architectural miniatures. I like the idea of being able to walk around plans and models. I try to configure the viewing rooms in a way so people can decide when they want to go into the installation and when they want to come out again. I like that you have to think about how you want the viewers to approach each work. But at the moment, I'm actually trying to take a step away from architecture in my work.

Doug:
How are you stepping away from it?

Pipilotti:
I'm concentrating mainly on the videos' content. The first things that come to me when I make a work are the image and the sound. Only then do I think about how I want it to be seen.

Doug:
The video's distorted pixels and color lines are visible in your work. The images seem to inhabit a world of electricity where colors switch and shift and video feedback cuts across the screen, like in Firework Television Lipsticky *(1994/2000). These distortions pull the viewer in, while at the same time the image seems to push itself outward, disrupting the way we typically experience a moving image. It's reminiscent of the work of experimental filmmakers like Stan Brakhage and others. But your medium is video rather than film. Can you talk about your preference for video over film?*

Pipilotti:
These qualities that you describe are what make video different from film, but they are also video's limitations and I try to work with these. I use video because I'm not interested in creating images that are more pictorial and sharper than reality, something that film often does. Video has its own beauty, even if it suffers from problems like super poor resolution, which is its major disadvantage. But its problems bring with them other unique qualities, like the way the light shifts or the way colors build up. I try to bring these qualities together in what I want to show about movement. I actually think the nervous quality of video is very beautiful. It lets me feel very calm in contrast.

Doug:
Your work has a three-dimensional quality to me.

Pipilotti:
I try to work like an applied artist—applying video to three dimensions.

Doug:
It seems like you try to challenge the flatness of the screen not only by manipulating video's pixels and colors, but also by introducing unpredictable moments. This creates an interesting progression from passivity to sudden agitation where the image lurches toward the viewer. It's as if the moving image gains an electrical physicality.

Pipilotti:
For me, video is less a tool for recording external reality than a way to show psychological and physiological inner worlds—like finding symbolic colors and speeds for different states of mind, or creating images that look like those graphic formations called after-images that you see when you close your eyes. The technology has been invented by human beings and it mirrors us back to ourselves.

Doug:
It's as if you're taking the camera inside the electricity of the moving image in order to hunt for stories and worlds, like in Pimple Porno *(1992), where bursts of electricity seem to leech out of the screen. What is the relationship for you between real experience and the kind of electrical experiences you create in your work?*

Pipilotti:
I think pure electrical experience happens only when you lie down, close your eyes, and come to terms with the billions of electrical impulses that our feelings and thoughts are made of. This is when, in your imagination, you experience the melting together of images you extract from reality and the electrical pictures you see in your mind's eye. Electrical experience on a monitor is something quite different. You will always have the unelectrified space around you.

Doug:
There's a mental editing too that goes on in the process—the way the mind edits the

inner and outer experiences of daily life. After you started editing video, did you begin to see the world differently?

Pipilotti:
Yeah, it has sharpened my perception. I'm able to talk to somebody now, or watch something, and simultaneously concentrate on the sounds coming from behind me. Another thing is that in editing you become very clear about what you want, whether it's three seconds of this or twenty seconds of that. But editing takes months. The challenge is that you have to keep watching and listening to your work as if it were the first time you've ever encountered it. You always have to be conscious of how the viewer will experience your work for the first time. And it's this moment that you manipulate.

Doug:
Can you describe this process of manipulation?

Pipilotti:
I don't mean manipulation in a negative way, although it is something that can always be abused. I only want to be as precise as possible in my work, not pushy.

Doug:
Do you conceive of the exhibition space as a way of editing the viewer's experience, or do you concentrate primarily on the moving image?

Pipilotti:
There are many different ways to edit the moving image. First of all, designing the installation itself gives you many options to work with. And in the final design, I like giving the viewer a few possibilities to choose from. When I go see other art, I want to experience the rhythm of the artist. I want to feel how long they want you to be in

front of their work. I want to be sucked in. I want to be guided by them. But in the end, each viewer decides how long he or she wants to be there. That's why I like museums. People choose to go there. They go there because they want to be manipulated.

Doug:
Does the museum offer an adequate platform to show experimental work with the moving image?

Pipilotti:
If you want to do something that has a beginning and an end, it needs a good room. It doesn't matter if it is in a museum, in a cinema, or a studio. Recent art history could have developed very differently in this way. What would have happened if in the 1960s video art had become part of cinema rather than fine art? Imagine going to the cinema today and seeing little screening rooms for video installations where you could watch videos before or after the movies. What if in every cinema, there were rotating video installations?

Doug:
That would be amazing. Sometimes I have the feeling that I have rotating installations going on in my head! When I dream, I feel like I'm continuously editing and reediting.

Pipilotti:
Yes, when I dream, I feel like I see much better than I actually do in real life. I'm very shortsighted normally, but in my dreams—even though I'm usually flying in them—I always see in sharp focus, like in film.

Doug:
It's always hard for me to gauge how long I've been sleeping when I wake up from a dream. The dream always seems to have compressed or expanded itself to be just the right length. With film, though, we instinctively know when it's too long. Making concentrated short pieces, do you find yourself restless when you see a two-hour movie?

Pipilotti:
I always think films are too short. They should be longer!

Doug:
When you're watching a movie, do you ever think about the physical experience of being part of the audience? Do you ever feel too safe?

Pipilotti:
I think there's a ritual that takes place between the audience members. Everyone's looking and concentrating in one direction and it creates this energy in the room. That said, in my own work I try to get away from the ritual that evolves out of watching moving images. I do, though, like the feeling of this collective concentration on a single screen in a movie theater. It creates a miraculous energy in the room.

Doug:
An energy from the collective act of watching?

Pipilotti:
Yes. It's really like a dance in silence, you know. People watching the screen all together is like a communal dance.

I TRY TO
EXPLODE
THE SCREEN.
I WANT TO
RECONQUER
THE SPACE
IN AND AROUND
THE VIEWER.

Ugo Rondinone

Artist Ugo Rondinone (b. 1963, Brunnen, Switzerland) works with numerous mediums, including video, sound, sculpture, photography, drawing, and painting. His diverse visual vocabulary subverts the possibility of a singular, unifying interpretation of his work. By presenting various methods of storytelling, he challenges the assumption that adhering to one style reflects consistency and coherence. In this conversation he talks about his nonlinear approach to selecting a medium and how this concurs with his life philosophy.

Doug:
Ugo, your work strikes me as stylistically restless. In each project you use different techniques and mediums. What do these different styles mean to you?

Ugo:
People have criticized me for not having a clear style—as if there are things in life that don't have contradictions. I have wanted to give myself as much ground as possible and as many different viewpoints as possible, but I don't force myself to come up with new forms. Using formal and material contradictions is about broadening how you perceive the work. Of course, there are similarities that run between my works, like the recurrence of certain subjects, but I hope that they can refuse to be weighed down by their own self-resemblance.

Doug:
How do these contradictions manifest themselves in your work?

Ugo:
As soon as I set something in place, I like to contradict it. It's an opportunity to set your own rules. Getting up in the morning and doing the same thing day after day just doesn't work for me. Working with different forms and materials is more liberating. Every medium has a specific energy and that's the starting point. The medium is just a tool, and its aesthetic is an open field. Sometimes I make landscapes, sometimes I make rainbows, sometimes windows, sometimes labyrinths, sometimes blurred paintings, sometimes broken mirrors, sometimes rubber masks, sometimes walks in a circle. It feels satisfying to be working on different formal fronts, but I'm not trying to make a point of it. I'm not engaged in a formalistic practice of using different styles for their own sake.

Doug:
How does a work begin for you? Do you find fragments of ideas that you then put together, or do you follow one idea to the end?

Ugo:
I don't know where the work will lead me when I begin. Each work is an entity of interrelated parts with an ambivalent dialogue running between them that implies ruptures and detachments. I would like to play the game without the security or comfort of an omniscient origin.

THIS CONVERSATION TOOK PLACE IN NEW YORK CITY.

It's as if you present snapshots of memory and time. I'm thinking specifically of your multiple-screen piece ROUNDELAY (2003) you showed at the Centre Georges Pompidou. Can you tell me about the ideas behind it?

Ugo:
There's no story line in that piece, it's more about giving multiple perspectives. I set it up as a two-part installation with an outside and an inside. The outside consisted of eight dilapidated walls, and on the inside the walls were covered with felt and burlap. You walk in and you see images of a day in the life of a man and woman on six screens. What's important to me in video installations is that the viewer is never directed by the space but remains autonomous. With a video installation, you can go in for a second, get the whole picture, and go out again. You can place yourself differently within the space as you walk through it. It's more like a dance than an inevitability. It's about using all your senses rather than only perceiving the moving image intellectually. An installation has a personal connection and its meaning is informed by this fact. It's an environment for the individual; there is a spiritual moment that it can give the viewer.

Doug:
To me your work is like an explosion of questions, all moving outward in different directions. Can you tell me a little bit about how you approach storytelling?

Ugo:
In *Three Dialogues with Georges Duthuit* (1949), Samuel Beckett objects to the notion that the artists Pierre Tal-Coat and Henri Matisse should be called revolutionary. He feels that they only managed to disturb a "certain order on the plane of the feasible." When he is asked to elaborate on what other planes there could be, he answers, "Logically none. Yet I speak of an art turning from it in disgust, weary of its puny exploits, weary of pretending to be able, ...of doing a little better the same old thing, of going a little further along a dreary road." Asked what art should be then, Beckett asserts that it should be "the expression that there is nothing to express, nothing with which to express, nothing from which to express, no power to express, no desire to express, together with the obligation to express." So then how do I explain my approach to narrative and storytelling? I don't know. And why don't I know? Because to me every work is grounded in nothingness. Nothing is not something to be explained and understood. It negates understanding and comprehensibility. So I'm locked in a vicious circle, constructing useless explanations for this paradoxical nothing that constitutes the poetry of my work. In other words, here we are and our lives have no essential purpose.

Doug:
It's sometimes hard to use language to talk about artwork. How do you cope with that?

Ugo:
Perhaps we can take comfort in the fact that there is no end to the game of words. The irony is that to speak is to exist, but in order to speak one must adopt a system

language to prove our existence, yet it's an inadequate system for ascertaining any type of abstract truth. Language is slippery. We use concepts to explain other concepts, so the lack of referents means not only a lack of meaning in language itself, but in life. Language gives us an excess of meaning while simultaneously ensuring a lack of meaning because it is always already overdetermined. Nevertheless, we still have the desire to prove our existence and make sense of the world.

Doug:
Can we express different things through art than through language?

Ugo:
Every language sets up a reductive model of human events, and within this model our motivations are represented as logical, predicable, and comprehensible, when in fact they are ultimately obscure and uncertain. Art creates a world that can contain a range of things simultaneously, from the plausible to the impossible. Art places importance on symbols and analogies; it doesn't rely on a closed, hermeneutic linguistic system. At its best, art is a screen against emptiness. Art gives you a spiritual value for yourself. It's something that can make you grow. My real concern is that we don't have a sufficient language to describe contemporary art. It has not developed on a par with the visual. The language we use is still deeply ordered.

Doug:
Is it that you think the visual landscape of modern society has surpassed the written word?

Ugo:
To me, language is headed down a dead end. Why do you think we can't evaluate what's happened in art over the last twenty years? No one has been able to evaluate what's going on. We have huge amounts of information on art, but it doesn't mean we're able to evaluate it. We just don't have the language for it. I think we need another twenty years to understand what's going on in art today.

Doug:
If you had to venture a characterization of the differences between art twenty years ago and art today, what would it be?

Ugo:
Art today is about including rather than excluding. It's about contradictions—about the balance between hot and cold. Critics should evaluate it by looking at how this energy comes out in the work. They should account for these contradictions.

Doug:
What does it take to be good at looking at art?

Ugo:
If you want to be good at looking at art, you have to charge yourself with knowing the whole history of it. That's the only way you can develop a sense for a work.

Doug:
And being good at making art?

LANGUAGE IS HEADED DOWN A DEAD END

Ugo:
If you want to be good at making art, I think an artist has to go further and know each medium's own history. You carry another kind of weight on your shoulders when you make art.

Doug:
Looking back on your career, how would you describe your diverse bodies of work?

Ugo:
Do I have different bodies of work? I think I just have different ways of approaching the same story of nothingness. Taken as a whole, my works are allergic to the idea of wholeness. I would like to make work that's composed of parts that resist gathering themselves into one substance. They each break free from what has come before them, and they resist solidifying into a whole after they're made. They do not come to rest. The works' narratives change when placed in different settings. Change the setting and you change the meaning and visual impact. Just as a human body moves between many different experiences of space, it is nevertheless always oriented to one ground.

Doug:
How would you define your working method?

Ugo:
My work is not driven by ideas, but by pulses and rhythms. The work's progress should flow like a musical score, at times bizarre and ridiculous, and at other times just as easily normal and calm. If one of my exhibitions is black and white, the next one will be color. These contradictions continue in the choice of material, medium, and form. For me, it's more like the last lines of Beckett's *The Unnamable* (1953): "...where I am, I don't know, I'll never know, in the silence you don't know, you must

go on, I can't go on, I'll go on." I like to try to approach a zero state where action and inaction become the same thing—like the nameless protagonist in Kobo Abe's novel *The Box Man* (1974) who gives up the trappings of a normal life to walk the streets with a cardboard box over his head. On the interior walls of the box, he describes the world outside as he sees it through the two holes he's cut out of the box for his eyes. And more importantly, he can look out, but can never be looked at.

Doug:

In a similar way your work seems to question the act of looking and perceiving. Yet I'd have to say you differ from Abe's protagonist in that your work, to me, isn't about passive observation and documentation. Rather, it allows the viewer to explore new worlds. In a piece like GRAND CENTRAL STATION (1999), where you hung speakers from trees wrapped in electrical tape, you make the viewer work to come up with his or her own story of what's going on. You can only be but so detached when looking at it. They keep you conscious and awake.

Ugo:

Abe's story is about a great refusal. The box man rejects society and retires from the world. He's a social dropout and takes refuge inside the box. He isolates and cocoons himself there and creates a world for himself. He is at home within himself in his box. I see a similarity there between the box man and myself. One advantage of being an artist is that you can be alone in your box with only your thoughts and pos-sibilities. The place that is like this for me is my home, where I have my studio. It is a site of trust for me, a site for orienting myself to meaning and place. In the studio my thoughts and my life are held in a sort of murky, gelatinous stasis—in an experience of slowness. Slowness doesn't make demands of me, unlike speed, which is inflam-matory. Slowness doesn't pull me into its own notion of time, like speed does. But we often mistake the experience of slowness for something negative. If only things could go more quickly, we say. But slowness is not a negative thing. If I create new worlds for the viewer at all, they are for the purpose of recreating this slowness, of delivering an impulse to slow down, to linger, to delay.

Ed Ruscha

In paintings, drawings, and photographs, Los Angeles-based artist Ed Ruscha (b. 1937, Omaha, Nebraska) creates new narratives from familiar landscapes, commercial signs, and words. Trained in painting and graphic design and inspired by Pop Art, he isolates logos, symbols, and icons from their contexts. His deadpan straightforwardness levels the hierarchies in meaning, an effect also found in the nonlinear style of his early films. His work conveys the sense that it is not language at stake, but the meanings we have assigned to it.

Doug:
You're from the Midwest originally. What made you come to California?

Ed:
I grew up in Oklahoma City. It went dry for me about the time you have to get serious and do something—take a direction in your life that is a little bit different than what you're used to. I knew I wanted to go to art school and didn't like the East Coast. I knew New York from movie images and I had traveled to California. I thought, maybe California is the place to go. That started it for me. Then I came out here and started art school.

Doug:
So you already had a vision of Los Angeles and Hollywood before you came that you'd adapted from cinema?

Ed:
From the cinema and visiting on road trips.

Doug:
When did you move to Los Angeles?

Ed:
I came here in 1956. I remember meeting an old man who said, "God, this place used to be a paradise in 1942." I'll never forget that. I knew exactly what he meant.

Doug:
So it was in the 1970s that you started making films.

Ed:
I made two. One is called *Premium* (1969–70) and the other is called *Miracle* (1975). They are half-hour movies. Hardly scripted but there is dialogue. I kinda lucked out with a ragtag crew of six or seven people from UCLA. I was able to use a lot of their equipment. In 1969 I got this Guggenheim Fellowship and I wanted to make something out of it, so I made the film *Premium*. I made it in three days and it cost $13,000, which was exactly what I got from the Guggenheim. Several years later I made *Miracle* for $25,000—that would probably cost $250,000 today.

THIS CONVERSATION TOOK PLACE IN SANTA MONICA, CALIFORNIA.

on Fire *(1965–68) and the one of the 20th Century Fox sign,* Large Trademark with Eight Spotlights *(1962). In a very subtle and sly way there are aggressive marks that come off the canvas and out at the viewer, like the fire in one and the zoomed-in logo in the other. They don't feel passive at all. Were these paintings reactions to ideas or were you consciously thinking of ways to break the picture plane?*

Ed:
I was thinking like an abstract artist. Both of those pictures have a lower-right-hand to upper-left-hand thing. Many movies have that issue, like a transitional shot of some-body traveling on a train followed by a shot of a train coming from out of nowhere in the lower right-hand corner that pretty soon fills up the frame. That little piece of film, which doesn't really tell us anything except "train going by," shows us someone travel-ing in the scene. But that idea always leapt out at me. I have been responding to that and admiring that idea for many years. It probably still affects me. The *Los Angeles County Museum of Art on Fire* painting is sort of like the same thing, just like a piece of tabletop sculpture. A lot of my paintings have that aerial oblique view. It is just one of those simple things. That to me is dependent on abstract art. Even though my work is figurative, I still feel like I learned it all from abstract art. I have pretty much been doing the same thing since I was eighteen years old. I view the world the same. I have taken little side trips with other forms of art, but I have always come back to these initial things that got me going. Maybe it is because I painted signs and worked for a printer and learned how to set type.

Doug:
You were part of the first generation of artists who had access to tools of mass communication and mass marketing like graphic design and advertising. You had all these new tools at your fingertips with an art-making sensibility. It is very different now. Those things are taken for granted.

Ed:
They really are. Did you go to art school?

Doug:
I went to Art Center for a little bit. I studied illustration initially. Like you, something other than fine art.

Ed:
I finally went into fine art in school, but I took advertising courses and design courses also.

Doug:
It was the same for me. I was fascinated by everything that related to communication, but I didn't want to pigeonhole myself.

Ed:
Art Center was the premier school in L.A. That's where I intended to go, but when I got here, the quota was filled. That's how I ended up at the Chouinard School of Art. At that time, they had a dress code at Art Center. There were things you couldn't wear. Like you couldn't wear a beret or have facial hair. So I ended up at Chouinard, which was actually a blessing because I got to mix with some good people who shaped me. My dad was really skeptical about me going to art school until he read an article about Disney supporting Chouinard artists. When we were in art school it was all didactic—then someone would come along and make some clumsy painting of a spark plug, and we'd just wake up and say, "Wow, a spark plug. Let's see more spark plugs."

Doug:
Exactly.

Ed:
Maybe it was the dumbness, or the shock of it, or the tabooness of it. You were not really supposed to paint spark plugs. People are so much more aware of these things blending together than they were forty years ago. At one time there was easel painting and that's what you did. You had to pick a subject or you could paint abstractly if you wanted to, but only as long as you didn't bring popular culture into it. I just felt like bringing popular culture into it.

Doug:
What was your motivation to bring popular culture into it?

Ed:
Probably seeing the possibilities of it and seeing the beauty of it. Not that an artist has to grow up to be naughty, but you want to do something that not everyone else is doing.

Doug:
Was your first book also your first exhibited artwork?

Ed:
My first book, *Twentysix Gasoline Stations* (1963), came out at the same time that I was doing paintings. I had my first exhibit of paintings in 1963 over at Ferus Gallery on La Cienega. I was making those books at the same time I was making paintings. And wrestling with it. What exactly am I doing? If you want to do it, keep doing it, keep asking yourself: "Why am I doing it?"

Doug:
Where did the books come from? Were they an extension of painting and photo-graphy, or did they come out of a restlessness with books?

Ed:
It was a reckoning with the things of books—pages, print, typography, and even photo-graphs—coming to you in the form of information. I even got to the point where I would paint the sides of the canvas. I would paint the words on the sides like the spine of a book. I could have argued the point that I was a sculptor. I just sculpted things that were an inch and a half wide. People would say, "Do you qualify to be a sculptor?"

Doug:
It's like saying, what ghetto would you like to put yourself in?

Ed:
I am a two-dimensional artist. But I had fantasies.

Doug:
Of all of your books, Royal Road Test *(1967) and* Hard Light *(1978) with Lawrence Weiner seem the most filmlike. They're suggestive to me of cinematic narratives.*

Ed:
I think so. The word narrative is a broad term though. I'm not sure I would apply it to it, but there is a kick start to something that makes you think. As I recall doing that collaboration, the idea was to keep it as free-flowing, as unserious as possible. Collaborations have always had the lightest attitude. You would think that it would call for serious planning—not at all.

Doug:
Hard Light *feels like stills from some kind of imaginary movie. It feels like there is something going on that is dramatic, which, when I saw it for the first time, was something I hadn't seen in your work before—the character interplay, the lighting, the transitions.*

Ed:
I know. It was not part of my usual approach, and neither were my films. I appreciated this Hollywood way of keeping the fluidity of movement, like if someone walks through a door, you match the action. I really admire those people for what they do, but I think it's not crazy enough.

Doug:
The books are interesting in how they suggest a story out of the most banal scenes. The images act like mirrors in the extremely simple way they isolate these spaces and hold them up to the viewer. They somehow reflect the viewer's own associations with passing moments that he or she might have had in similar places.

Ed:
You're speaking of seeing them having grown up as a city boy here in L.A.?

Doug:
Yeah. To me your books, through their coolness, offer up different stories to each viewer. What's going on between the characters isn't very clear, so the viewer has to project his or her own understanding of what's going on. It's like you are offering up an empty screen with a couple of triggers on it.

Ed:
Or suggestions—things that suggest you along. I was thinking of myself as coming from more of a rural environment to a place like L.A., which is an accelerated culture. Coming out here, I see the possibility and potential in living in a place like this.

Doug:
These books make me think of some of your paintings from the 1980s. The silhouette

of a ship at sea in Homeward Bound *(1986) or the image of a Hollywood Hills house at night in* Fistful of Aliens *(1986). To me, they're like film stills or frame grabs from incomplete stories.*

Ed:
It's information age art. I'm not a seafaring guy. My reason for doing that is to capture the idea of the thing rather than the thing itself. Lately, I've painted pictures of mountains. Some people like to think that I set up a canvas outside in front of a mountain and paint that picture to try to capture that particular mountain, but I'm really not. I'm trying to capture the idea of the idea of the idea of the mountain.

Doug:
Do you find that's also true of words? Do you see words as shapes and forms, or are you trying to distill meaning from them?

Ed:
I'm not too strict with myself about messing with words. I try to keep it as fluid as possible and not have too many reasons for using or trying to capture a certain word. And I don't illustrate 'em. I don't search 'em out—they come to me. If I find them funny or valuable, that's when I move on them. There's no goal.

Doug:
In your painting Highland, Franklin, Yucca *(1999), there are mountains in the background and superimposed on top of them at right angles are L.A. street names. It seems like there is a very specific relationship going on between the landscape and the urban topography. The viewer is forced to see the mountains through the urban grid of Los Angeles.*

Ed:
I was trying to hammer down my feelings about those particular city intersections and the idea of the city grid. You might say, "How about Lincoln Boulevard and Pico?" Your mind can drift and call up all kinds of past experiences that happened on that corner. You can go through your whole evaluation of society by sizing up a strip mall there that you see as totally valueless or decadent. But it still has some truth to it that makes you want to do something with it.

Doug:
I've always wanted to have a way of understanding this city better. This city is so nonlinear, so broken apart. I've wanted some kind of a timeline to follow, some kind of single thread throughout. But instead I've found many divergent paths. I recently took an interesting trip through Los Angeles. I went south to the San Pedro Bay, where the Los Angeles River meets the Pacific, and tried to go upriver on a small military-style boat to see how far we could go.

Ed:
That is a good challenge. You might just reach a dead end.

Doug:
It was a two-day trip. The first day I went as far as I could go up the river by boat. Then the second day we drove the continuation of the river to its source fifty miles away.

Even though it's a joke of a river—the riverbed is more like a concrete runway through a dense urban metascape—I wanted to follow it till it ended so I could understand the narrative of the city a little bit better. And so we followed it until we found the place where it begins as a trickle of water literally the size of a knife.

Ed:
That should be J.G. Ballard's next book—a story about the L.A. River. He could do it. Have all these great descriptions of the concrete viaducts, embankments, and all that.

Doug:
The whole L.A. River experience was motivated by my feeling that I needed to find a different way to navigate through information and experience in this massive city.

Ed:
Maybe this is what you are really doing here talking to people for your book. This is like a work of art for you.

Doug:
It is in a way. Would you say your attraction to the everyday urban and suburban sights and signs lies in the challenge of seeing them with fresh eyes and reliving the fascination of the new?

Ed:
The fascination of the new is a great motivating force. Some people are convinced there is nothing really new, and that there won't be anything in the future to respect or be inspired by. I say that's wrong. It depends on how you look at that question. There are going to be a lot of things that people do with art to be inspired by.

Doug:
There will never be anything entirely new, but I agree with you, trying to discover ways of seeing that are closer to how we experience the world is always going to compel people to create the new. It's a search and an appetite that I don't think can ever be satisfied. It will keep pushing people to keep trying to find new value in our surroundings and in our lives—like in a John Cage kind of way, opening up our perception to a wider framework and allowing ourselves to be open to connections that occur by happenstance.

Ed:
John Cage was like a Zen master of all that, wasn't he? Things go in cycles. We recognize people who are doing things today that we find valuable and profound. You can bet that these people and events will someday be buried. The ideas will be revolted against and forgotten, maybe resurrected somewhere way down the line. I have a real philosophical take on the whole thing. All this is so fast and so temporary. I'll always remember when Robert Smithson, who was a friend of mine, said, "One pebble that moves ten inches in twenty million years is enough action to keep me really excited." I like to think of myself as an ambling-rambling person who doesn't have to concern himself with time. The wandering soul. That's what we all dream about, isn't it?

Doug:
I think not being concerned with time is one of the most difficult things we can try to do.

Ed:
Yes, that's a tough one.

Amos Vogel

Through his tireless efforts to promote cinema, Amos Vogel (b. 1921, Vienna, Austria) helped intro-
duce postwar America to foreign, documentary, and independent film. Driven out of Austria by
the Nazis in 1938, he fled with his family to New York. Nine years later he and his wife founded the
country's first film club, Cinema 16. In 1967 he cofounded the New York Film Festival, and seven
years later he published his classic tribute to alternative film, *Film as a Subversive Art*. He is cred-
ited as the first to screen publicly the films of John Cassavetes and Roman Polanski, among others.

Doug:
You've dedicated your life to championing film outside the mainstream. In your opin-
ion, do you think the threat from the commercial world to co-opt the avant-garde has
always existed, even in 1974 when you published Film as a Subversive Art?

Amos:
There's no doubt about it. Film has such great potential and it has been misused
again and again. There are real artists out there creating new perspectives, but there
is also a tremendous amount of utilization and corruption by the commercial industry
of the ideas that the avant-garde first propounded. But I only recently fully realized
the profound extent to which they have influenced the commercial world. Maybe that's
because I watch more television now that I'm older. It's inevitable that everything
influences everything, but these commercial artists are not creating new perspectives,
they're just using the ideas generated by the avant-garde. It's spectacular the extent
to which they use the methods and criteria of the more serious artists out there. It is
abhorrent to me.

Doug:
Some would say that the avant-garde movement has time and again been the initial
breeding ground for new approaches to perception that are then incorporated into
the mainstream.

Amos:
Yes, definitely. But the amount of money and resources that's now available to the
people making television commercials is stupendous. They're intelligent people, and
they're sitting there selling crumbs, dog food, and underwear using techniques that
serious filmmakers used before them. But because these commercial artists have
loads of money and resources, they can expand the techniques totally beyond the
means that were available to the original filmmakers. I am constantly taken aback
by the total misuse of the wonderful creative function that human beings possess
to create new forms, new shapes, and new ideas. There is a certain purity to
expressing your own inner self, you know? To me, there's an enormous difference
between people who create something out of love and an inner need, letting their
unconscious guide their creations, and those who corrupt and vulgarize these
same ideas for commercial purposes. It's unbelievable, really, what's happened.

THIS CONVERSATION TOOK PLACE IN NEW YORK CITY.

Film
as a
Subversive
Art

Amos Vogel

the Visual

on sex itself, the most fundamental, most powerfully desired, and hence most dangerous act of human existence.

Many primitive people display a lively fear of the consequences of sexual intercourse either for themselves or for others. Mystic dangerousness invests the organs of generation; they are a seat of sorcery. Because a woman is so often regarded as inferior... temporarily or permanently unclean, contact with her in the intimacy of the sex embrace would naturally be considered to involve pollution, especially for the man alone, sometimes for the woman as well. Such an idea combines readily with the further notion that the physical uncleanliness resulting from the discharge of fluids by both parties, at the completion of cohabitation, becomes a source of ritual uncleanness...

Judeo-Christian concept of original sin... qualitative extension of these early tendencies, an 'elaboration' of a taboo by of a legend. But nudity and exposure of sex organs cause neither shame nor surprise in primitive society: it requires special motivation, René Guyon notes, to produce the apparently natural and spontaneous reaction... which Western people experience when they see the naked body'.

The mere fact that certain organs are related to excretory functions surely affords no ground for aversion or disgust ... neither physiology, biology nor logic can provide the philosopher satisfactory reasons for excommunicating a particular muscles and sensory organs ... though sex prohibitions themselves that a special value comes to be placed upon the exhibition of sex organs...

The system of taboo was superseded by an... of religion (latter-day magic), a reappearance in the new guise of ethical and moral imperatives, so carefully embedded in the collective unconscious as to give them the primacy of natural laws. Webster concludes that these imperatives in-

Erotic and Pornographic Cinema

...rage, and that it is silly to exclude so human and beloved an enterprise from the screen. Thus we see done on a hay-cleared floor (though the bra at first will not unhook); in a lake (with a long shot of heaving buttocks periodically emerging from the water); in a tree (a messy, giggly affair); from behind (in anger and lust); and while straddling the balustrade of the Royal Palace in Stockholm, with a guard at attention, sweating to keep his composure amidst dropping panties and voluptuous movements. The lovemaking throughout is neither titillating, mechanical, bourgeois nor deeply significant, but casual and free: filled with warmth, strife and experimentation. He is her Number 30 or so, and there will be others (including Sjoman, the film's director who periodically enters the action, and intentionally blurs reality and illusion). The portrayal of sex goes further than ever before.

There is no mistaking the spread legs, the man between them, the movements, the outspoken dialogue. Yet, while sex organs are sometimes shown and even (somewhat) manipulated, we see no erection nor penetration.

But the sex scenes (at least on first viewing) overshadow the film's main theme: the attack on the values (or lack of values) of the Swedish welfare state and contemporary society in general. Alienation, cynicism, and boredom seem to characterize the people appearing in its many political discussions and interviews. The young heroine both investigates and symbolizes the social and...

...welfare state, fearful of society. The sexual episode is used all over again to attack the abstraction of their tenderness. As sex scenes appear as attempts (however successful or not) at real human involvement they are essential components of an ideological statement.

The final subversion of this work is in its form. Sjoman, in other contemporary film-makers, aims at immediacy and veracity by constantly breaking down the boundaries between fiction and reality (even to the extent of appearing within the film as its director, commenting on its action, and having the actress deconstruct real themes with real dancers-by). The spectator is thus confronted with the need to redefine the concept of reality in his own...

Last Tango in Paris

Bernardo Bertolucci, France/Italy, 1972 (f)

After years of disregard, the international furor so suddenly bestowed upon Bertolucci for having created a break-through film all but obscures the question of just what this break-through is meant to be for neither stylistically, thematically nor in terms of erotic tension does it go beyond before. The Revolution, his best work. In fact, the youthful exuberance and lyricism of this earlier work seem preferable to the more conventional and subdued style of Tango, and the intellectual weight and ideological subtlety of Revolution make the puzzling message of Tango. As for...

Films

The Bed

James Broughton, U.S.A. 1967

The entire cast of this delightful wise manifesto of counter culture sensibility performs in the nude. An ornate bed magically located in a meadow provides, as always, the stage for man's most significant moments: birth; sex; death. The actors, who exuberantly perform scenes of the human comedy, include Imogene Cunningham, Alan Watts, and other San Francisco artists and writers. While even avant-garde nudity seems often to betray an absence of joyful or uncom-

...but they are limp, denoting not impotence but the precise moment in time at which this film was made.

Documentary Footage

Morgan Fisher, U.S.A. 1968

A nude girl on a stool reads a series of inane questions addressed to herself into a tape recorder without answering them, leaving fifteen-second pauses after each. She re-runs the tape, rises, and answers each question with charming improvisations. An early example of structural cinema, the formalist meaninglessness of...

Montage techniques, fast edits, and intercuts are techniques that originally came out of experimental filmmaking. They were then co-opted into mainstream cinema and ultimately brought into television commercials. Do you think there could be something gained from this now that the average viewer is more likely to be better at reading the moving image?

Amos:
I doubt that. People are inundated with images that they can barely even comprehend. Even as we speak, there's no doubt that there are young people who are stimulated by television commercials and later go on to make experimental films. But I don't think that overall these commercials really contribute to the viewer's welfare and artistic education. I think they actually serve to emasculate.

Doug:
Is it possible in this climate to make experimental film or artwork that pushes the boundaries of experimentation even further because experimental approaches from the past are familiar to the general public?

Amos:
The value of experimental cinema is precisely that it opens up new vistas for people so they can see what's possible out there. I always think to myself, "My God, they must surely be at the end of the road. There's nothing else left." But there's always something left. There's always something new. The eternal hope is that this will continue. But it is a very difficult struggle.

Doug:
It's also a philosophical question too, isn't it?

Amos:
Of course. Philosophy resides in images. It doesn't only reside in what is written or spoken. In fact, images express a special kind of philosophy. It's very important to realize this, to welcome it, and to cherish it. That's what I've tried to do all my life.

Doug:
Narrative in cinema has traditionally been based on linear storytelling. Yet I struggle with this myself because I find it's a strategy that doesn't accurately capture what it's like to live in the world right now. For me, experimental cinema's greatest contribution is showing us alternative approaches that we can build on. I want to know what it takes for a film to really shake up and disturb the distance between the moving image on-screen and the people who are watching it.

Amos:
I think this can be achieved with regular kinds of film too. Think about the great films of the past and the present that don't use any special devices whatsoever, just the power of the narrative, the cinematography, the acting, and the editing. Unfortunately, you often see very good creative ideas about lessening this distance between the viewer and the screen used in commercials. Actually, these ideas appear in only a minority of films, really. There are exceptions, of course, but generally speaking,

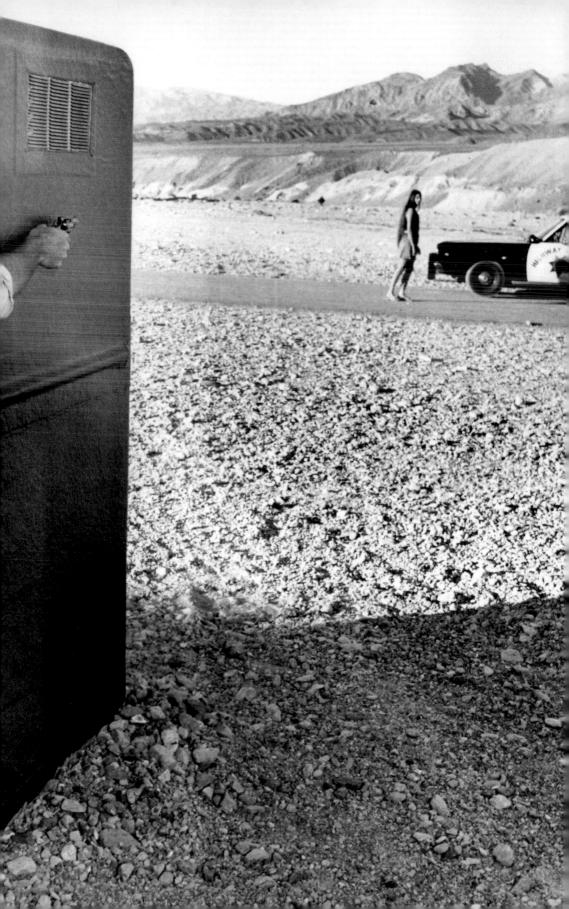

I don't think there has been any real improvement in commercial cinema, and the reason for that is very simple: commercial media, like commercial cinema, is based on profit and loss. Unfortunately, you're not going to get huge sales numbers for a Stan Brakhage film. I believe the profit motive is a false criterion, but it dominates the entire industry now—and virtually the entire structure of society. But that said, please don't misunderstand my criticism of society as a whole for criticism of film. The worst thing for me would be for my pessimism to prevent you, and others like you, from asking the questions you're asking. That would be terrible.

Doug:
One of the great values for me of your book Film as a Subversive Art *is seeing all the different approaches that have been tried before by people like Jean-Luc Godard, Alejandro Jodorowsky, Hans Richter, Michael Snow, and Andy Warhol. Seeing all the ways they challenged the straight story with nonlinear, open, fragmented, or circular narratives is really inspiring. Looking back at the experimental work over the past several decades, the most pressing question for me is, how do we formulate today's experience on-screen?*

Amos:
We need new options because the old-fashioned, straightforward, linear narratives —with their beginning, middle, and happy endings—have none of the real mysteries of existence that we all know to be true in our own lives. Somehow, we've become conditioned by our culture to produce artistic expressions for the purpose of leveling our experiences. For the average person, life is not a very easy thing to bear, and art is used as an escape from it. This explains why television has millions of viewers. Perhaps I'm giving the impression that my and your enterprise is a losing battle not worth engaging in. To me, it is actually the most important thing. But as long as our society is organized the way it is, it will remain a great challenge for us.

Doug:
But maybe numbers don't matter. Maybe ten thousand people showed up at your film festivals in the 1960s, while today there are millions of people who watch television. But it's the fact that you may have reached one individual in a provocative way that is to me motivation enough.

Amos:
That's right.

Doug:
My question is, how do you think we view the world differently now that information is moving faster? How do we deal with this personally within our own psyches?

Amos:
Those are the questions that keep me going…it's really wonderful. I do not think that faster-moving information is really useful for letting us view the world differently. All I can say is that, in my opinion, the future of mankind rests with the minorities, people like you and me, and people in other areas who are working for a better society. There is no doubt about that in my mind. It's a difficult struggle, one that every generation has to fight, if the human race is to survive as a race that is truly human.

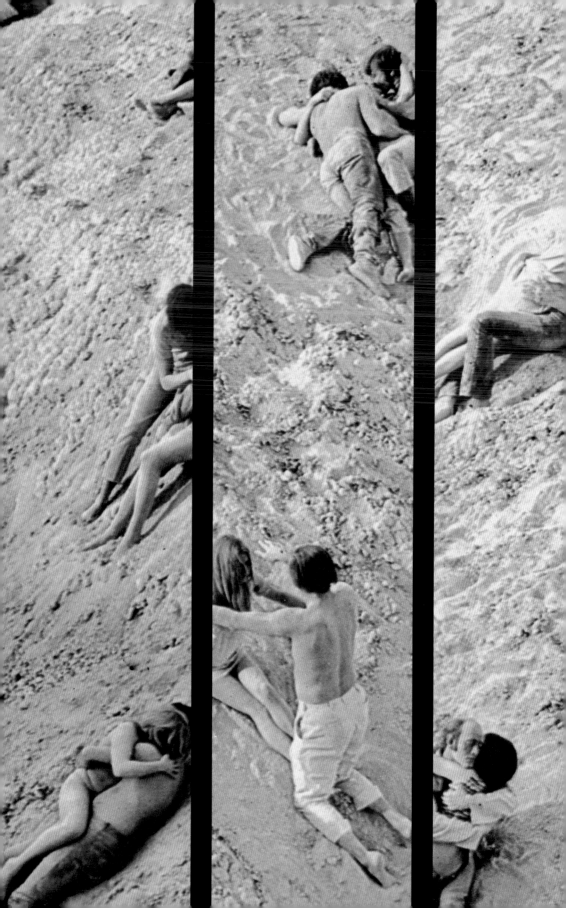

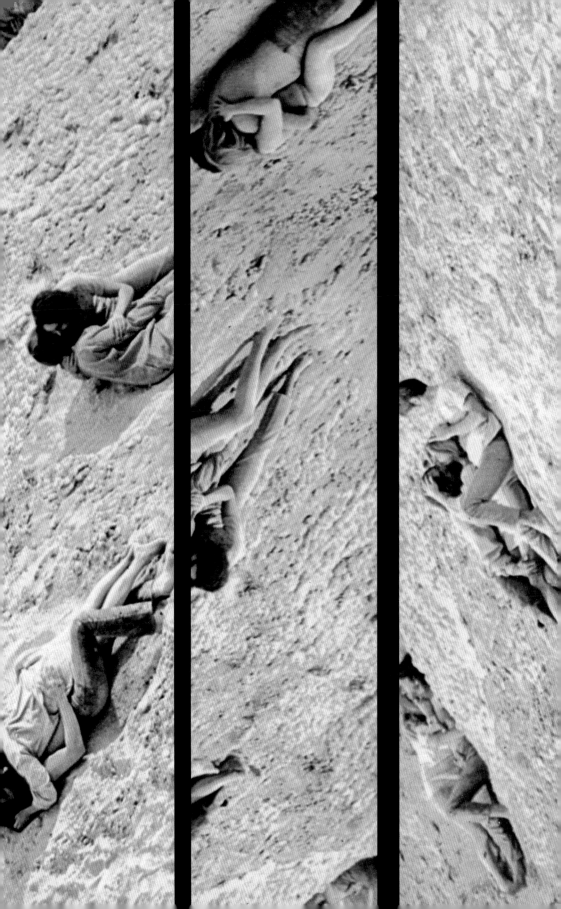

Robert Wilson

Theater director Robert Wilson (b. 1941, Waco, Texas) is renowned for his conceptual experiments with space and time, most famously in his single- and multiple-day performances. His concentrated, minimalist designs galvanize the stage, while the extreme isolation of the actors and the pieces' measured tempos turn the stories into fragmented moments. Wilson studied architecture, design, and painting in Texas, New York, and Paris before settling in New York in the mid-1960s. He has staged productions in opera houses and theaters worldwide.

Doug:
Your theater productions, especially those that followed your seminal piece Einstein on the Beach *(1976), could be described as pared down to the barest essentials—to people, iconography, symbols, to some extent sound, and above all to colored light. While there's the suggestion of graphics, film, and performance in your work, the visual language remains condensed and elemental.*

Robert:
You start with the surface, and then you have the skin, and then the meat, and then the bone. When you go through all the layers and come back to the surface, it all resonates in a very different way.

Doug:
The way you describe it, I feel like I'm at a barbecue!

Robert:
I know! But really, the theater, to me, is like a big hamburger or something. You have all these layers. You have lettuce, tomato, mustard, pickles, meat, you add a piece of bread, and you have this sandwich of all these transparent, stratified zones layered together. They are all independent, but together they make up the whole.

Doug:
How much do these different layers change as the pieces travel to different venues?

Robert:
Well, they change with the people who are in them and with the spaces that they're in. You try and do exactly the same thing, but it's always different.

Doug:
And do the narratives change sometimes too?

Robert:
True, yes. *The Black Rider* (1991) played in Germany for almost ten years. At one point the guy who played the devil Peg Leg was an androgynous skinny little guy. Now Marianne Faithfull plays the devil. She is totally different, so the character is different now, and that makes the tale different too.

THIS CONVERSATION TOOK PLACE BETWEEN HAMBURG, GERMANY, AND VENICE, CALIFORNIA.

266

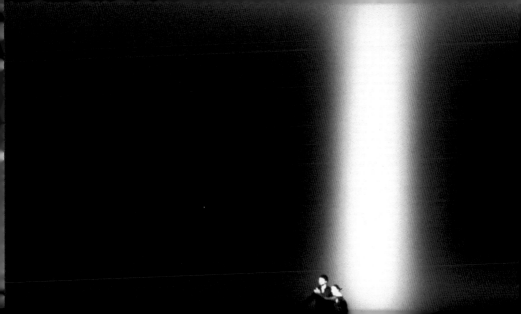

Doug:
So these layers you described remain, but reassemble differently with each run.
When you're working on creating a new piece, do you find yourself constantly
incorporating new experiences and aspirations?

Robert:
I think the world is a library, and the more you have exposure to it, the more you
learn. That also changes the work each time it's repeated because I'm bringing
different things to it, whether it's shortly after I made it or fourteen years later. I'm
doing *Parsifal* in Hamburg now. I first did it in 1991. Although we are essentially trying
to do the same thing, I've changed too and the actors change, so the piece will also
change. But there are always constants. Charlie Chaplin once came to see a piece
I did in Paris, *Deafman Glance* (1971), which at that point was seven hours long and
silent. After the performance, he came backstage and one of the younger actresses
asked him, "Oh, Mr. Chaplin, when you did the flea circus act in *Limelight* (1952),
how did you come to do that?" And he says, "My dear, I've been doing that act for
forty-five years." I mean, if you start when you're two and play Mozart when you're
eighty-two, you're still playing Mozart.

Doug:
Has film been an influence on your work or not so much? Do you feel like you are
working in opposition to it in any way?

Robert:
Yes, in opposition to it. As a medium, film is different. Video is different too. First of all, the idea of time and space in both is different. In theater I can have someone crossing a stage over an hour and a half, or seventeen hours, or thirty minutes. Early on, I did a play called *KA MOUNTAIN and GUARDenia TERRACE: a story about a family and some people changing* (1972). The first performance ran continuously for seven days—nearly one hundred and sixty-eight hours—in Shiraz, Iran. Shortly after that I made an overture version of the same piece that ran for twenty-four hours in Paris. In a theatrical work this can be riveting. If you put this same idea of duration on film and you step back at a distance, and someone's crossing the stage over seventeen hours, it doesn't have the same power. Film and video, as you probably know much better than I do, is about the close-up. With a close-up you can really get into the movement of the eye or the face. In theater it's another time and space. It's kind of anti-film, not toward the culture of film but toward the medium.

Doug:
How is this expressed in your work?

Robert:
In all of my early work, one of the ideas I worked with was that I never wanted to focus the eye. I never lit any one thing because I wanted the audiences' eyes to move panoramically. I wanted the eye to wander constantly.

Doug:
Yes, you're right, it was really cinema that brought about the idea of the extreme close-up, the wide-angle shot, and the pan. All of these things create a predetermined path or journey into the image. There aren't really precedents for this in theater besides the spotlight as you mentioned. It seems that your work is driven by testing the limits of the viewer's perception, especially by using light abstractly. It's like you are guiding the viewer through different emotional temperatures represented by each of the colors.

Robert:
Without light, there is no space. Light is one of the layers. Light can have its own rhythm, its own structure, its own integrity and it can complement things or it can contradict them or follow them. But light is unique because it has its own purity.

Doug:
What other ideas about perception have influenced your work?

Robert:
In the 1960s I was very interested in the idea of the blink of the eye. As I'm talking to you now, you blink your eyes and what do you see? You don't know, but maybe for a fraction of a second you were dreaming or seeing a negative image. This is also a part of seeing. We are always alternating between interior, exterior, audio, and visual screens. It's like when you get on the subway in New York and you hear this excruciatingly loud sound, and after a few seconds you turn it off. For the longer pieces I've done, like the opera *The Life and Times of Joseph Stalin* (1973), which goes from

seven in the evening until seven in the morning in silence, I've had people say, "Oh, you had the red elephant in the scene in the morning. That was really great." There was no red elephant onstage! But they thought they'd seen it. I think it has to do with reaching that point in time when images from one's interior and exterior worlds commingle and become less distinguishable from one another—when the awareness of the separation and fragmentation of these two worlds changes.

Doug:
It tests the limits of what you assume to be true, of what we think we've seen. Your example of the red elephant shows how fallible our perception is, and how that fallibility can open up a place for our imagination to step in.

Robert:
In 1967 I met a child psychologist named Daniel Stern who was the head of the Department of Psychology at Columbia University. He's seventy now, living in Geneva. When I first met him, he'd made over two hundred and fifty films of mothers picking up their babies when they cried. Stern would slow the films down and look at them frame by frame, twenty-four frames per second, and he found that what's happening between the mothers and children is far more complicated than you might think. In eight out of ten cases, in the first one or two frames, the mother lunges at the child and the baby reacts with fear or terror. In the next two to four frames, the mother again reacts aggressively and the child responds by withdrawing in shock and terror. Now, when the mothers saw Stern's films, they were horrified and would say, but I love my child. And even when you view the film at normal speed, one just sees a mother picking up her baby. But that doesn't change the fact that in slow motion we can see them lunging at their children when they cried. This is all to say that perhaps the body is moving faster than we think, and we can only see things in slow motion.

Doug:
It's really interesting the way film technology captures this and theater doesn't. Memory and emotions are fragmented experiences that don't necessarily all point in the same direction. It's remarkable that sometimes we're not even aware of how deeply fragmented and out of place our subconscious reactions are.

Robert:
Exactly. What's happening is so complex. We see that it is a totally fragmented experience—highly charged and full of many different emotions and images and exchanges that aren't at all what you think they might be. In one second, actions can become totally disconnected from intent. Sometimes when we are very still or quiet—as if the audio screen is off—we can become more aware of this disconnected language.

Doug:
We're exposed to so much information that we often don't take in the images fully, or at least I find that's the case with me. The momentum sandblasts the content down.

Robert:
Yes, this is the other side of the spectrum: the awareness of the acceleration of information.

PERHAPS THE BODY IS MOVING FASTER THAN WE THINK, AND WE CAN ONLY SEE THINGS IN SLOW MOTION

Doug:
We're absorbing experiences all the time, but the real issue is, at what frequencies do we tune in? It's when we tune in that constitutes who we are, what we like, what we don't like, what turns us on or off. We can imagine our external world to be one way right now, but it might change in an hour. In your work you create these atmospheric, nonnarrative spaces that invite the viewer to tune in to them in his or her own way.

Robert:
That's a nice way to say it.

Doug:
You did some work with film and video in the 1960s and 70s. Have you found that this work with the moving image has made you see things differently in theater?

Robert:
Yeah, I did a little work in the 1970s with video. In one piece I blocked out the center of a television monitor with a piece of paper. I wanted to replace the news broadcaster's head and shoulders, the usual focal point hot area. I wanted to make the edges of the screen hotter and more powerful. At the time few people were dealing with the edges of space. I guess people are afraid of the edges. Then I started experimenting with putting the back of someone to the camera. There's so much actors can learn when their backs are to you. It lets them learn the camera in a different way. This was confirmed for me again in some of my first theater works, where I had some of my actors stand with their backs to the audience. Recently I saw an actress I used to work with, and she said to me that the most important lesson I ever taught her was that if you stand with your back to the audience, you'll learn the audience.

Doug:
To recognize that is beautiful and very counterintuitive.

Robert:
It's always that space in back of you that's as important as—or almost more important than—the space in front of you, no matter if you are facing the camera or facing the public. It's like a bow. The more you are aware of that space in back of you, the more you can calibrate how tense or relaxed you are. You can stretch the bow and become stronger. We sometimes forget about that.

Doug:
It's a very finely tuned game that you are playing. It's as if you're making work that walks this fine line between losing the viewer and bringing the viewer to a very different and often deeply personal space of interpreting what's going on.

Robert:
When I first came to New York from Texas, I went to the theater and the opera and I didn't like it. And for the most part, I still don't. Then I saw the work of the Russian ballet choreographer George Balanchine at the New York City Ballet, and I liked that very much and I still do. Balanchine's genius was to have the dancers, for the most part, dance for themselves. They never demanded the audience's immediate attention, so in turn, we were drawn to them. That was so different from the opera or Broadway theater.

Doug:
Does this contradict the idea of performing for an audience?

Robert:
We make theater for the public, of course, and we act for the public, and we find the right costumes and music for the public. But I think the best ones do it for themselves first. It allows the public to come to them, and it is in this transition that you can lose yourself. It's like the opposite of a bad high school teacher who tries to teach someone by knocking them over the head.

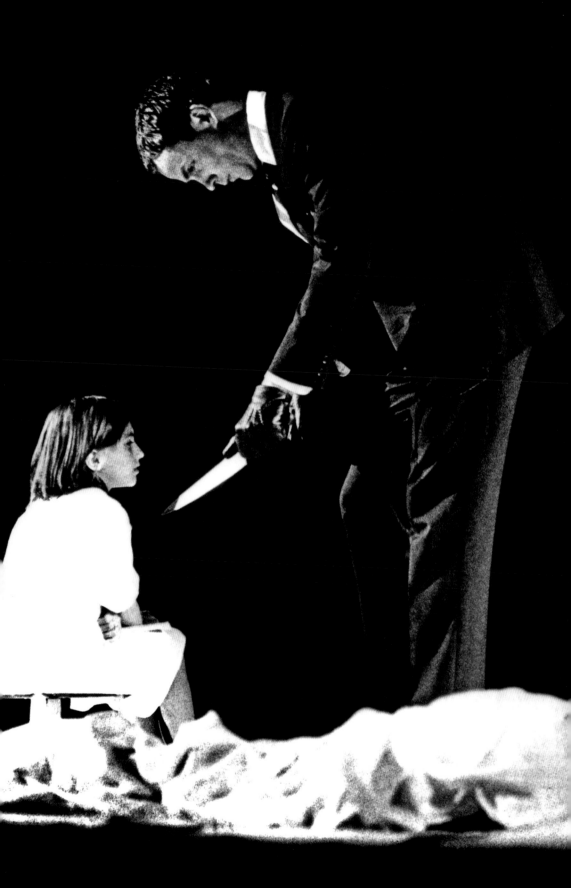

...that's not all...

Moments of alternative narratives and points of light

By Doug Aitken and Hans Ulrich Obrist

These pages present a selection of alternative
narratives in film and moving image architecture
that have been drawn from the voices of the past.

La Jetée

At the core of Chris Marker's 1962 film *La Jetée* is the simple question: "How do we experience time?" I wasn't surprised when Marker told me *La Jetée* is one of the only films he's storyboarded, because the film itself feels like a storyboard. Made from a series of filmed photographic images, *La Jetée* tells a fragmented story of a future that takes place in the past and of a past that seems to be erasing itself from the protagonist's memory. In the haunted caverns of his mind, we find that the future's rebel is the one who can retain memories of the past. In this, Marker suggests that we can rewind, fast-forward, and erase time and memory at random will. Jumping forward to the past and backward to the future, *La Jetée* asserts a nonlinear idea of time, undermining the basic assumptions we live by.

DA

I REMEMBER ONCE GOING INTO A VIDEO STORE TO PICK UP A JEAN-LUC GODARD FILM. I FOUND THE "G" SECTION AND, AS I SCROLLED THROUGH IT TO FIND GODARD'S FILMS, I SAW SOMEONE HAD CROSSED OUT THE "ARD" IN HIS LAST NAME ON THE SECTION DIVIDER. TO ME, HIS 1967 *WEEK-END* IS THE REASON FOR THIS.

IT'S A COLOSSAL, NIHILISTIC ROLLER COASTER RIDE THAT CHALLENGES EVERY TABOO OF MIDDLE-CLASS SOCIETY. YET MORE IMPORTANTLY, IT BREAKS EVERY TABOO OF LINEAR STORYTELLING: A DARKLY COMEDIC, REVOLUTIONARY, EROTIC, VIOLENT, UNPREDICTABLE, SENSUOUS, CANNIBALISTIC ROAD TRIP OF OUR NEW, COLD GENERATION. NOT ONLY DOES THE INNOVATIVE CAMERAWORK BLATANTLY REMIND YOU THAT YOU'RE WATCHING A FILM, IT ALSO TELLS YOU YOU'RE SLOWLY BLEEDING.

DA

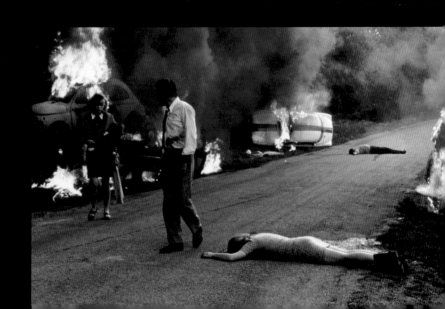

WHAT YOU SEE IS NOT WH YOU SEE

WHAT YOU SEE IS NOT WHAT YOU SEE

MOONS PASS, SUNS GLIDE ACROSS THE SKY, TREES DECAY, MOSS GROWS, MAN, ANIMAL, SEX

WHAT MOONS PASS, SUNS GLIDE ACROSS THE SKY, TREES DECAY, MOSS GROWS, MAN, ANIMAL, SEX

SEE
SEE

YOU SEE IS NOT WHAT YOU SEE

MOONS PASS, SUNS GLIDE ACROSS

WHAT YOU SEE IS NOT WHAT YOU SEE

MOONS PASS, SUNS GLIDE ACROSS THE SKY, TREES DECAY, MOSS GROWS, MAN, ANIMAL, SEX

WHAT YOU

WHAT YOU SEE IS NOT WHAT YOU SEE

MOONS PASS, SUNS GLIDE ACROSS THE SKY, TREES DECAY, MOSS GROWS, MAN, ANIMAL, SEX

IS NOT WHAT YOU SEE

WHAT YOU SEE
IS NOT

IS NOT WHAT YOU S

NOT
MOONS PASS, SUNS GLIDE ACROSS THE SKY, TREES DECAY, MOSS GROWS, MAN, ANIMAL, SEX

WHAT YOU SEE IS

WHAT YOU SEE IS NOT
WHAT YOU SEE

MOONS PASS, SUNS
GLIDE ACROSS THE
SKY, TREES DECAY, MOSS
GROWS, MAN, ANIMAL, SEX

MOONS PASS, SUNS GLIDE ACROSS
THE SKY, TREES DECAY, MOSS
GROWS, MAN, ANIMAL, SEX

MOONS PASS, SUNS GLIDE ACROSS THE SKY, TREES DECAY, MOSS GROWS, MAN, ANIMAL, SEX

MOONS PASS, SUNS GLIDE ACROSS THE SKY, TREES DECAY, MOSS GROWS, MAN, ANIMAL, SEX

Stan Brakhage

What you see is not what you see, and Stan Brakhage proves this in his five-part *Dog Star Man* (1961–64), in which even something as seemingly simple as a woodsman planting a tree in the forest and eventually chopping it down becomes a meditation on a new hyperconsciousness. Along with *Cat's Cradle* (1959) and *Blue Moses* (1962), these early films explore every fiber and texture of Brakhage's cinematic perception in abstract detail. Objects move in and out of optical abstraction: moons rise and set, suns glide across the sky, trees decay, moss grows. Man, animal, and sex vacillate. With a phantom precision, Brakhage transforms the observable moment and the simple everyday event into explosions of awareness. And when the films end, we are left with the memory of a deeply emotive, atmospheric experience. DA

DOUG: ARCHIGRAM'S *INSTANT CITY* (196
PROPOSES A FUTURE CITY. HOW DO YO
SEE IT?

HANS: A A City Abandoned City ABCity Abject City Abstract City Acme City
Actor-Network City Actual City Ad Hoc City Additive City Affect City
African City Agglomeration City Aggregative City Agora City Agricultural
City Aids City Air City Air-Conditioning City Airport City Airship City Airstrip City Alarm City Alert
City Amazon City Ambiguous City And-So-On-City American City Anal City Analogous City Angel
City Angle City Animate City Anti-City Anticipatory City Any City Apocalyptic City Apotheotic City
Arcade City Archaic City Archipelago City Arty City Artesian City Ash City Asian City As-It-Could-
Be City Astral City Asylum City Atopic City A-to-Z City Automobile City Autonomous City B
Babylonian City Bag City Balance City Bamboo City Banal City Baroque City Bastard City Bath
City Baton City Beginning City Best City Better City Beyond City Big City Bike City Bio City
Bio-Climatic City Bird City Bird's Eye City Bit City Bite City Blitz City Blood City Blow City Blowout City Blur City Body City Bold Cit
City Boom City Box City Brain City Brand City Brave City Breathing City Bridge City Broad Acre City Broken City Bubble City Bunker City
City Busy City Button City C Cable City Calibration City Camp City Camping City Campus City Capital City Caprice City Capsule City
City Car City Cartoon City Casino City Cell City Center City Centerless City Chaos City Characteristic City Children City Choice City
City City City on the Move Clandestine City Cliff City Climax City Clip City Cloaca City Cloud City Club City Cluster City Cohab City Cold City
City Collapse City Collage City College City Collective City Collision City Color City Combinational City Coming City Coming-To-Be City Comme
Commodity City/City-as-Commodity Communal City Commuter City Compact City Compassion City Competition City Complex City Complex-
City Compu City Computer City Concentration City Conclave City Conclusive City Concrete City Confused City Conglomerate City Compre
City Consolidated City Constant City Constellation City Construction City Container City Contemporary City Context City Continent City Co
City Conversion City Cool City Cord City Cordless City Core City Corporate City Correspondence City Corridor City Cosmic City C
City Coupling City Crazy City Cream City Creative City Creole City Crime City Criss City Critical City Crowd City Crumpled City C
Crossing City Cruise City Crying City Crystal City Cult City Cumulative City Cutting-Edge City Cyber City Cybernetic City Cyborg City Cy
D Dark City Darrow City Data City Date City Day City Dead City Dead-End City Decentered City Declining City Deconstruction City De
Defense City Definite City Delirious City Demo City Demon City DenCity Departure City Deregulation City Derelict City Desert City Detac
Device City Diamond City Diaspora City Diffuse City Dilate City Dim City Dirt City Disaster City Discourse City Discovery City Disintegrable C
antled City Disposal City Distinctive City Distorted City DiverCity Dizzy City DNA City Doc City Dogma City Do-It City Do-It-Again City
Doom City Door City Double City Doubt City Down City Drag City Drainage City Dream City Drop City Drug City Drum City Dull City
Dust Cloud City Dwelling City Dynamo City Dystopian City E E-City Earth City Earthbound City Easy City Ebola City Echo City Eco City Ec
City EcstaCity Ecumenical City Edge City Edible City Edo City Effect City Electric City Electronic City Elementary City Elusive City Emerg
Emergent City Empty City Enclave City End City Enhanced City Enigmatic City Entertainment City Entropic City Ephemeral City Erosion City E
Erratic City Escalator City Esoteric City Etcetera City Ether City European City Ever City Every City Everything-But-the-City Everywhere City
Exacerbated City Excuse City Exhibition City Expanding City Expensive City Experimental City Export City Extension City Extra City Extra
City Exuberant City F Fabulous City Facade City Factory City Fair City Falls City Fame City Fax City Fast City Feather City Feedback City
City First City Fist City Flat City Floating City Flood City Flow City Fluctuation City Fluid City Flux City Fly City Folly City Footnote City F
City Forest City Format City Formatted City Fort City Fortress City Fountain City Fragile City Free City Free-Flying City Free Form City Free
Frenzy City Fringe City Frivolous City Frontier City Fuck City Fuck-Context City Functional City Funnel City Fuse City Future City Futurist Cit
City G Gallery City Game City Gap City Garden City Gate City Gateway City Gay City Generic City Genetic City Geodesic City Ghetto Cit
City Giant City Glam City Global City Glocal City Gonna City Gossip City Gotham City Gothic City Graffiti City Great City Green City
Grey Realm City Groundless City Group City Growing City Growth City Gulag City Gum City H Hang-On City Happening City Harbor Cit
City Harmony City Heart City Heavy City Her City Heterogenic City Hideous City High-Tech City Highway City Hip-Hop City His Ci
City Holistic City Holland City Holographic City Holy City Homogenic City Horizontal City Hot City House City Hovering City Hub Cit
City Hurry City Hybrid City Hyper City I Ice City Ideal City Illegal City Imaginary City Imagination City Immaterial City Immediate City I

City Imperfect City Inanimate City Indefinite City Indiffe
Individual City Industrial City Infiltration City Infinite City Inflat
Infra City Inhibited City Insertive City INSTANT CITY
mental City Intangible City Integral City Intelligent City IntenCity
Interchange City Interconnected City Interdisciplinary City Inte
Interface City Interfolded City Interior City International City Inte
City Intertwined City Interval City IntraCity Invisible City Is
Isotropic City J Jargon City Joint City Jumbo City Jump Ci
Cut City Junk City Just-in-Time City K Kaleidoscope City
King City Knowledge City Kool City Kraftwerk City L
Label City Labor City Laid-Back City Landmark City Langu
Large-Scale City Last City Layered City Leaf City Lear

l Order City Major City Mall City Malleable City Manga City Manifesto City Marine City Mark City Market City Markmatical Me

atrix City Maybe City Mayor City Maximum City Mean City Mechanical City Media City Mediated City Medical City Medieval City Me

City Meeting City Mega City Memory City Mental City Merge City Meta City Metaphoric City Meteorite City Middle City Micro City

k City Millennium City Mini City Minimal City Minor City Mitigated City Mixing City Mobile City Model City Modern City Modest City

odule City Möbius City Molecular City Monad City Money City Mono City Monopoly City Monumental City Morphing City M

ctional City Multinational City
City Must City Museum City
City Mutant City My City Mythology
Naked City Nano City Narrow City
City Naval City Near City Nego-
y Neo City Neo- Babylonian City
Neo-Realist City Nerd City Nerve
v City Nested City Net City Net-
Neural City Never City New City
y Night City No City Node City
ity Noise City Nomadic City Non-
Non-Place City Nonstop City No
Northern City Nostalgic City Non-
y Notable City Not-a-City Nothing
mber City O Oasis City Oblique
sessive City Obvious City Ocean
d City Office City OK City Old
ly City Open City Open-to-the-Sky-

INSTANT CITY

tion City Oral City Orchard City Organ City Organic City Original City Oscillation City Ought-to-Be-a-City Our City Ouss City

City Oyster City Ozone City P Paint City Palm City Pan City Panoptic City Panorama City Para City Parallel City Park City Pas

City Patchwork City Pathological City Patient City Pavilion City Pedestrian City PC City People's City Performance City Performative City

ipatetic City Peristaltic City Pervasive City Phantom City Piazza City Pilot City Piss City Pixel City Pizza City Placard City Placebo

nt City Pleasure City Plug-in City Pneumatic City Pocket City Political City Pompous City Poor City Pop-Up City Porno City Port City

rtal City Portfolio City Post City Post-it City Postcard City Post-Human City Post-Identitarian City Postindustrial City Post-It City Po

st-National City Post-Urban City Precinct City Preemptive City Prefab City Present City Present-Day City Pretext City Price City Pri

ty Procedural City Process City Program City Programmable City Project City Promiscuous City Prosperous City Protein City Proto

oxy City Psycho-Geographic City Public City Public Transport City Pulse City Punch City Pyramid City Q Quantum City Quartz

een City Queer City R Radio City Rain City Ramified City Random City Ready City Ready-Made City Real City Realized City Re

ection
nce City
surrection
Rock City
Rumor
y Scene

City Refugee City Regional City Regulation City Reject City Relational City Rema
Rent-a-City Repressive City Reserve City Residential City Residual City Resist City F
City Revolution City Rich City Ring City Riot City Rising City Rite City Road Cit
Rogue City Romantic City Roof City Rose City Rough City Row City Royal City R
City Running City Rural City Rush City S Sale City Sand City Sandwich City Scad
City Science City Sci-Fi VCity Scoop City Scream City Screen City Sea City Se

City Sedative City Self-Organized City Semi City Sequential City Service City Sewer City Shadow City Shanty City Sh

ty Shopping City Side-by-Side City Sign City Signal City Sim City Simple City Sin City Sinking City Skin City Skinny City Sky Cit

acker City Slam City Sleepless City Slick City Slow City Snow City So-and-So City So-Called City Social City Soft City Software

y Sonic City Sore City Sorry City Soul City Sound City So What City Space City Space-Time City Sparkling City Spatial City Sp

City Spider City Spiral City Splendid City Sprawl City Sprawling City Spreading City Stage City Star City Start-Up City State City

ity Stereo City Still City Stir City Story City Straight City Street City Stress City Stretched City String City Stroll City Strong City

udio City Substitute City Subtle City Suburban City Succeeding City Success City Sudden City Suicide City Sun City Sun Belt City S

ck City Superfluid City Suprematic City Surreal City Surrogate City Survival City Syntax City System City T Tactile City Take-Off C

chno City Tele City Telematic City Temptation City Tender City Temple City Temporary City Tenacity Tenant City Tender City TentCity

tative City Term City Terminal City THE City Their City Theme City Thick City Thin City Think City This Way City Ticklish City Time

y Toast City Toll City Tool City Tool Kit City Tower City Trading City Traffic City Trans City Transact City Trans-Experience City Tran

nsitory City Transnational City Transvestite City Trauma City Traveling City Travesia City Travesty City Tree City Tri City Trickling City

City True City Try City Tuned City Tunnel City TV City Twin City Twisted City U U City UFO City Un-City UN City Unbound City

nfinished City Unforeseen City Uninhibited City Unitary City Unlimited City Unrealized City Unrealistic City Unstable City Urban Mark City

Value City Vanishing City Vast City Vegan City Velcro City VeloCity Vernacular City Verge City Vertical City Very City Vespa City

ty Village City Vintage City Virgin City Virtual City ViscoCity Vital City Voyage City Vulgar City W Walking City War City Wash Ci

ater City Waterproof City Weak City Weather City Web City Weird City Whale City What City What If City While City Why Not C

despread City Wild City Wind City Winner City Wired City Wood City Working City World City Worldwide City Worse City Worst C

ww city X X City X-File City X-Ray City Y You City You Too City Your City Z Zero Degree City Zip City Zombie City

Glimpses of the USA

In 1959 a dome that was part of the American National Exhibition rose over Sokolniki Park, the site of the Moscow World's Fair. It was designed by Buckminster Fuller and housed Charles and Ray Eames's film installation *Glimpses of the USA*. With a score by Elmer Bernstein, *Glimpses* assaulted visitors in just over twelve minutes with more than two thousand two hundred images of American life projected onto seven 20 x 30-foot screens. Not only was this a brilliant piece of propaganda organized by the United States Information Agency, but it dramatically pushed the limits of the amount of visual information spectators could handle. JW

Film Guild Cinema

Imagine walking into a movie theater and finding an enormous eye front and center staring right at you. In 1929 architect and designer Frederick Kiesler set out to create a space in which the audience could become completely engrossed in the imaginary world of cinema. To do this, he invented a shape-shifting screen known as the Screen-O-Scope, with mechanical, rounded scrims that framed the projection. Kiesler's intention was nothing less than to completely reinvent cinematic architecture. In an era in which the cinema had not yet been branded and standardized, the Film Guild Cinema had more in common with Thomas Edison's moveable-part film studio from 1893, which Edison called the Black Mariah, than with the kind of theater most moviegoers are used to today. Kiesler's theater rejected the ornate sculptures, layers of drapery, and luxury-palace feel of the typical cinemas of his day in favor of a mechanical device that delivered a clean, unmediated transmission of the film's reality to our own.

DA & JW

Expanded Cinema

DON'T LET THIS LITTLE BOOK, FIRST PUBLISHED IN 1970, FALL ASLEEP ON THE DUSTY SHELVES OF USED BOOKSTORES. RESCUE IT, OPEN ITS PAGES, AND HEAR THE VOICES OF THE PROGRESSIVE PAST. INSIDE, GENE YOUNGBLOOD QUIETLY STATES, "JUST AS THE TERM 'MAN' IS COMING TO MEAN MAN/PLANT/MACHINE, SO THE DEFINITION OF 'CINEMA' MUST BE EXPANDED TO INCLUDE VIDEOTRONICS, COMPUTER SCIENCE, AND ATOMIC LIGHT." LET THE EXPERIMENTAL WORKS IN THIS BOOK OF THE PAST BE FUEL FOR OUR FUTURE.

DA

Chelsea Girls

When I first went to see Paul Morrissey and Andy Warhol's 1966 film *Chelsea Girls*, I found myself waiting in line outside the theater for a long time. The moviegoers in line with me were eclectic and curious. Everyone wanted to get a taste of the Warhol magic: the superstars, the image addicts, the ODs, and the black-candy-sex-victims of the downtown scene. The fidgeting moviegoers outside could not have guessed what they were about to see.

As the two reels rolled through the projectors simultaneously, images in real time slowly moved across the screen. Very little happened in them, proving Warhol's doctrine to create "not a plot, but an incident." As random juxtapositions between the two screens unfolded and the scenes played out in a narcoleptic stupor, we somehow saw deeper into the collective shadows of the on-screen characters and into what it truly means to want to be looked at. An hour or so into the film, my eyes left the screen and scanned the audience, where I saw that others were silently looking around too. It was as if in that moment, we were all realizing that the audience was as much the subject of the film as its celluloid characters.

<div align="center">DA</div>

Man with a Movie Camera

A kaleidoscope of visual impressions bombards us in Dziga Vertov's 1929 black-and-white silent film *Man with a Movie Camera*. A rapid-fire montage of city life in split screens, freeze frames, double exposures, and dissolves...

We are the twenty-story tower high above the Soviet streets — We are the camera — We are the film — We are the viewer — We are the lens — We are the subject — We are the lights — We are the chemistry — We are the audience — We watch ourselves — We reflect ourselves — We fragment ourselves — We are the camera— We cannot be stopped — We are here to stay!

<div align="center">DA</div>

New Babylon

Constant Nieuwenhuys's *New Babylon* from 1949–75 is a collection of models, drawings, and writings critiquing consumer culture. He conceived it to be a city of fluid, permanently-shifting architectural situations. He has said, "*New Babylon* is the world of the *homo ludens*, the playful human. It's a pattern of society which takes into account that everything is in permanent flux and transformation." *New Babylon* was designed to be an entirely flexible environment, from the floor plan to the smallest detail. It is an open city without borders, capable of spreading out in all directions like a superfluid without barriers. Constant imagined the different parts of the city to be hyperconnected, constituting a horizontal web where every location is accessible to everyone. Constant travel is to be the life of the inhabitants of *New Babylon* so that they can remain in an ongoing and spontaneous relationship with their surroundings. Any intervention by an individual becomes an interaction with the collective and provokes reactions by others.

<div align="center">HUO</div>

Short-lived, idiosyncratic architectural installations by Kurt Schwitters, the *Merzbau* sites were, in his words, accumulations of "spoils and relics." Constructed three times in three different countries between 1923 and 1947, a partial reconstruction of which is now in the Sprengel Museum Hannover, Schwitters's undertaking combined

Merzbau

uncertainty and unpredictability with nonlinear organization. The *Merzbau* sites functioned as highly personal structures and display spaces, at once shrines to friendship (he also called the design a "cathedral of erotic misery") and spaces with neither a dominant throughway, nor a definite beginning or end. Instead of certitudes, they expressed connective possibilities and created highly fragmented experiences — a nonlinear interior complexity we could call the *Merzbau* condition.

<div align="center">HUO</div>

Diagram of Nonlinear Film

The following diagram presents an overview of non-
linearity and fragmentation in film history. Divided
into five groups of tendencies, this diagram is not
intended to be a definitive overview, but a point of
departure for further conversation.

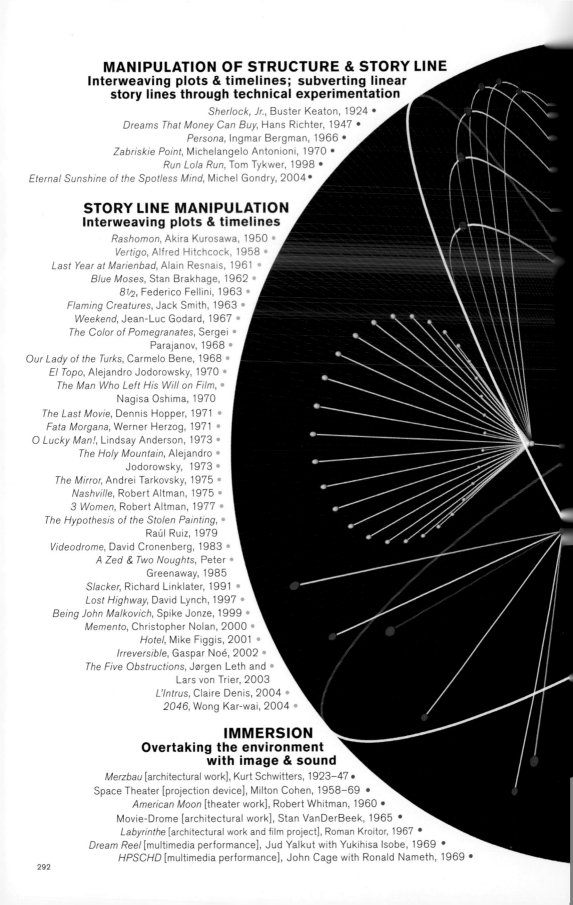

MANIPULATION OF STRUCTURE & STORY LINE
Interweaving plots & timelines; subverting linear story lines through technical experimentation

Sherlock, Jr., Buster Keaton, 1924 •
Dreams That Money Can Buy, Hans Richter, 1947 •
Persona, Ingmar Bergman, 1966 •
Zabriskie Point, Michelangelo Antonioni, 1970 •
Run Lola Run, Tom Tykwer, 1998 •
Eternal Sunshine of the Spotless Mind, Michel Gondry, 2004 •

STORY LINE MANIPULATION
Interweaving plots & timelines

Rashomon, Akira Kurosawa, 1950 •
Vertigo, Alfred Hitchcock, 1958 •
Last Year at Marienbad, Alain Resnais, 1961 •
Blue Moses, Stan Brakhage, 1962 •
8½, Federico Fellini, 1963 •
Flaming Creatures, Jack Smith, 1963 •
Weekend, Jean-Luc Godard, 1967 •
The Color of Pomegranates, Sergei •
Parajanov, 1968 •
Our Lady of the Turks, Carmelo Bene, 1968 •
El Topo, Alejandro Jodorowsky, 1970 •
The Man Who Left His Will on Film, •
Nagisa Oshima, 1970
The Last Movie, Dennis Hopper, 1971 •
Fata Morgana, Werner Herzog, 1971 •
O Lucky Man!, Lindsay Anderson, 1973 •
The Holy Mountain, Alejandro •
Jodorowsky, 1973 •
The Mirror, Andrei Tarkovsky, 1975 •
Nashville, Robert Altman, 1975 •
3 Women, Robert Altman, 1977 •
The Hypothesis of the Stolen Painting, •
Raúl Ruiz, 1979
Videodrome, David Cronenberg, 1983 •
A Zed & Two Noughts, Peter •
Greenaway, 1985
Slacker, Richard Linklater, 1991 •
Lost Highway, David Lynch, 1997 •
Being John Malkovich, Spike Jonze, 1999 •
Memento, Christopher Nolan, 2000 •
Hotel, Mike Figgis, 2001 •
Irreversible, Gaspar Noé, 2002 •
The Five Obstructions, Jørgen Leth and •
Lars von Trier, 2003
L'Intrus, Claire Denis, 2004 •
2046, Wong Kar-wai, 2004 •

IMMERSION
Overtaking the environment with image & sound

Merzbau [architectural work], Kurt Schwitters, 1923–47 •
Space Theater [projection device], Milton Cohen, 1958–69 •
American Moon [theater work], Robert Whitman, 1960 •
Movie-Drome [architectural work], Stan VanDerBeek, 1965 •
Labyrinthe [architectural work and film project], Roman Kroitor, 1967 •
Dream Reel [multimedia performance], Jud Yalkut with Yukihisa Isobe, 1969 •
HPSCHD [multimedia performance], John Cage with Ronald Nameth, 1969 •

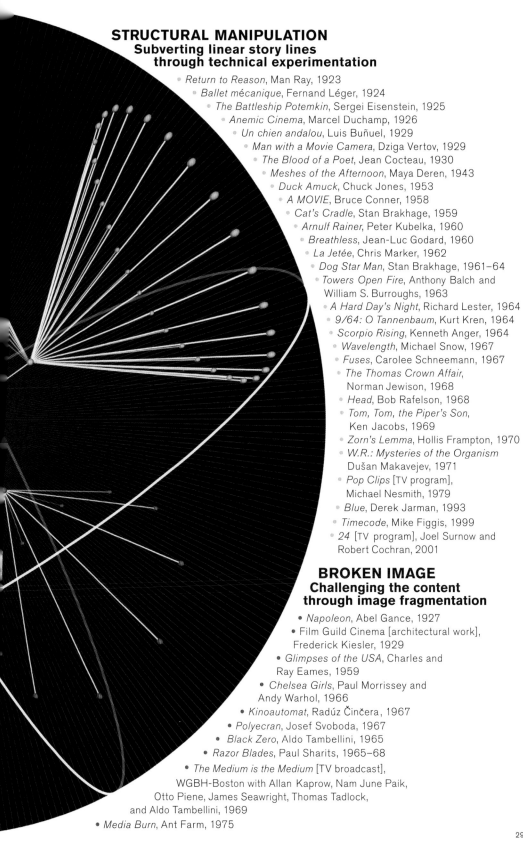

STRUCTURAL MANIPULATION
Subverting linear story lines through technical experimentation

- *Return to Reason*, Man Ray, 1923
- *Ballet mécanique*, Fernand Léger, 1924
- *The Battleship Potemkin*, Sergei Eisenstein, 1925
- *Anemic Cinema*, Marcel Duchamp, 1926
- *Un chien andalou*, Luis Buñuel, 1929
- *Man with a Movie Camera*, Dziga Vertov, 1929
- *The Blood of a Poet*, Jean Cocteau, 1930
- *Meshes of the Afternoon*, Maya Deren, 1943
- *Duck Amuck*, Chuck Jones, 1953
- *A MOVIE*, Bruce Conner, 1958
- *Cat's Cradle*, Stan Brakhage, 1959
- *Arnulf Rainer*, Peter Kubelka, 1960
- *Breathless*, Jean-Luc Godard, 1960
- *La Jetée*, Chris Marker, 1962
- *Dog Star Man*, Stan Brakhage, 1961–64
- *Towers Open Fire*, Anthony Balch and William S. Burroughs, 1963
- *A Hard Day's Night*, Richard Lester, 1964
- *9/64: O Tannenbaum*, Kurt Kren, 1964
- *Scorpio Rising*, Kenneth Anger, 1964
- *Wavelength*, Michael Snow, 1967
- *Fuses*, Carolee Schneemann, 1967
- *The Thomas Crown Affair*, Norman Jewison, 1968
- *Head*, Bob Rafelson, 1968
- *Tom, Tom, the Piper's Son*, Ken Jacobs, 1969
- *Zorn's Lemma*, Hollis Frampton, 1970
- *W.R.: Mysteries of the Organism* Dušan Makavejev, 1971
- *Pop Clips* [TV program], Michael Nesmith, 1979
- *Blue*, Derek Jarman, 1993
- *Timecode*, Mike Figgis, 1999
- *24* [TV program], Joel Surnow and Robert Cochran, 2001

BROKEN IMAGE
Challenging the content through image fragmentation

- *Napoleon*, Abel Gance, 1927
- Film Guild Cinema [architectural work], Frederick Kiesler, 1929
- *Glimpses of the USA*, Charles and Ray Eames, 1959
- *Chelsea Girls*, Paul Morrissey and Andy Warhol, 1966
- *Kinoautomat*, Radúz Činčera, 1967
- *Polyecran*, Josef Svoboda, 1967
- *Black Zero*, Aldo Tambellini, 1965
- *Razor Blades*, Paul Sharits, 1965–68
- *The Medium is the Medium* [TV broadcast], WGBH-Boston with Allan Kaprow, Nam June Paik, Otto Piene, James Seawright, Thomas Tadlock, and Aldo Tambellini, 1969
- *Media Burn*, Ant Farm, 1975

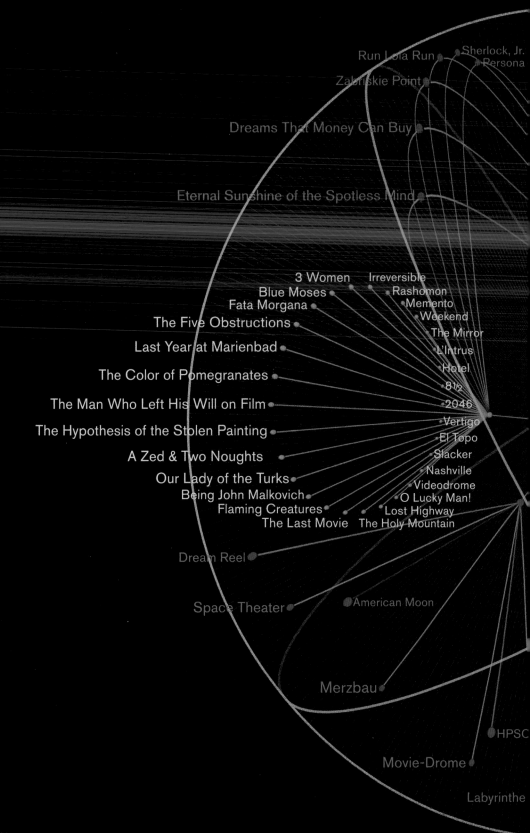

Run Lola Run
Sherlock, Jr.
Persona
Zabriskie Point

Dreams That Money Can Buy

Eternal Sunshine of the Spotless Mind

3 Women
Blue Moses
Fata Morgana
The Five Obstructions
Last Year at Marienbad
The Color of Pomegranates
The Man Who Left His Will on Film
The Hypothesis of the Stolen Painting
A Zed & Two Noughts
Our Lady of the Turks
Being John Malkovich
Flaming Creatures
The Last Movie

Irreversible
Rashomon
Memento
Weekend
The Mirror
L'Intrus
Hotel
8½
2046
Vertigo
El Topo
Slacker
Nashville
Videodrome
O Lucky Man!
Lost Highway
The Holy Mountain

Dream Reel

Space Theater

American Moon

Merzbau

HPSC

Movie-Drome

Labyrinthe

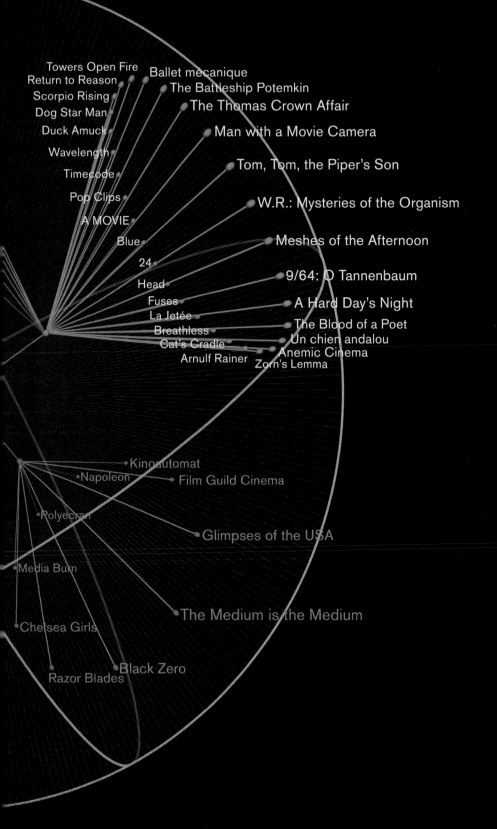

Towers Open Fire
Return to Reason
Scorpio Rising
Dog Star Man
Duck Amuck
Wavelength
Timecode
Pop Clips
A MOVIE
Blue
24
Head
Fuses
La Jetée
Breathless
Cat's Cradle
Arnulf Rainer

Ballet mécanique
The Battleship Potemkin
The Thomas Crown Affair
Man with a Movie Camera
Tom, Tom, the Piper's Son
W.R.: Mysteries of the Organism
Meshes of the Afternoon
9/64: O Tannenbaum
A Hard Day's Night
The Blood of a Poet
Un chien andalou
Anemic Cinema
Zorn's Lemma

Kinoautomat
Napoleon
Film Guild Cinema
Polyecran
Glimpses of the USA
Media Burn
The Medium is the Medium
Chelsea Girls
Black Zero
Razor Blades

CAPTIONS

Introduction

Pages 6–7: Ed Ruscha, *Miracle*, 1975, color, 16 mm, sound, 28 min, black-and-white production still. Courtesy of Gagosian Gallery, Los Angeles

Page 10: All images Mike Figgis, *Miss Julie*, UK/USA, 1999, 103 min. Courtesy of the artist

Page 11: Olafur Eliasson, *Erosion*, 1997, suction sifter, water hose, gas motor pump. Installation view 1997 Johannesburg Biennale. Courtesy of Tanya Bonakdar Gallery, New York

Eija-Liisa Ahtila

1 *The Present*, 2001, DVD installation for 5 monitors (5 x 72–120 sec) and 5 TV spots (5 x 30 sec) with sound

2 *The Wind*, 2002, DVD installation for 3 projections with sound, 14:20 min. Installation view Tokyo Opera City Gallery. Photo by Keizo Kioku

3 *The House*, 2002, DVD installation for 3 projections with sound, 14 min. Photo by Marja-Leena Hukkanen

4 *If 6 Was 9*, 1995, 35mm and
–5 DVD installation for 3 projections with sound, 10 min [composite of two installation views]

All images © Crystal Eye Ltd., Helsinki. Courtesy of Klemens Gasser & Tanja Grunert Inc., New York

Robert Altman

6 *Nashville*, 1975, USA, 159 min [composite]

7 *3 Women*, 1977, USA, 124 min

8 *Nashville*, 1975, USA, 159 min

9 *3 Women*, 1977, USA, 124 min
–10

All images courtesy of the Academy of Motion Picture Arts and Sciences

Kenneth Anger

11 *Scorpio Rising*, 1963, USA, color, 16mm, 29 min. Music by The Angels, Ray Charles, Claudine Clark, The Crystals, Kris Jensen, Little Peggy March, Gene McDaniels, Ricky Nelson, Elvis Presley, The Ran-Dells, The Surfaris, and Bobby Vinton

12 *Fireworks*, 1947, USA, tinted black and white, 16mm, 15 min. Music by Ottorino Respighi

13 *Inauguration of the Pleasure Dome*, 1954/1966, USA, color, 16mm, 38 min. Music "Glagolithic Mass" by Leos Janáček

14 *Lucifer Rising*, 1970–81, USA/UK/
–15 Germany, color, 16 mm, 30 min

[composite of two film stills]. Music by Bobby Beausoleil and the Freedom Orchestra, Tracy Prison (originally by Jimmy Page)

16 *Invocation of My Demon Brother*, 1969, USA, color, 16 mm, 11 min. Music composed by Mick Jagger on a Moog Synthesizer. Courtesy of the artist and Stuart Shave/Modern Art, London

All images other than no. 16 courtesy of the artist

John Baldessari

17 *Helicopter and Insects (One Red) version I*, 1990, color photographs, acrylic and vinyl paint, 96 x 65 in

18 *Endearment and Enmity*, 2000, black-and-white photographs, color photographs on museum board, 95⅜ x 48 in

19 *Imploded House (With Two Observers)*, 1989, black-and-white photograph, 7½ x 12¼ in; created especially for publication in *John Baldessari: A Retrospective*, Coosje van Bruggen, Rizzoli, 1990); recreated for *Broken Screen*, Doug Aitken, D.A.P., 2005

20 *Floating: Color*, 1972, 6 color photographs, 11 x 14 in each

21 *Blasted Allegories (Colorful Sentence and Purple Patch): Starting with Red Father...*, 1978, 36 C-type prints on board with colored pencil and tape, 30⅝ x 36⅝ in. Collection Morton G. Neumann Family

22 *Two Figures (Kissing) and Four Figures (With Knife and Chains)*, 1990, color photographs, acrylic and vinyl paint, 91 x 65 in

All images courtesy of the artist

Matthew Barney

23 *CREMASTER 5*, 1997, production still. Photo by Michael James O'Brien. © 1997 Matthew Barney

24 *DE LAMA LÂMINA*, 2004, production still. Photo by Chris Winget. © 2004 Matthew Barney

25 *CREMASTER 2*, 1999,
–26 production still. Photo by Michael James O'Brien. © 1999 Matthew Barney

27 *DRAWING RESTRAINT 7*, 1993, video monitors, laserdisc players, laserdiscs, high-abuse fluorescent fixtures, steel, and internally lubricated plastic. Installation view Whitney Museum of American Art. © 1993 Matthew Barney

28 *Matthew Barney: The Cremaster Cycle*, Solomon R. Guggenheim Museum, New York, February 21–June 11, 2003. Installation view. Photo by David Heald. © The Solomon R. Guggenheim Foundation, New York. Courtesy The Solomon R. Guggenheim Foundation, New York

29 *CREMASTER 1*, 1995, produc-
–30 tion still. Photo by Michael James O'Brien. © 1995 Matthew Barney

All images other than no. 28 courtesy of Gladstone Gallery, New York

Chris Burden

31 *TV Hijack*, 1972, silver gelatin print, 8 x 10 in. February 9, 1972, Channel 3 Cablevision, Irvine, California

32 *747*, 1973, silver gelatin print, 8 x 10 in. January 5, 1973, Los Angeles, California

33 *TV Hijack*, 1972, silver gelatin print, 8 x 10 in. February 9, 1972, Channel 3 Cablevision, Irvine, California

34 *Fist of Light*, 1993, color transparency, 4 x 5 in

35 *Through the Night Softly*, 1973, silver gelatin print, 8 x 10 in, September 12, 1973, Los Angeles, California

36 *Shoot*, 1971, silver gelatin print, 8 x 10 in. November 19, 1971, F Space, Santa Ana, California

All images courtesy of the artist

Bruce Conner

37 *SOUND OF TWO HAND ANGEL*, 1974, silver gelatin print photogram, 88 x 37 in. Photo by Bruce Conner and Edmund Shea. Collection Tim Savinar and Patricia Unterman, San Francisco. Courtesy of the artist

38 *A MOVIE* (details from filmstrip), 1958, black and white, 16mm, sound, 12 min. Photo by Dan Dennehy. Courtesy of Walker Art Center

39 *BREAKAWAY* (detail from
–40 filmstrip), 1966, black and white, 16mm, sound, 5 min. Courtesy of the artist and Canyon Cinema

41 *LOOKING FOR MUSHROOMS* (details from filmstrip), 1959–67, color, 16mm, sound, 14 min. Photo by Dan Dennehy. Courtesy of Walker Art Center

42 *COSMIC RAY* (details from filmstrip), 1961, black and white, 16mm, sound, 4:43 min. Photo by Dan Dennehy. Courtesy of Walker Art Center

Claire Denis

43 *Vendredi Soir*, 2002, France, 90 min. Courtesy of Wellspring Media

44 *Beau Travail*, 1999, France, 90
–45 min. Courtesy of New Yorker Films

46 *Vendredi Soir*, 2002, France, 90 min. Courtesy of Wellspring Media

Stan Douglas

47 *Suspiria*, 2004, single channel video with sound, approximately 7 min each cycle, virtually infinite permutations, dimensions variable

48 *Win, Place or Show*, 1998,
–51 2-channel video projection, 4-channel sound track, 204,023 permutations, approximately 6 min each, dimensions variable

52 *Der Sandmann*, 1995, black and white, 2-track 16mm loop installation, stereo sound track, 9:50 min each rotation, dimensions variable. Installation view Hauser & Wirth, St. Gallen, 1995. Collection Hauser & Wirth

All images courtesy of the artist

Olafur Eliasson

53 *The weather project*, 2003, monofrequency light, reflective panel, hazer, mirrored foil, steel. Installation view Turbine Hall, Tate Modern, London (The Unilever Series). Photo by Jens Ziehe

54 *The mediated motion (water)*, 2001 (with landscape architect Günter Vogt), water, foil, wood, duckweed, smog, compressed soil, mushrooms. Installation view Kunsthaus Bregenz. Photo by Markus Tretter

55 *La situazione antispettiva*, 2003, stainless steel. Installation view Danish Pavilion, 50th Venice Biennale, 2003. Photo by Olafur Eliasson

56 Olafur Eliasson, photo by Doug Aitken

57 *Green river*, 1998, nontoxic green dye, island. Photo by Olafur Eliasson

58 *360° room for all colors*, 2002, neon tubes, control system, scaffolding. Photo by Marc Domage

59 *360° room for all colors*, 2002, neon tubes, control system, scaffolding. Photo by Bertrand Huet

60 *Color spectrum kaleidoscope*, 2003, color effect filter, stainless steel. Installation view (detail) Danish Pavilion, 50th Venice Biennale, 2003. Photo by Olafur Eliasson

All images courtesy of neugerriemschneider, Berlin and Tanya Bonakdar Gallery, New York

Pablo Ferro

61 Multiple-screen polo sequence, The Thomas Crown Affair, 1968, directed by Norman Jewison, USA, 102 min

62 Title sequence, Dr. Strangelove, 1963, directed by Stanley Kubrick, USA, 93 min

63 Self-portrait

64 Title sequence, Woman of Straw, 1968, directed by Basil Dearden, UK, 115 min [composite]

65–66 Title sequence, To Die For, 1995, directed by Gus Van Sant, USA, 106 min

All images courtesy of Pablo Ferro Films

Mike Figgis

67 Hotel, Italy/UK, 2001, 109 min

68 Timecode, USA, 1999, 97 min

69–82 About Time–2, UK, 2000, 10 min (featured in the collection of short films, Ten Minutes Older: The Cello, 2002)

83–88 Timecode, USA, 1999, 97 min

All images courtesy of the artist

Werner Herzog

89 Werner Herzog, photo by Doug Aitken

90 Fitzcarraldo, Peru/Germany, 1982, 158 min

91 Fata Morgana, 1971, Germany/USA, 79 min

92 Even Dwarfs Started Small, 1970, Germany, 96 min

All images courtesy of Werner Herzog Film

Gary Hill

93 Tall Ships, 1992, 16-channel video installation. Photo by Mark B. McLoughlin

94 Still Life, 1999, 13-channel video installation. Installation view Gladstone Gallery, New York

95 Inasmuch As It Is Always Already Taking Place (detail), 1990, 16-channel video and sound installation. Installation view Museum of Modern Art, New York. Photo by Mark B. McLoughlin

96 Reflex Chamber, 1996, single channel video and sound installation. Installation view White Cube Gallery, London, 1996–97. Photo by Steve White

All images courtesy of the artist and Donald Young Gallery, Chicago

Carsten Höller

97 Light Wall, 2001. Installation view Instruments from the Kiruna Psycho Laboratory, Schipper & Gallery, Berlin, 2001. Photo by Howard Sheronas

98 Y, 2003. Installation view Delays and Revolution, 50th Venice Biennale, 2003. Photo by Attilio Maranzano. Collection Thyssen-Bornemisza Art Contemporary, Vienna

99 Slide #6, 2002. Installation view Half Fiction, Institute of Contemporary Art, Boston, 2003

100–01 Light Wall, 2003. Installation view One Day One Day, Färgfabriken, Stockholm, 2003. Photo by Stefan Frank Jensen

102–05 Phi Wall, 2002. Installation view One Day One Day, Färgfabriken, Stockholm, 2003. Photo by Stefan Frank Jensen

All images courtesy of Schipper & Krome, Berlin

Pierre Huyghe

106 Pierre Huyghe, photo by Doug Aitken

107 Atari Light, 1999, computer game program interface, joysticks, halogen lamps

108 Les Grands Ensembles, 1994/2001, VITAVISION transferred to Digi Beta and DVD, 8 min, ink on transparency, lightbox

109 L'Expédition Scintillante, Act I: Untitled (ice boat), 2002, ice, offshore radio. Photo by KuB Markus Tretter

110 One Million Kingdoms, 2001, animated film, sound, 6 min

All images courtesy of Marian Goodman Gallery, Paris/New York

Alejandro Jodorowksy

111 Alejandro Jodorowksy, photo by Doug Aitken

112–14 El Topo, 1970, Mexico, 125 min, film still. Courtesy of ABKCO Films

115–16 The Holy Mountain, 1973, Mexico/USA, 114 min, film still. Courtesy of ABKCO Films

Rem Koolhaas

117 Rem Koolhaas, photo by Doug Aitken

118–19 CCTV Television Station and Headquarters, Beijing, competition 2002, projected completion 2008

120 Seattle Public Library, commissioned 1999, completed 2004. Photograph by Philippe Ruault

121 Center for Art and Media Technology (ZKM), 1992, Karlsruhe, Germany. Construction drawings finished, construction cancelled 1992. Photo by Hans Werlemann

122 Prada New York Epicenter, commissioned 2000, completed 2001

123 Seattle Public Library, commissioned 1999, completed 2004. Photo by Philippe Ruault

All images courtesy of OMA/AMO Rem Koolhaas

Greg Lynn

124 Greg Lynn, photo by Doug Aitken

125–26 Hydrogen House Visitors Pavilion and Information Center, OMV Aktiengesellschaft, 1996–98, Schwechat, Austria, commissioned 1996, cancelled 1999

127 Stranded Sears Tower, 1992, Wacker Drive, Chicago, Illinois, model of speculative project

All images courtesy of Greg Lynn FORM, Los Angeles

Carsten Nicolai

128 Carsten Nicolai, photo by Doug Aitken

129 logik licht, 2002, 9 dataflashes, DMX programming (strobe light), cables. Installation view Watari Museum of Contemporary Art, Tokyo, 2002

130 wellenwanne, 2001, wave baths, speakers, amplifier, CD, CD player, light table, various cables. Installation view Milch Gallery, London. Photo by Dave Morgan

131 snow noise, 2001, acrylic tubes, polystyrene boxes with copper tubes, dry ice, magnifying lamps, acrylic and steel tables, pairs of gloves, wall drawing, random noise generators, instructions. Installation view Art Gallery of New South Wales, 2001. Photo by Jenni Carter and Brenton McGeachie. © AGNSW

All images other than no. 131 © VG Bildkunst Bonn. All images courtesy of the artist and Galerie EIGEN+ART, Berlin

Richard Prince

132 Untitled (Cowboy), 1997–98, Ektacolor photograph, 60 x 40 in

133 Untitled (Publicity), 2002, 3 publicity photographs, 41 x 33 in

134 Untitled (Girl Hunting), 1991, Ektacolor photograph, 24 x 20 in

135 Entertainers, 1982–83, Ektacolor photograph, 54 x 47 in

136 Untitled, 1990, silkscreen and spray paint on paper, 40 x 26 in

All images © Richard Prince and courtesy of Gladstone Gallery, New York

Pipilotti Rist

137 Feuerwerk Televisione Lipsticky (Firework Television Lipsticky), 1994/2000, video still. Courtesy of the artist, Luhring Augustine Gallery, New York, and Hauser & Wirth, Zurich/London

138–39 Selbstlos Im Lavabad (Selfless In The Bath Of Lava), 1994, video installation, sound, LCD monitor installed under the floor, 7:30 min, video still. Collection Musée d'Art et d'Histoire, Geneva and Kunsthaus Zürich. Courtesy of the artist and Luhring Augustine, New York, and Hauser & Wirth, Zurich/London

140–41 Pickelporno (Pimple Porno), 1992, video with sound, 12 min, video still. Courtesy of the artist and electronic art intermix (eai), New York

142 Open My Glade (Flatten), 1994/2000, 9 1-minute videos for Panasonic Screen, running every quarter past the hour from April 6 to May 20, 2000. Commissioned by the Public Art Fund, New York. Installation view Times Square. Photo by Dennis Cowley. Courtesy of the artist, Public Art Fund, and Luhring Augustine Gallery, New York

143 I'm Not The Girl Who Misses Much, 1986, video with sound, 7:46 min, video still. Courtesy of the artist and electronic art intermix (eai), New York

Ugo Rondinone

144 Ugo Rondinone, photo by Doug Aitken

145 A SPIDER. A SPIDER IS RUNNING ACROSS MY HEART AND THEN ANOTHER. SPIDERS RUN ACROSS MY HEART AND IF I CLOSE MY EYES, I CAN HEAR THE RUSH AND THE RUSTLE OF THEIR TINY DRY BODIES SCURRYING THROUGH ME, 2003, 6 video projections, 6 video loops, sound. Installation view La Criée Centre d'Art contemporain, Rennes, 2003. Courtesy of Eva Presenhuber Gallery, Zurich

146 Ugo Rondinone, photo by Doug Aitken

147 THE EVENING PASSES
−50 LIKE ANY OTHER. MEN
AND WOMEN FLOAT ALONE
THROUGH THE AIR. THEY
DRIFT PAST MY WINDOW
LIKE THE WEATHER. I CLOSE
MY EYES. MY HEART IS A
MOTH FLUTTERING AGAINST
THE WALLS OF MY CHEST.
MY BRAIN IS A TANGLE OF
SPIDERS WRIGGLING
AND ROAMING AROUND.
A WRIGGLING TANGLE
OF WRIGGLING SPIDERS.
(STILLSMOKING PART IV),
1998, polyester, paintwork,
metal chains, speakers, sound,
VHS-PAL videotapes, 4 moni-
tors, 4 players, paintings, acrylic.
Collection Hauser & Wirth,
St. Gallen. Courtesy of Eva
Presenhuber Gallery, Zurich
and Almine Rech, Paris

151 ALL THOSE DOORS, 2003,
29 pillars, acrylic glass, MDF,
loudspeakers, audio CD,
dimensions variable. Installation
view Short Nights, Long Years,
Le Consortium, Dijon, 2004.
Courtesy of Eva Presenhuber
Gallery, Zurich

Ed Ruscha

152 Large Trademark with Eight
Spotlights, 1962, oil on canvas,
66³⁄₄ x 133¹⁄₄ in. Collection
Whitney Museum of American
Art

153 Los Angeles County Museum
of Art on Fire, 1965−68, oil
on canvas, 53¹⁄₂ x 133¹⁄₂ in.
Collection Hirshhorn Museum and
Sculpture Garden, Smithsonian
Institution, Washington, DC

154 Premium, 1971, color, 16mm,
sound, 24 min, black-and-white
production still

155 Royal Road Test, 1967,
−56 photographic book

157 Ed Ruscha and Lawrence
Weiner, Hard Light, 1978,
photographic book

158 Miracle, 1975, color, 16mm,
sound, 28 min, black-and-white
production still

159 Hollywood, 1968, silkscreen
on paper, 17¹⁄₂ x 44⁷⁄₁₆ in

All images courtesy of the artist
and Gagosian Gallery, Los Angeles

Amos Vogel

160 Collage of book cover and
selected pages from the first
edition of Film as a Subversive
Art, Amos Vogel, Random
House, 1974

161 Michelangelo Antonioni,
−62 Zabriskie Point, 1970, USA,
110 min, film still. One half
of film still appears on p. 261,
other half on p. 262. Courtesy
of Photofest

163 Michelangelo Antonioni,
Zabriskie Point, 1970, USA,
110 min, film still [composite].
Courtesy of Photofest

Robert Wilson

164 Bluebeard's Castle/Erwar-
tung, Grosses Festspielhaus,
Salzburg, Austria, 1995. Photo
by Thomas Wollenberger
© Elisabeth Bühler and Thomas
Wollenberger

165 KA MOUNTain and GUARDenia
TERRACE, Shiraz, Iran, 1972.
Photo by Bahman Djalali

166 Bluebeard's Castle/Erwartung,
Grosses Festspielhaus, Salz-
burg, Austria, 1995. Photo
by Thomas Wollenberger.
© Elisabeth Bühler and Thomas
Wollenberger

167 Video 50, 1978, color, 51:40
min. Photo by Kira Perov

168 Overture to the Fourth Act of
Deafman Glance, Salle Vilar,
France, 1976. Photo by Pietro
Privitera

All images courtesy of The Byrd
Hoffman Water Mill Foundation

Moments of Nonlinearity

169 Jean-Luc Godard, Weekend,
1967, Italy/France, 105 min,
Production Gaumont, film still.
Courtesy of the Collection
Musée Gaumont

170 Stan Brakhage, Cat's Cradle,
−72 1959, USA, color, 16mm, silent,
6 min, film still. Courtesy of the
Estate of Stan Brakhage and
www.fredcamper.com

173 Peter Cook, Instant City, 1970,
−76 collage. Photo by Christian
Wachter, Kunsthalle, Vienna.
Courtesy of Archigram Archives,
London

177 Charles and Ray Eames, Glimpses
of the USA, 1959, installation
view. © 2005 EAMES OFFICE
LLC (www.eamesoffice. com)

178 Auditorium with Screen-
O-Scope, Film Guild Cinema,
New York, 1928, by Frederick
Kiesler. Photo by Ruth Bernhard.
© Austrian Frederick and Lillian
Kiesler Private Foundation,
Vienna. Courtesy of Kiesler
Foundation Archive, Vienna

179 Images of book cover and
selected pages from the first
edition of Expanded Cinema,
Gene Youngblood, E. P. Dutton
& Co., Inc., New York, 1970

180 Paul Morrissey and Andy
Warhol, Chelsea Girls, 1966,
USA, 210 min [installation view].
© 2005 The Andy Warhol

Museum, Pittsburgh, Pennsylvania,
a museum of the Carnegie
Institute. All rights reserved.
Courtesy of The Andy Warhol
Museum

181 Dziga Vertov, Man with a Movie
Camera, 1929, Soviet Union,
80 min, film still. Courtesy of
Photofest

INDEX

Page numbers in italics
refer to illustrations

ACKNOWLEDGMENTS

AUTHOR
Doug Aitken

EDITOR
Noel Daniel

GRAPHIC DESIGN
Paul Wysocan

ART DIRECTION
Doug Aitken

DIAGRAM DESIGN & RESEARCH
Jason Wesche

PICTURE RESEARCH
Jason Wesche, Charlie Skinner

PROOFREADER
Lori Waxman

INDEXER
Helen Chin

DESIGN ASSISTANCE
Gabie Strong

TRANSCRIPTIONS
Sharice Babakhan, Muriel Bartol, Jessica
Fairbanks, Manwell Hernandez, Sara
Licastro, Leigh McCarthy, Laurie Rajski,
Lauren Rosenblum, Jessica Silverman,
and Livia Van Haren

**STUDIO ASSISTANCE
& PHOTO ARCHIVING**
Alex Amerri, Daniel Desure, Brian Doyle,
Daniel Hope, Hisako Ichiki, Tsuguko Kano,
Teh Park, Sean Rhyan, and Roshni Sharma

*Broken Screen
Expanding the Image,
Breaking the Narrative
26 Conversations with Doug Aitken*

Thank you for permissions, production, and other
assistance to:
Alex Bacon, Maggie Berget, Marilyn Brakhage, Fred
Camper, Cooperative Association for Internet Data
Analysis (CAIDA), Lesley Cohen, Barbara Corti,
Perry Daniel, Tom and Margery Daniel, Mary Dean,
Geralyn Huxley, Biljana Joksimovic, Jessica Jones,
Alexander Lee, Elisa Leshowitz, Jason Loeffler,
CK Lyons, Megan McFarland, Tonia Samman, Kim
Schoenstadt, Michelle Silva, Dana Simmons, Faye
Thompson, Céline Visse, Donna Wingate, Erik
Wysocan, Peter and Coleen Wysocan

Doug would like to give special thanks to:
all participants, Robert and Marilyn Aitken, Melanie
Archer, *Artforum*, Klaus Biesenbach, *Bomb*, Francesco
Bonami, Todd Bradway, Zoe Burns, Peter Eleey,
frieze, Sharon Gallagher, Tim Griffin, *Index*, Susan
Inglett, Lee Kaplan, Barbara London, Glenn Lowry,
Kristine McKenna, MoMA, Hans Ulrich Obrist, Anne
Pasternak, François Perrin, David Platzker, Eva
Presenhuber and Eva Presenhuber Gallery (Zurich),
P.S. 1, Shaun Regen and Regen Projects (Los
Angeles), Joni Sighvatsson, Roni Singh, Lisa
Spellman and 303 Gallery (New York), Sileen
Thomas, David Unger/ICM, Victoria Miro Gallery
(London), and Francesca Von Habsburg

Page 286 includes a list that Hou Hanru and
Hans Ulrich Obrist compiled for the exhibition
Cities on the Move (1997–99), as well as names
given by the architectural collective Gruppo A12
and artists Gilbert and George, among others.
Hans Ulrich Obrist would like to thank Archigram,
Peter Cook, Rem Koolhaas, Georges Perec, and
Cedric Price for triggering the list, as well as thanks
to Stefano Boeri, Andrea Branzi, David Greene, and
Peter Smithson. Obrist is curator of contemporary
art at ARC/Musée d'Art moderne de la Ville de Paris.
Page 286 cites JW, which refers to Jason Wesche.

Front cover, back cover, and unattributed artwork in
the book © 2006 Doug Aitken Workshop

These conversations took place between 2003
and 2005. They have been edited for clarity.

Publication © 2006 D.A.P./Distributed Art Publishers, Inc.
Conversations © 2006 Doug Aitken and the Participants
Images © 2006 the Participants unless otherwise specified

Managing Editor: Melanie Archer, D.A.P.
Typeface: Berthold Akzidenz Grotesk, ITC Avant Garde Gothic
Printing: Palace Press International, China

Published by:
D.A.P./Distributed Art Publishers, Inc.
155 Sixth Avenue, 2nd floor
New York, NY 10013
www.artbook.com

ISBN 1-933045-26-4
Library of Congress Cataloging-in-Publication Data
TK

In memory of Laurie Rajski

Doug Aitken Workshop, Los Angeles
www.dougaitkenworkshop.com